MANGA

THE MONSTER BOOK OF MANGA

GOTHIC

MANGA

THE MONSTER BOOK OF MANGA

GOTHIC

Edited by Jorge Balaguer

HARPER
DESIGN
An Imprint of HarperCollins Publishers

First edition packaged in 2013 by:
LOFT Publications
Via Laietana, 32, 4th fl., of. 92
08003 Barcelona, Spain
Tel.: +34 93 268 80 88
Fax: +34 93 317 42 08
www.loftpublications.com

First edition published in 2013 by:
Harper Design
An Imprint of HarperCollins*Publishers*
10 East 53rd Street
New York, NY 10022
Tel.: (212) 207-7000
Fax: (212) 207-7654
harperdesign@harpercollins.com
www.harpercollins.com

Distributed throughout the world by:
HarperCollins*Publishers*
10 East 53rd Street
New York, NY 10022
Fax: (212) 207-7654

Editorial coordination:
Claudia Martínez Alonso

Assistant to editorial coordination:
Ana Marques

Art direction:
Mireia Casanovas Soley

Ilustrations and texts:
Jorge Balaguer

Layout:
Emma Termes Parera
Sara Abril Abajo

Cover layout:
María Eugenia Castell Carballo

Translation:
textcase
www.textcase.nl

ISBN: 978-0-06-221024-1

Library of Congress Control Number: 2013941013

Printed in China
First printing, 2013

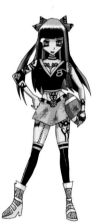
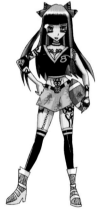

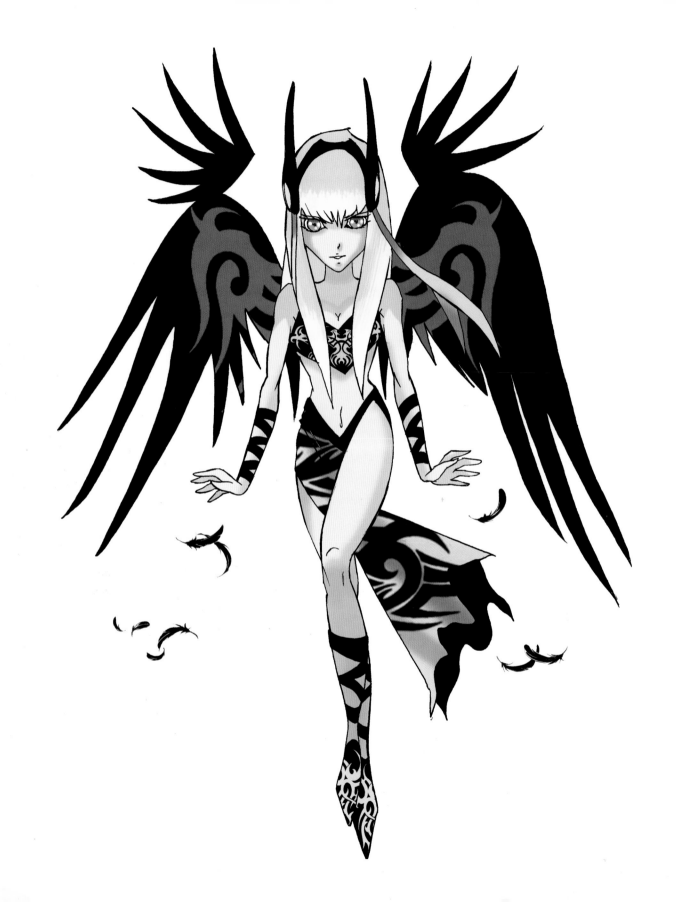

INTRODUCTION

Dear Manga Fans,

The book you have in your hands will help you improve your level of drawing and will provide you with ideas and techniques to create gothic manga characters, an increasingly valued style of character for manga fans around the world.

The gothic style was popularized in the mid-eighties. It was influenced by the gothic rock music of the post-punk culture, and showed aesthetic references to the clothing styles used in dark films and horror literature. Many types of these garments were inspired by Victorian and Renaissance styles in their most grim forms; for example, by the people who embraced dark clothing, white-painted faces, and black lips.

Movies with characters dress in gothic styles are *The Crow*, *Beetlejuice*, *Edward Scissorhands*, *Nightmare Before Christmas*, and *The Legend of Sleepy Hollow*, and have inspired those who embrace the style. Cult fans of anime, cyberpunk, and, especially, *The Matrix* trilogy are also often interested in this subculture.

More recently, the gothic style has had a strong affect on the world of manga comics, leading to the creation of what we call "gothic manga." Gothic manga stories and characters have been welcomed by fans, and have led to the creation of amazing sagas and alternative fashion trends, like the gothic lolita look. The clothing of a gothic lolita, which is one of the most well-known gothic styles, is often a combination of black and white clothes, particularly black skirts and white lace tops, and is usually decorated with ribbons. For other types of gothic characters, hats, umbrellas, crucifixes, chains, and pocket watches are popular accessories.

This book represents some of the styles of the gothic characters. To make it, I've chosen characters from different time periods, some are human, some are fantasy. I hope you enjoy creating the characters as much as I have enjoyed preparing and drawing the designs.

Best regards,
Jorge Balaguer

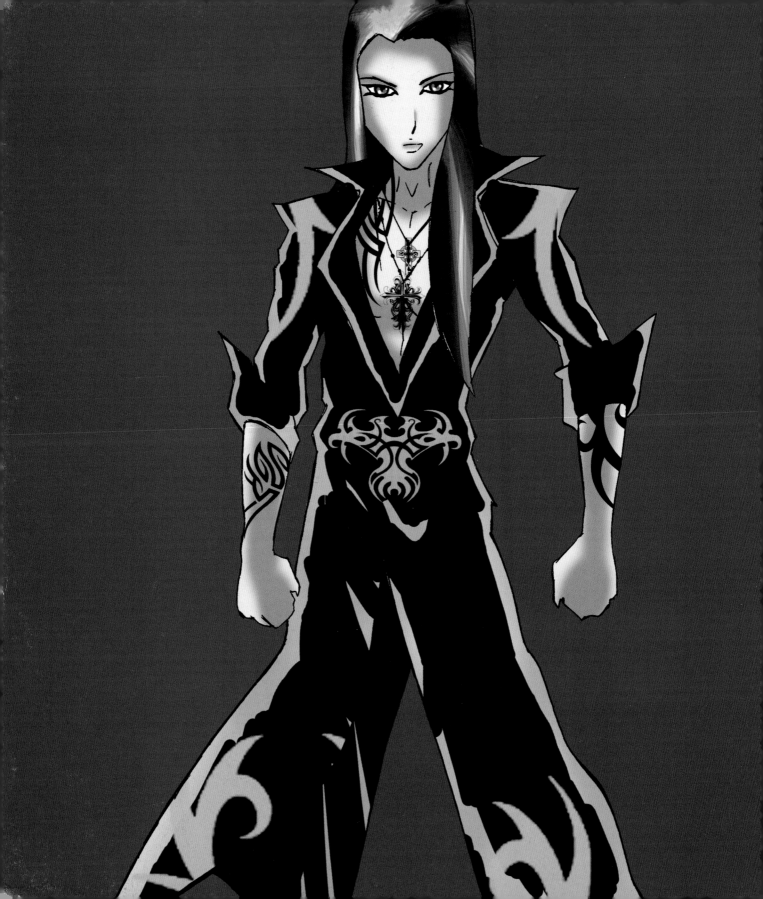

BOYS

CYBERPUNK BOY

Cross is a cyberpunk from Mighty City, a city divided into sectors with clans fighting to survive a war against police robots. The police robots turned against the humans, enslaving them after a wave of solar radiation.

Prepare the outline of the character using a blue pencil. Give him a crouching pose.

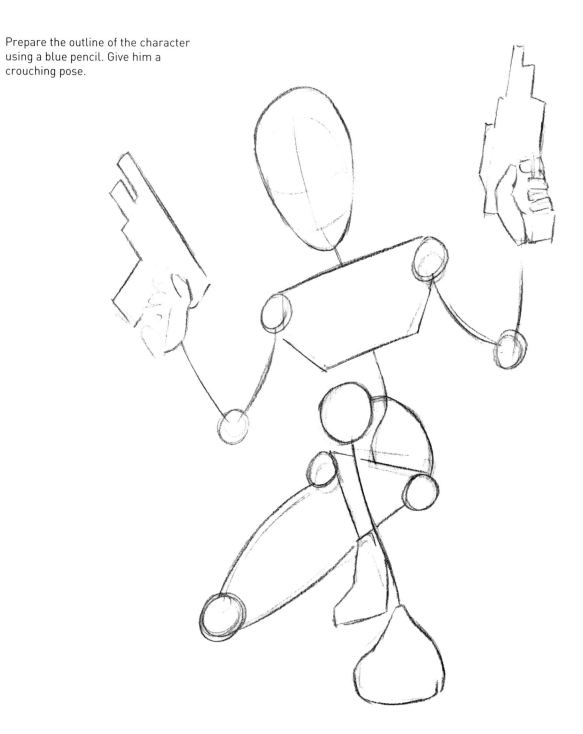

Use a 2H pencil for the contour
lines to define the figure and its
silhouette.

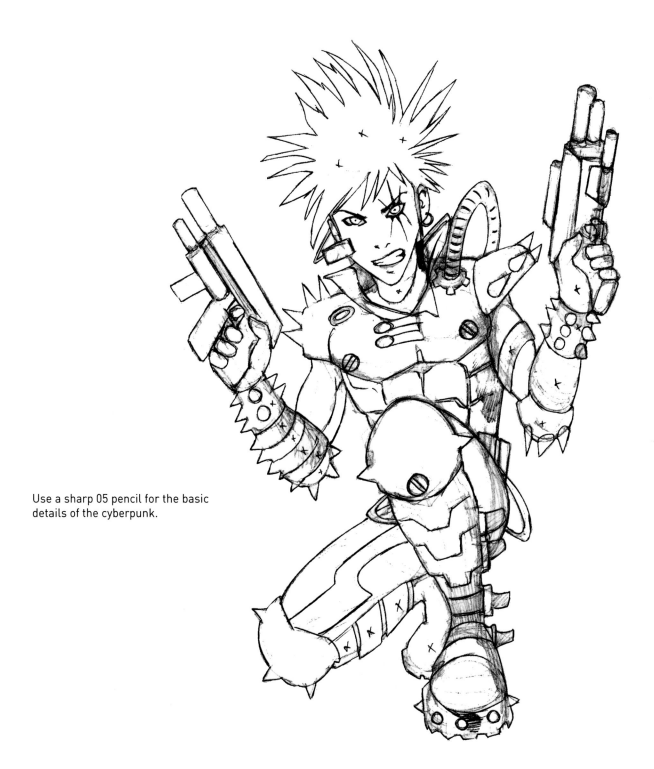

Use a sharp 05 pencil for the basic
details of the cyberpunk.

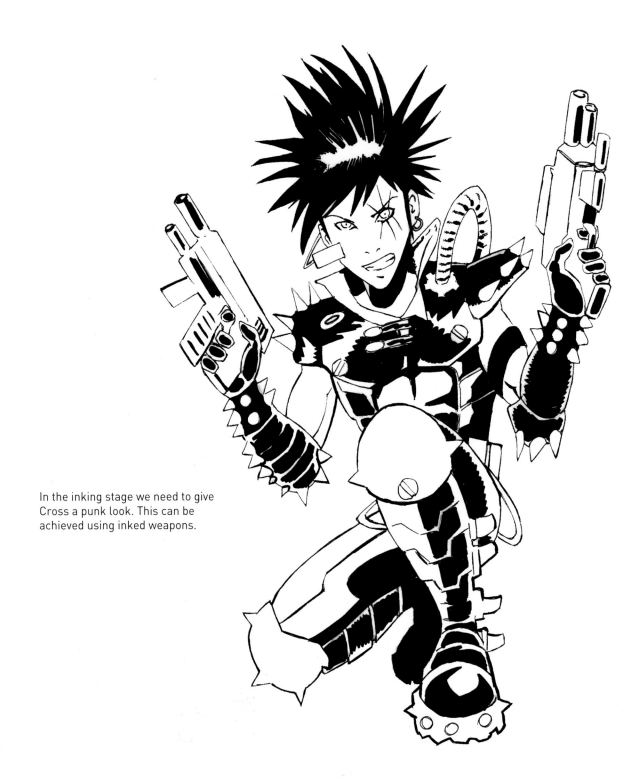

In the inking stage we need to give Cross a punk look. This can be achieved using inked weapons.

Crouching between light and
shadow as if about to spring into
action, Cross has several lights
above him and some to his side.

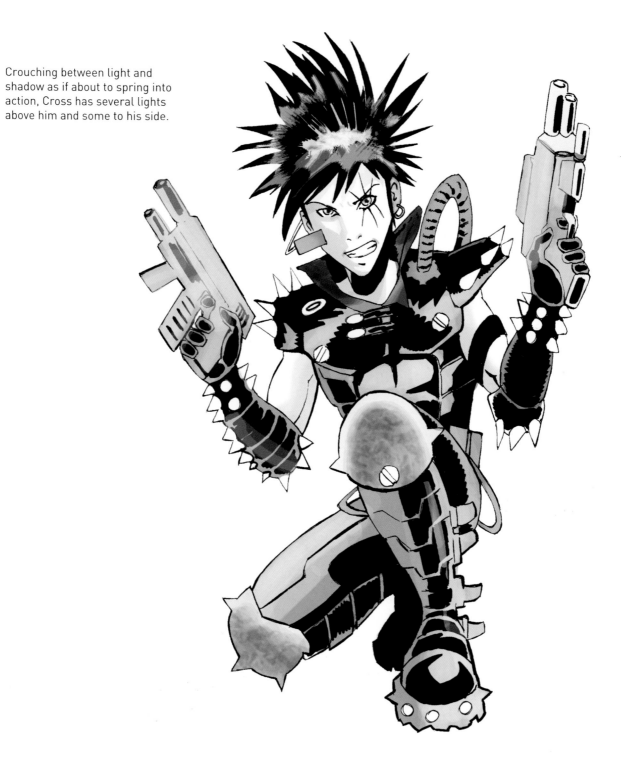

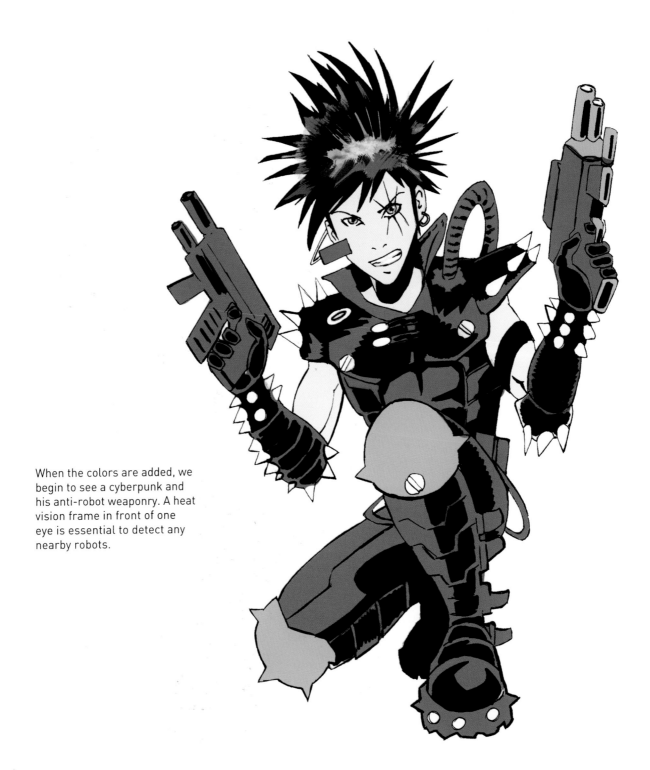

When the colors are added, we begin to see a cyberpunk and his anti-robot weaponry. A heat vision frame in front of one eye is essential to detect any nearby robots.

As finishing touches give Cross enhancements such as an energy supply, which is shown by the red lines attached to his weapons, and clan tattoos.

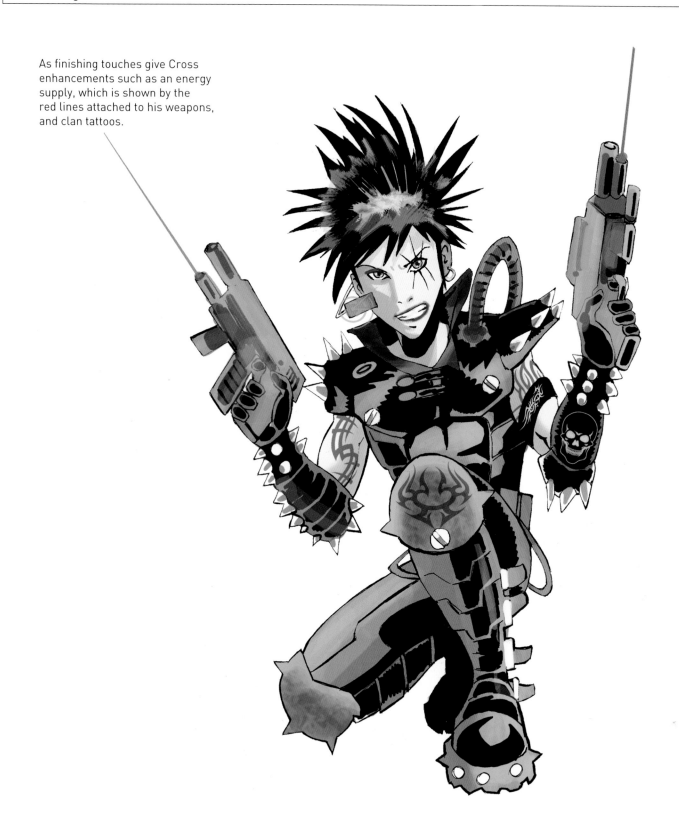

GOTHIC SPACE COWBOY

Red Maverick is a space cowboy, a great adventurer, and gunman. Recruited by McRoy, the sheriff of Saint Lance, for his great skill and aim, he makes sure all the mercenaries and visitors to the city respect the law.

Draw the cowboy's skeleton in blue.
Give it a pose that makes it look like
he is leaning on a bar in a saloon.

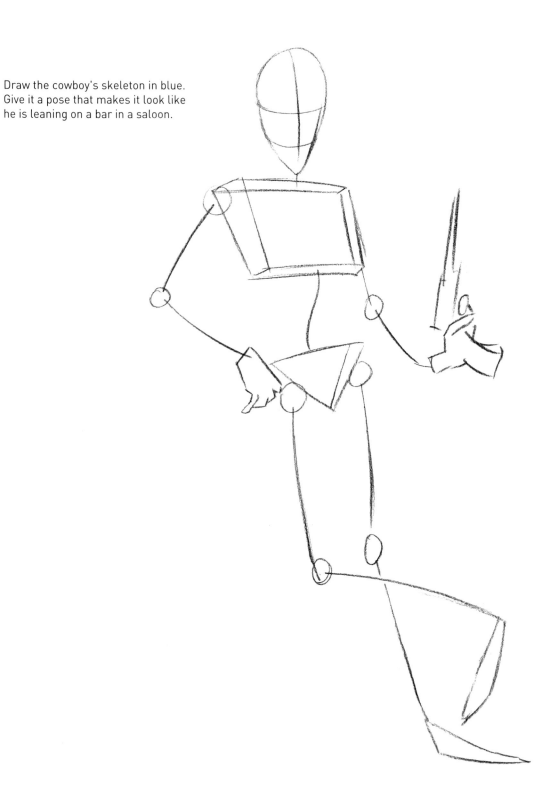

The contour lines help us with his
body language, giving him the look
of a self-assured gunman. Draw
these with a soft 2H pencil.

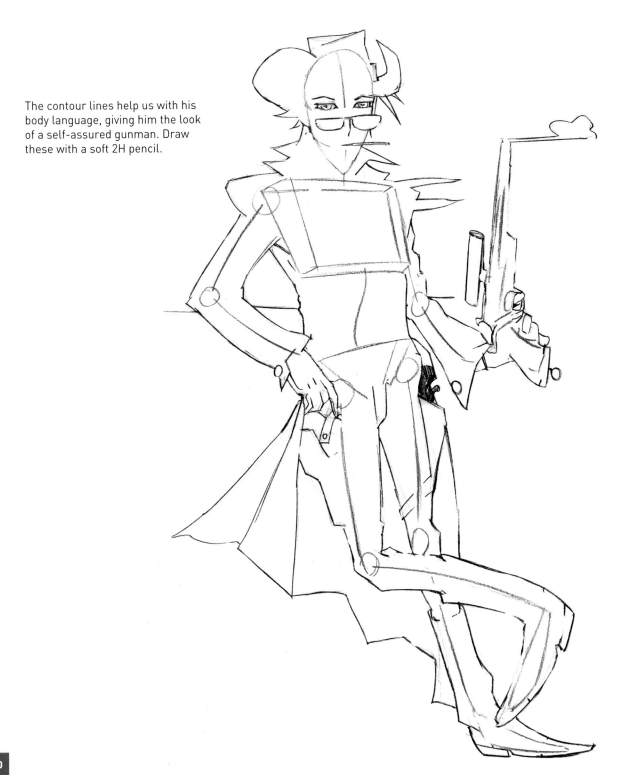

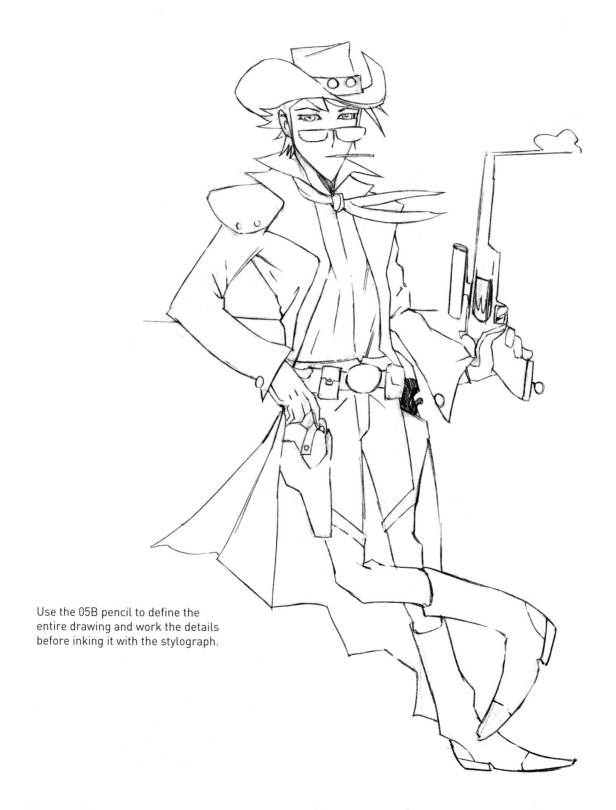

Use the 05B pencil to define the
entire drawing and work the details
before inking it with the stylograph.

Use an 02 pen to ink the entire drawing, then go over Red's silhouette with an 04 to add volume. Fill the black areas and the scarf, hat, and boots with an 08.

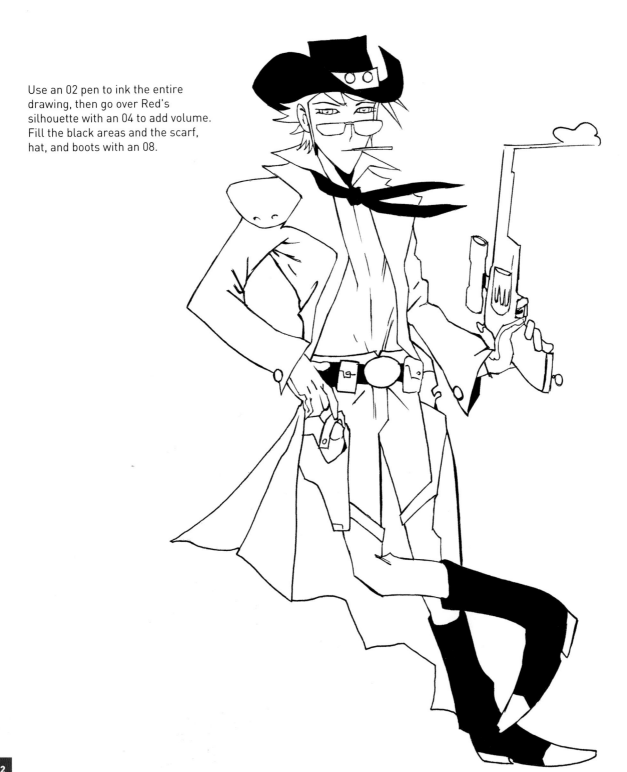

Light illuminates the character from the left. It adds volume to his jacket and casts shadow on his neckerchief and half of his face.

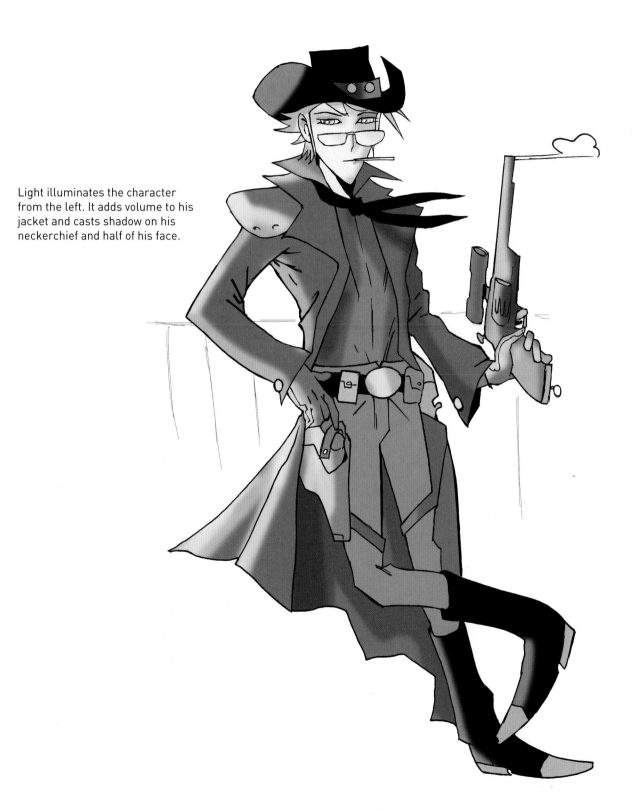

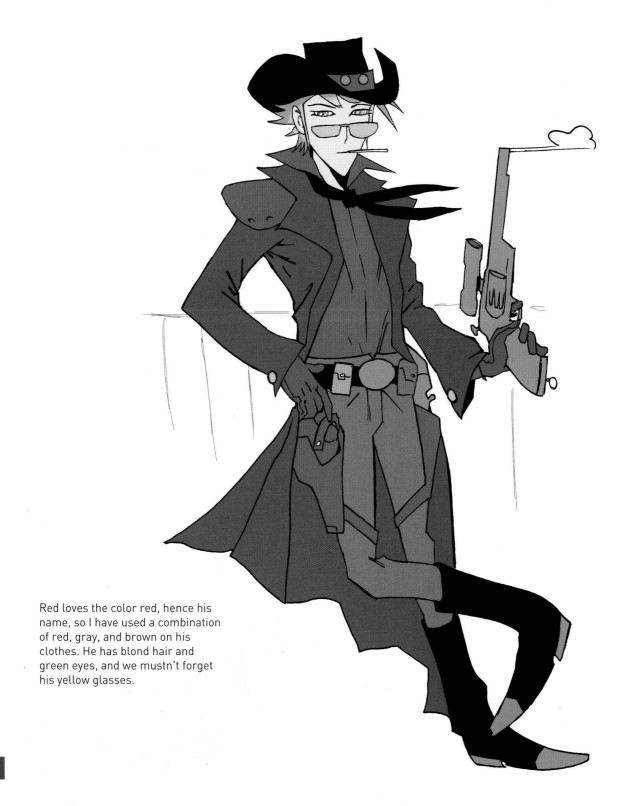

Red loves the color red, hence his name, so I have used a combination of red, gray, and brown on his clothes. He has blond hair and green eyes, and we mustn't forget his yellow glasses.

Add gothic touches, such as crosses on the character's shirt and a skull on his epaulette made with an 02 pencil. You can also make a cross on his belt and another skull on his studded hat with white pencil. Lastly, add softness to the jacket with a blue pencil and add volume to the pouches with a deep shade of red.

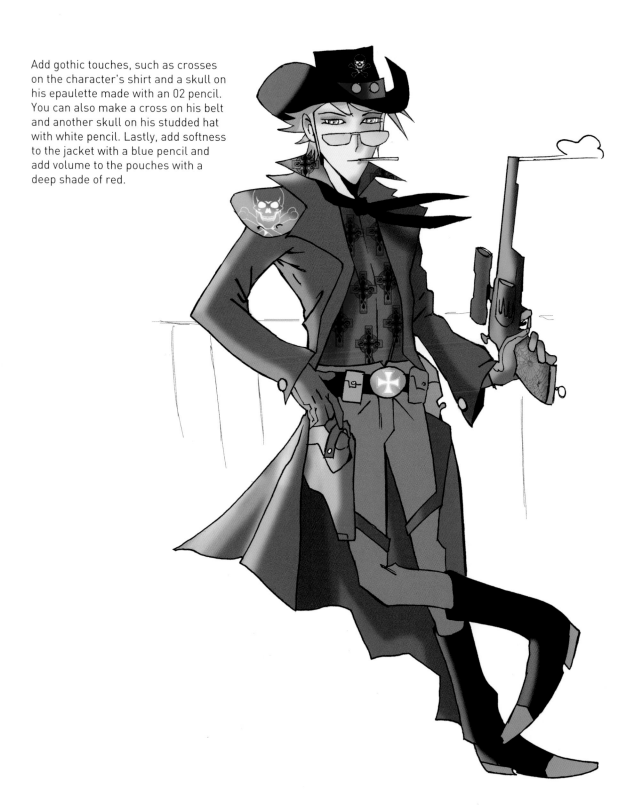

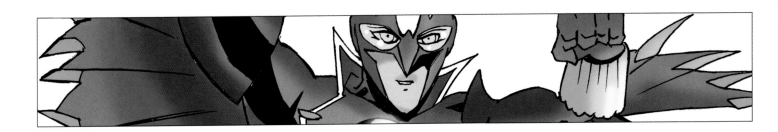

GOTHIC SUPERHERO

Moon Hawk is a great superhero. His high-tech suit allows him to fly and his sensors can trace all criminals and evildoers, shoot darts, and neutralize his attackers. He is a nocturnal hero and his suit recharges itself by moonlight, giving him superhuman strength.

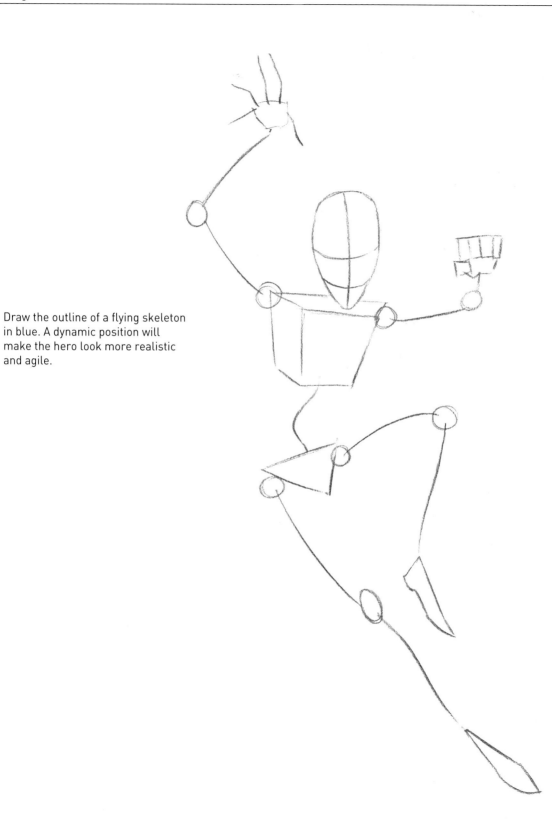

Draw the outline of a flying skeleton in blue. A dynamic position will make the hero look more realistic and agile.

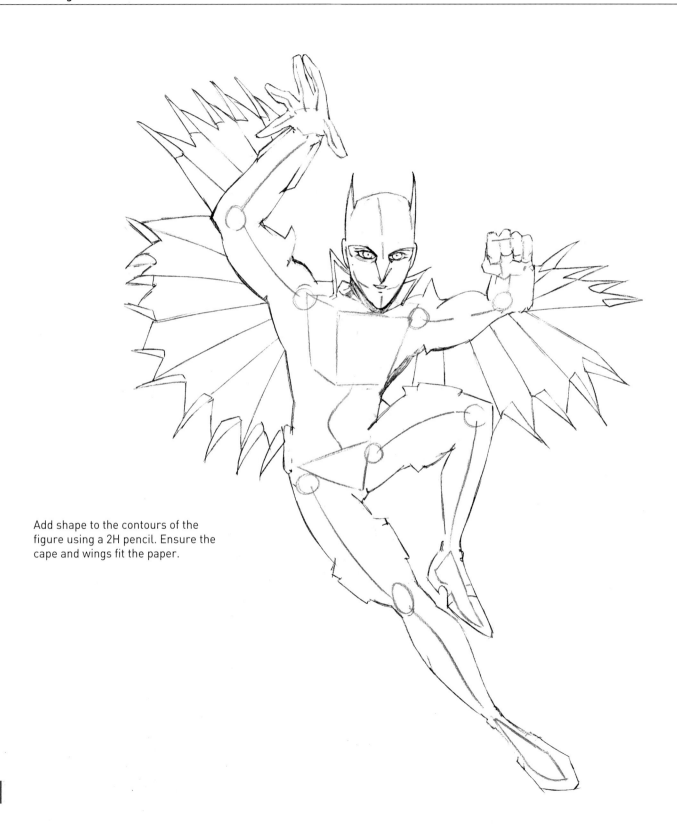

Add shape to the contours of the figure using a 2H pencil. Ensure the cape and wings fit the paper.

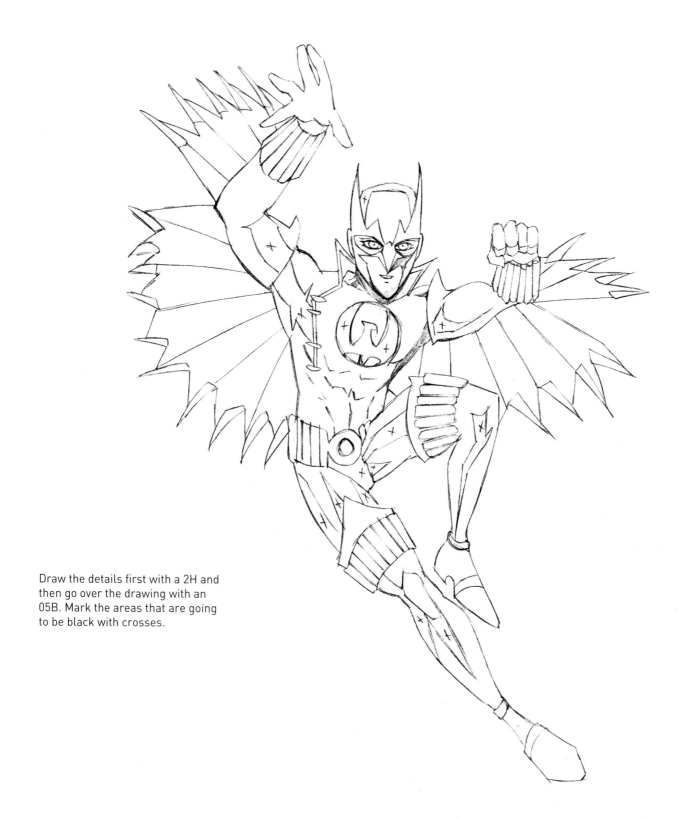

Draw the details first with a 2H and then go over the drawing with an 05B. Mark the areas that are going to be black with crosses.

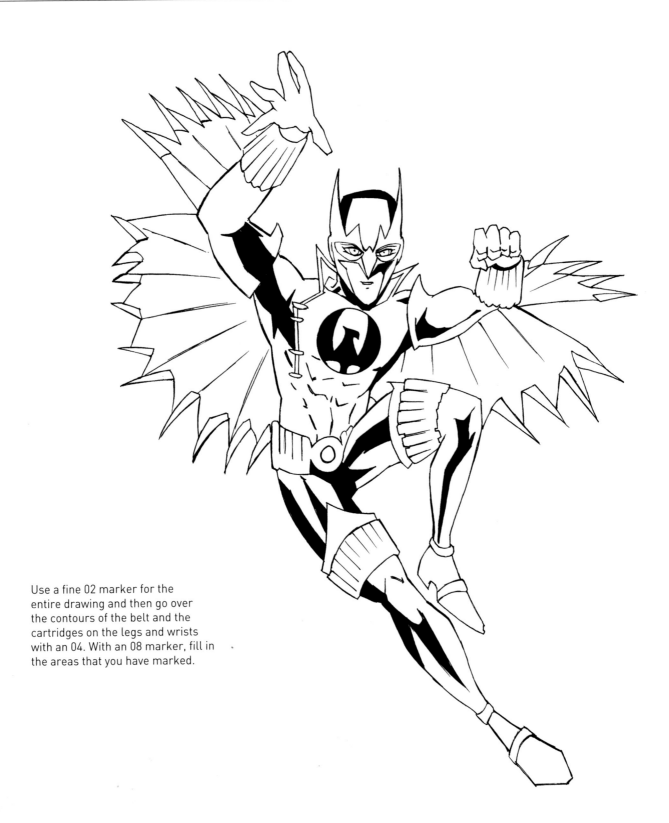

Use a fine 02 marker for the entire drawing and then go over the contours of the belt and the cartridges on the legs and wrists with an 04. With an 08 marker, fill in the areas that you have marked.

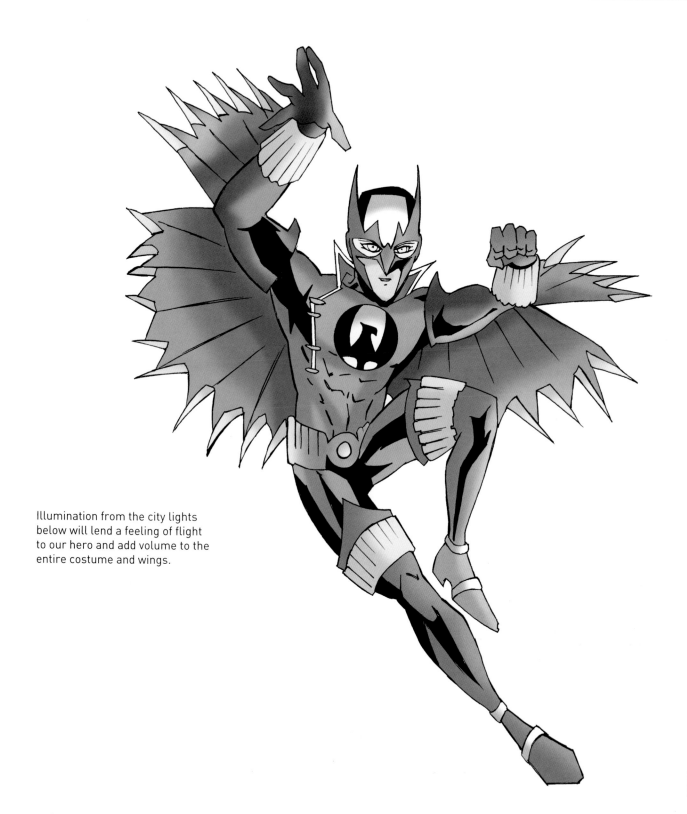

Illumination from the city lights below will lend a feeling of flight to our hero and add volume to the entire costume and wings.

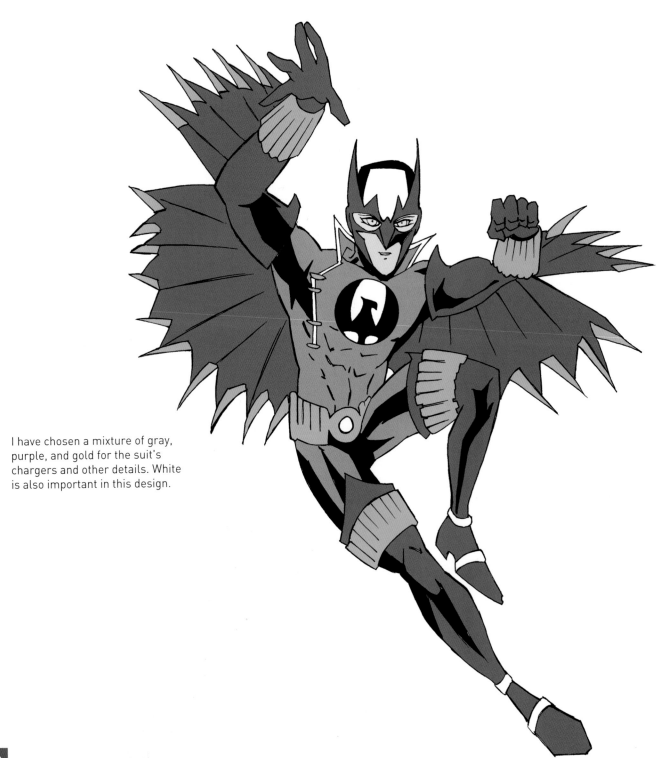

I have chosen a mixture of gray, purple, and gold for the suit's chargers and other details. White is also important in this design.

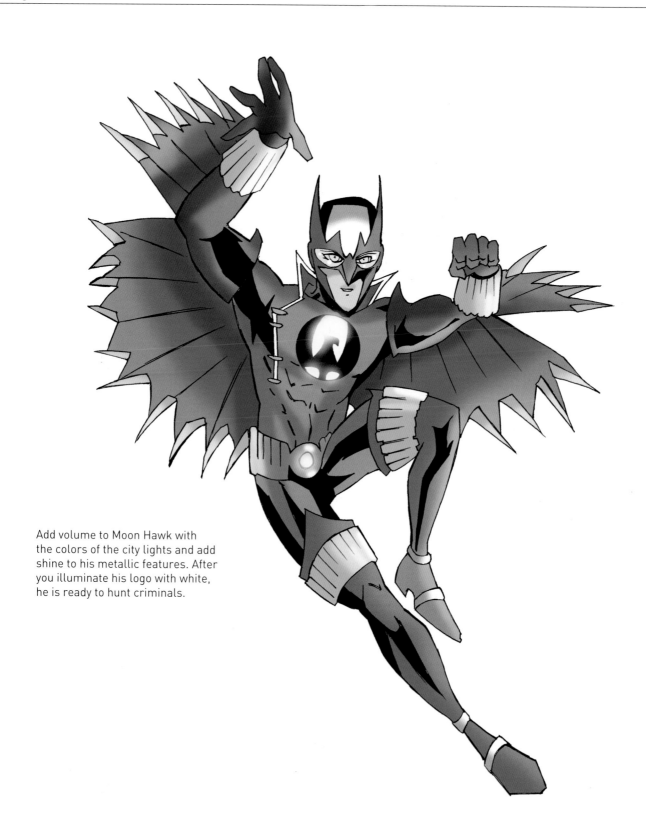

Add volume to Moon Hawk with the colors of the city lights and add shine to his metallic features. After you illuminate his logo with white, he is ready to hunt criminals.

GOTHIC SAMURAI

Jubotai is a samurai without a lord to serve. He travels to villages in search of fortune and adventures, always ready to put his knowledge into practice with his sword.

Draw the outline of Jubotai. Give his skeleton a combat pose, taking care to avoid it becoming too rigid.

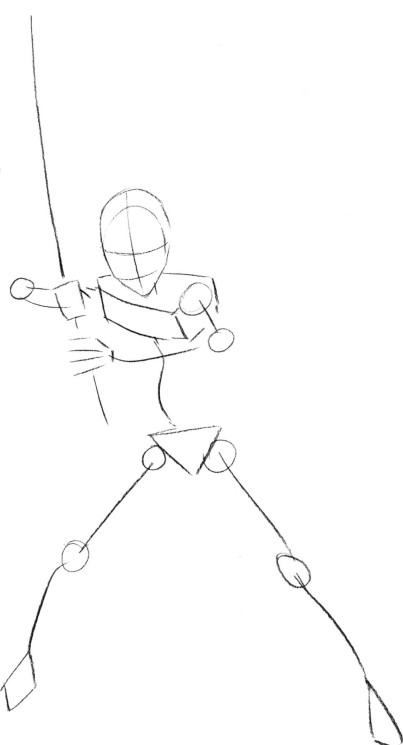

With a 2H pencil, mark the contours of the skeleton to give volume to the figure.

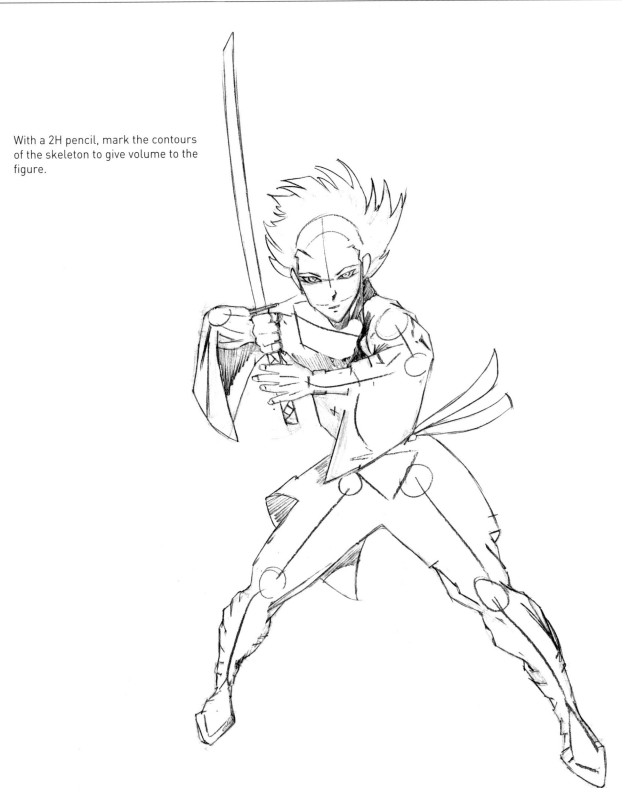

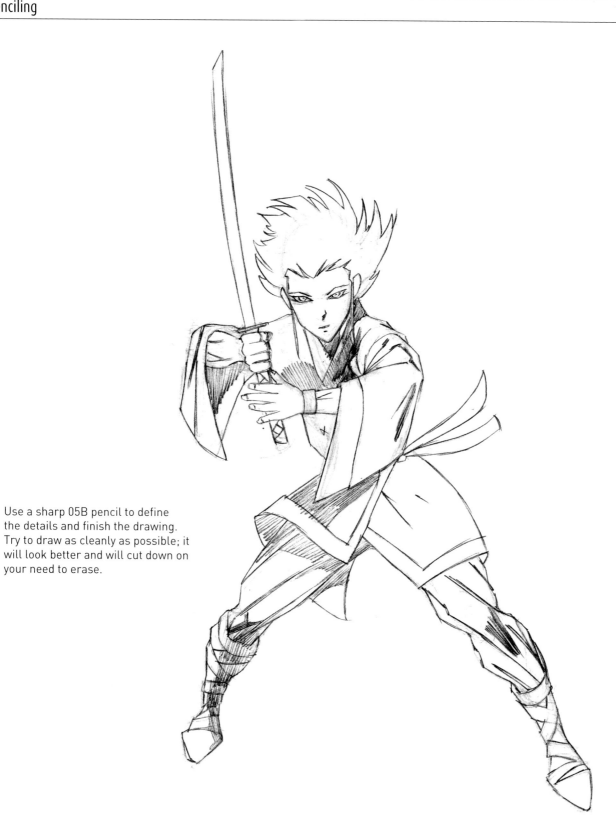

Use a sharp 05B pencil to define the details and finish the drawing. Try to draw as cleanly as possible; it will look better and will cut down on your need to erase.

Using the stylograph with a fine 02 nib, ink the entire drawing. Use an 04 marker for the sword and an 08 to fill areas of the kimono and boots with black.

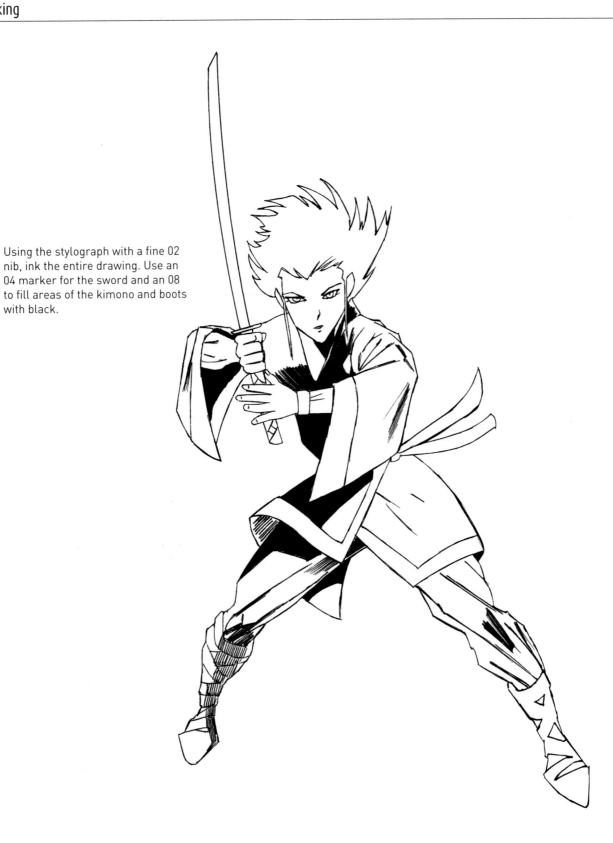

The light comes from the left. It shines most brightly on his face and hair and then diffuses softly.

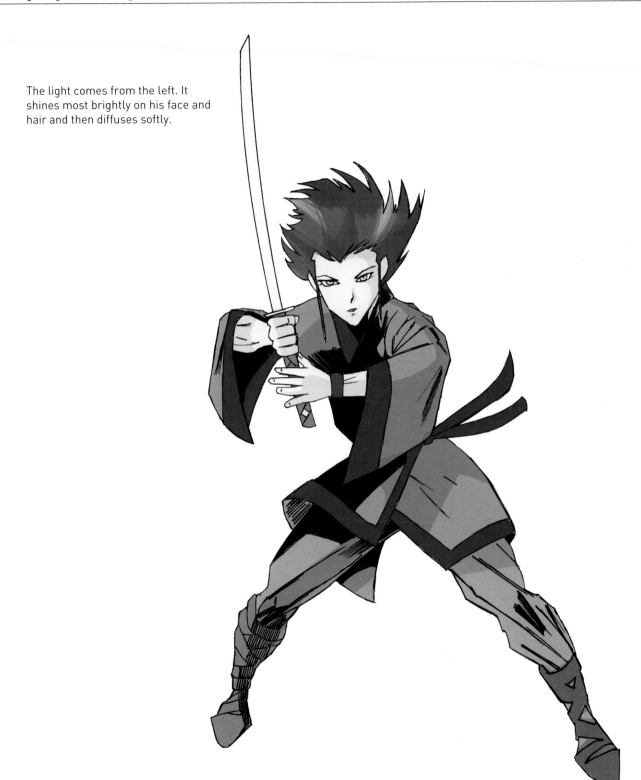

I have chosen green and gray for this design. These colors lend the character a certain darkness. Use them on the costume and then to add shine to Jubotai's black hair and to give him green eyes.

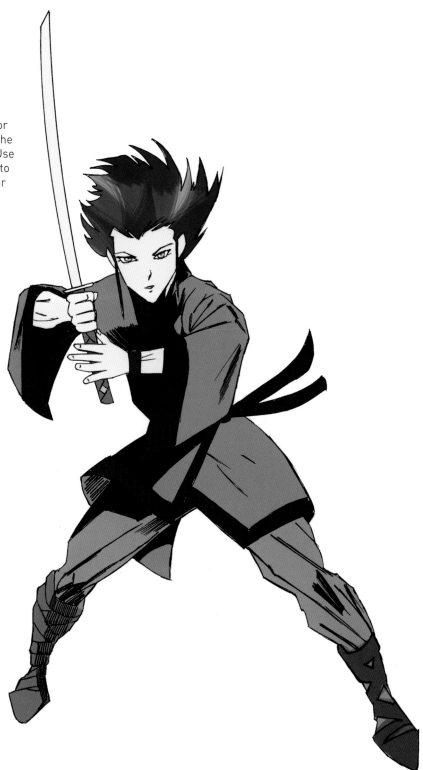

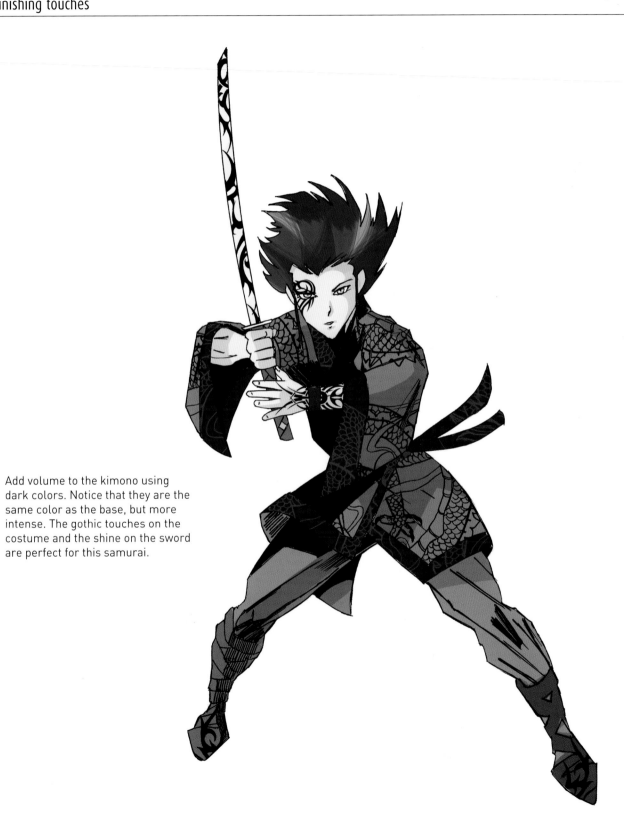

Add volume to the kimono using dark colors. Notice that they are the same color as the base, but more intense. The gothic touches on the costume and the shine on the sword are perfect for this samurai.

GOTHIC VAMPIRE BOY

Nicolay Ulivanoph is a gothic vampire. He moved from Europe to New Orleans in 1756 and since then has enjoyed frequenting the areas of the city that offer dancing and entertainment, the places where the most scrumptious people hang out.

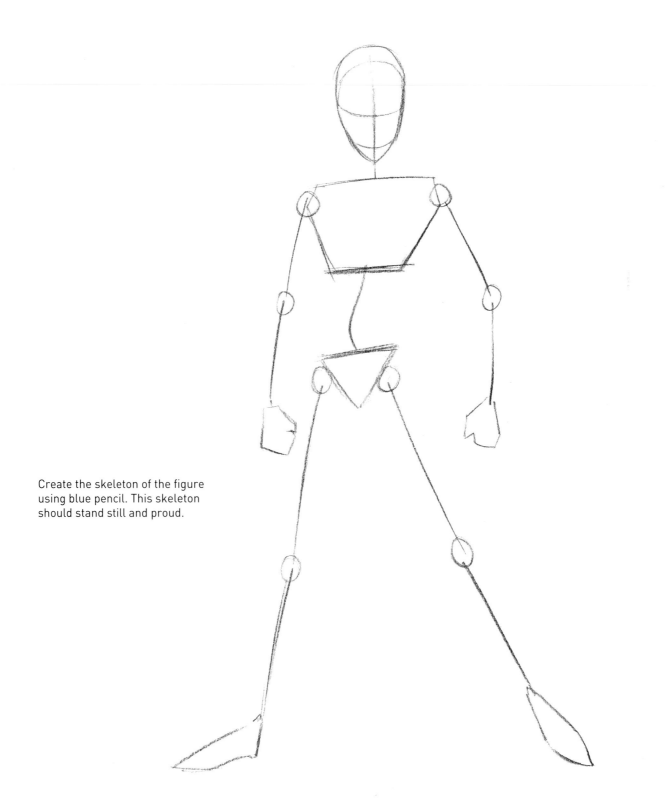

Create the skeleton of the figure using blue pencil. This skeleton should stand still and proud.

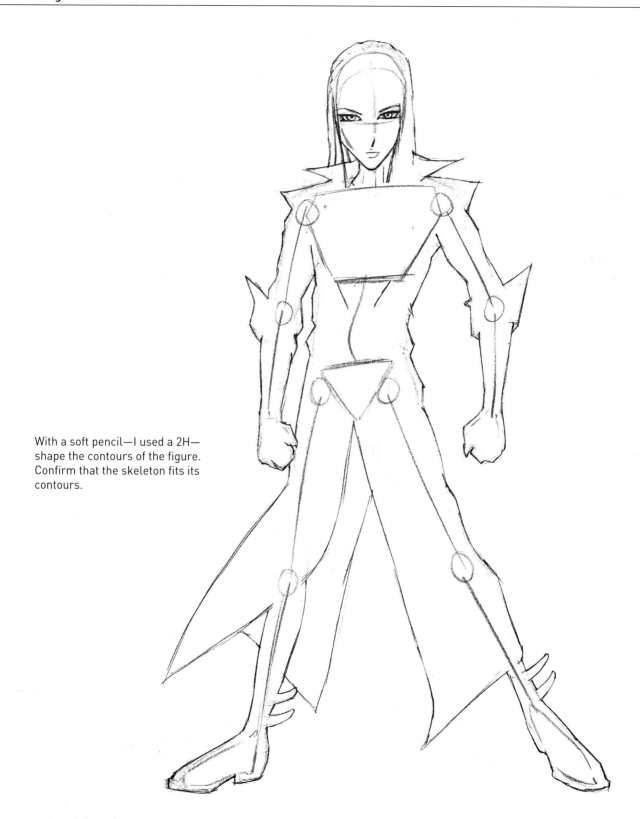

With a soft pencil—I used a 2H—shape the contours of the figure. Confirm that the skeleton fits its contours.

Using a fine tip pen or 05 mechanical
pencil, draw Nicolay. Be careful when
drawing the details of his costume.
The better your penciling, the better
the drawing will be for inking.

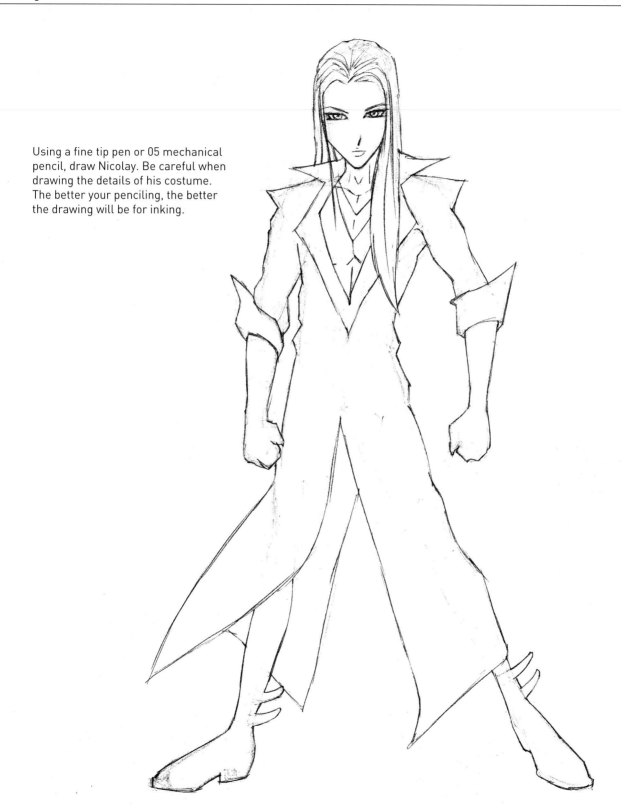

Use markers to fill the large areas and stylographs with fine 02 or 04 size nibs for the contours and details. For the black bodysuit, use an 04 for the contours and an 08 for the inside.

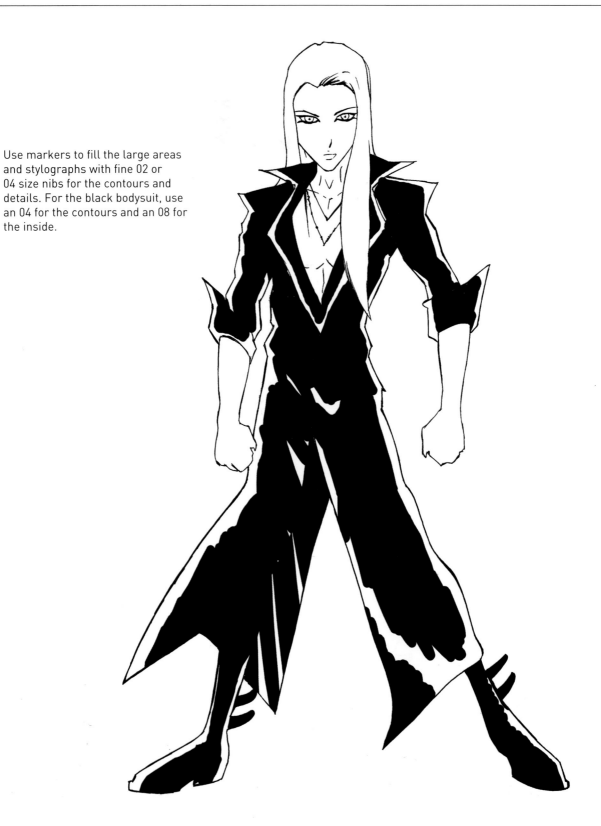

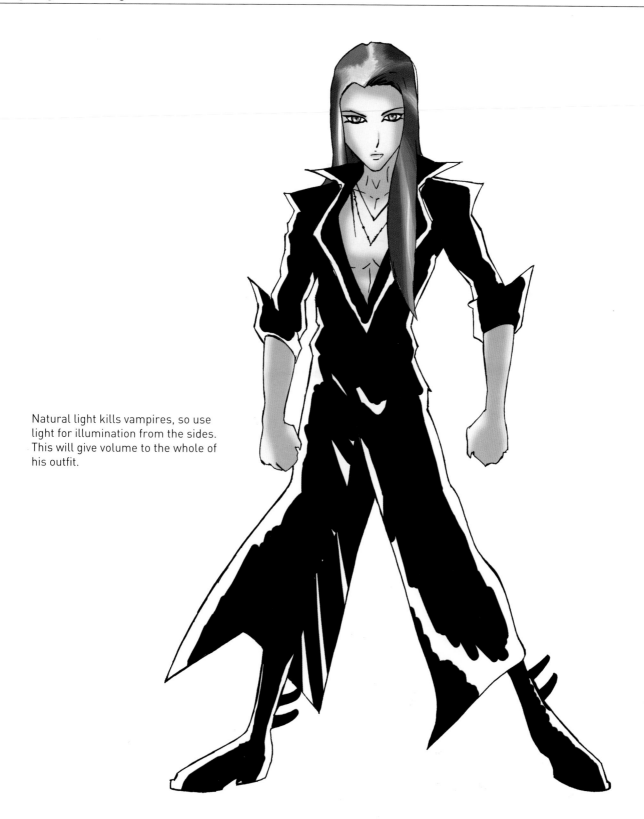

Natural light kills vampires, so use light for illumination from the sides. This will give volume to the whole of his outfit.

Add the base colors. For this drawing, reverse the traditional process by using dark shades first and then adding light ones with colored pencils. Add shine to the hair with a gray pencil and create red eyes.

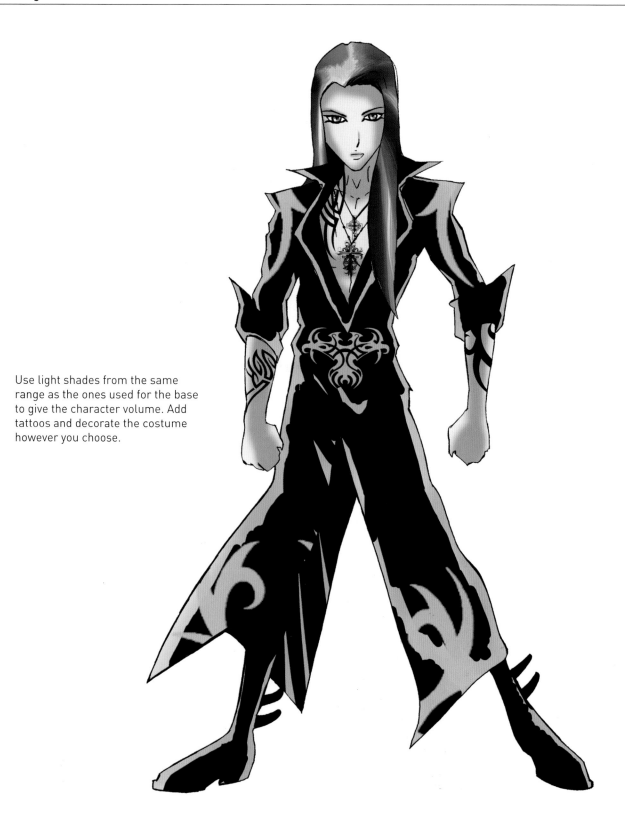

Use light shades from the same range as the ones used for the base to give the character volume. Add tattoos and decorate the costume however you choose.

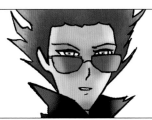

MOTORCYCLE RIDER

Gray Roma is a magnificent biker and world-famous stuntman; his show is an explosion of lights and pyrotechnics. His greatest secret is that, when riding his motorcycle, nothing can harm him because his motorcycle is protected by magic gothic symbols.

Using blue pencil, create the outline of Roma and his motorcycle. Make sure that the character and bike are sized to fit the paper.

Using a 2H pencil, shape the contours of the figure and make sure the skeleton fits into its contours and has the right volume. Repeat this process with the motorcycle.

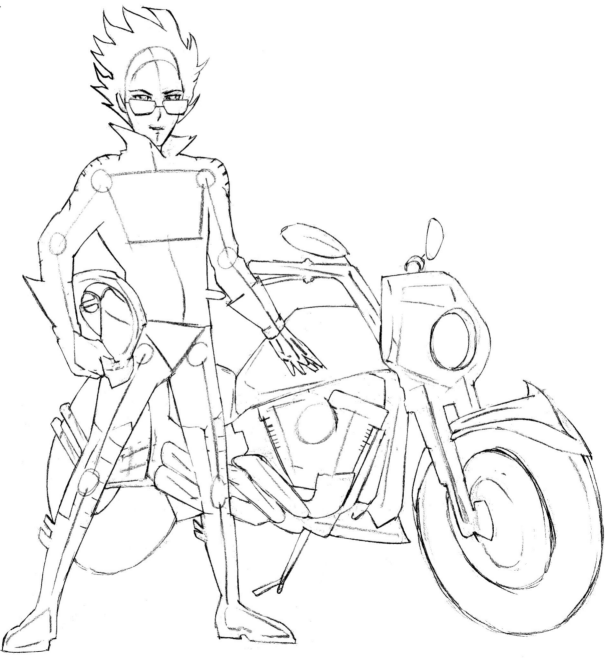

Draw Roma with an 05 mechanical pencil. Work carefully when creating the details of his attire, such as the jacket, boots, and goggles.

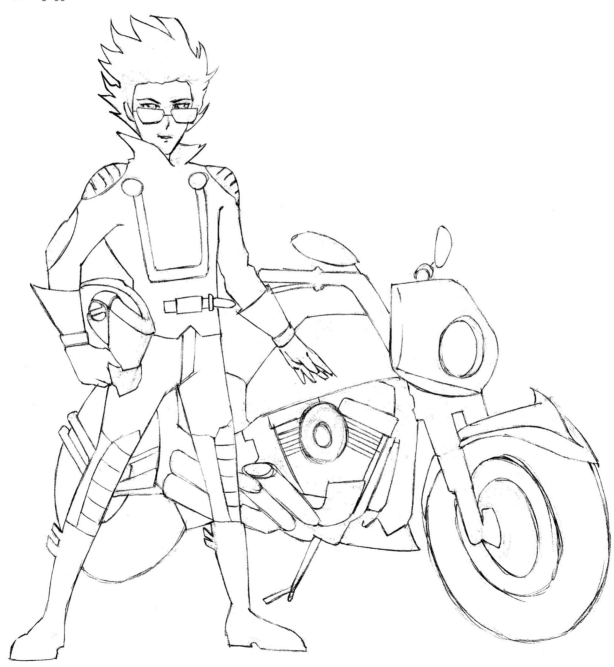

Use markers to fill the large areas of the illustration and stylographs with fine 02 or 04 size nibs for the contours and details. Use an 04 for the contours of the black jacket and an 08 for its insides.

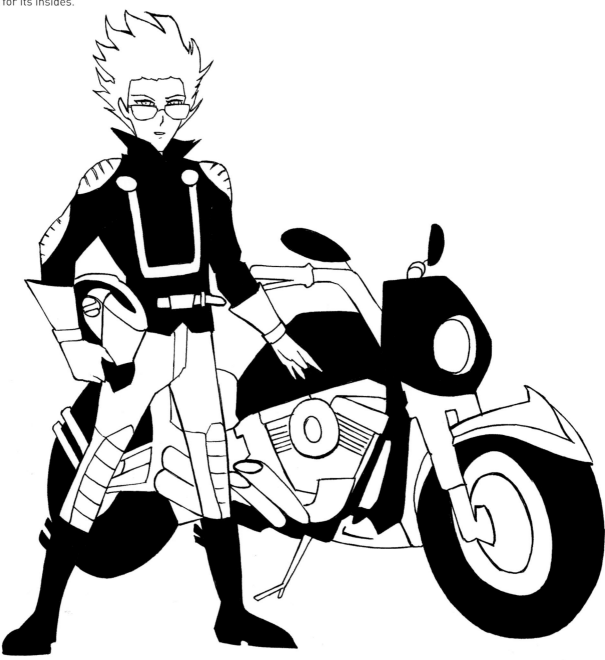

The sunset will give our biker a light
shining down his shoulders that will
gently add volume.

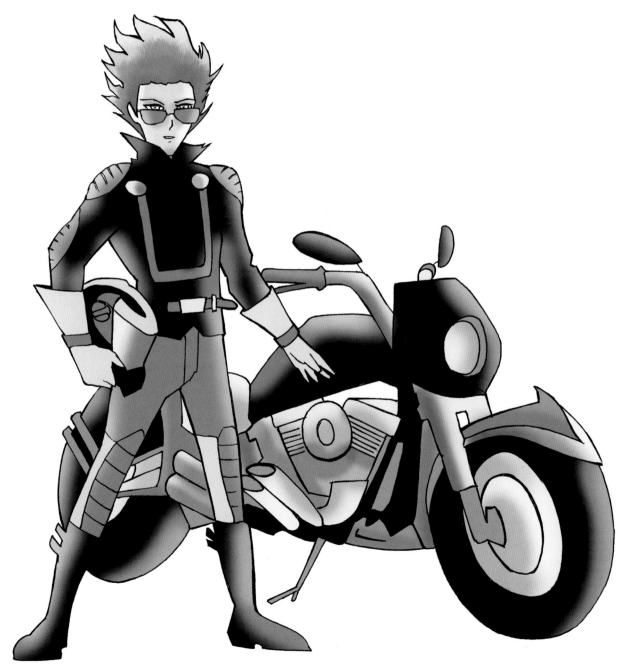

Add the base colors. For
this illustration, reverse the
traditional process by using
dark shades first and then
adding light ones with colored
pencils. Add shine to the jacket,
sunglasses, and motorcycle.

Add light shades from the same range as the base to create volume. Now add tattoos to Roma and decorate the motorcycle however you like, making it as aggressive as possible.

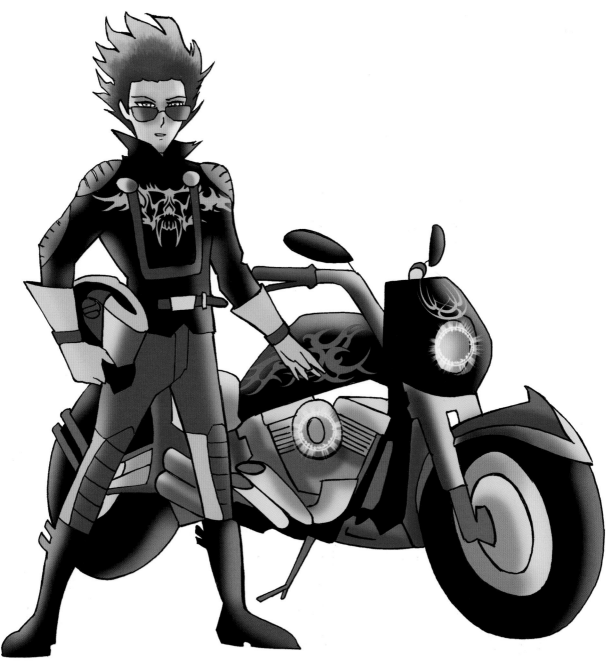

GOTHIC STUDENT

Karl is a student who likes the goth look. He wears a skullcap and some of his hair covers his face. He has to wear a school uniform, but he has customized it to fit his own taste.

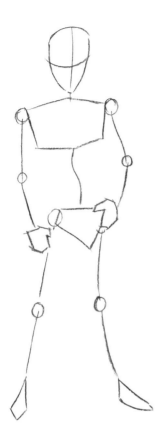

First draw the outline of Karl. He should have an adolescent gesture or pose, as if he is standing and watching girls go by.

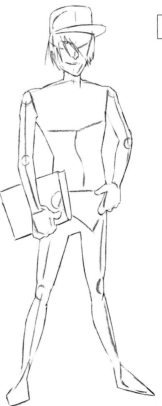

Contour lines help to define his body language.

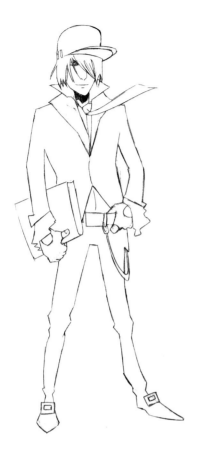

Define the whole of Karl's character in pencil and fine-tune the details so you can add the ink smoothly.

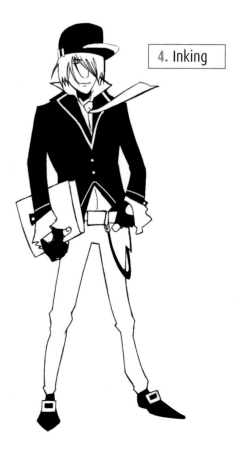

4. Inking

After inking in the black areas of the jacket and cap, the character begins to take on a more gothic look.

A glimmer of light shining on the middle of the character adds a mysterious touch.

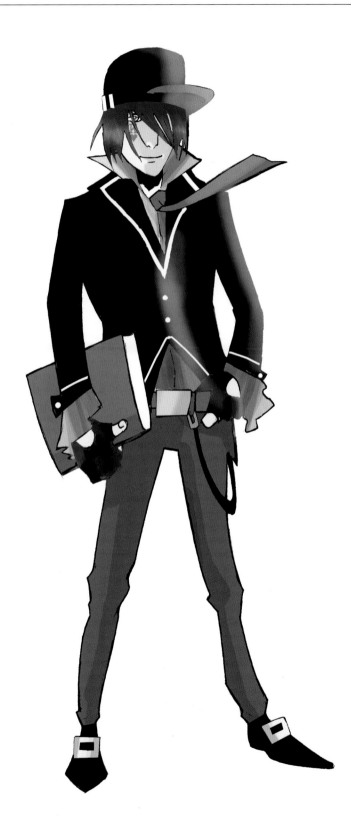

The base colors make Karl look like a student in a normal uniform. Adding a few unexpected shades give the character a more unique feel.

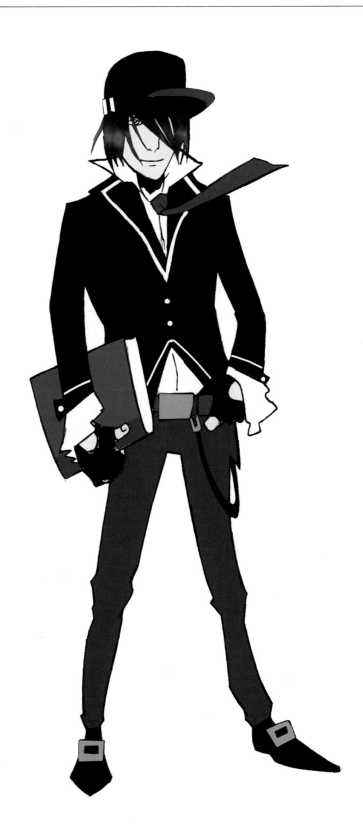

Now add the gothic touches that Karl likes to wear so much. A King of Hearts tattoo on his cheek gives him charm.

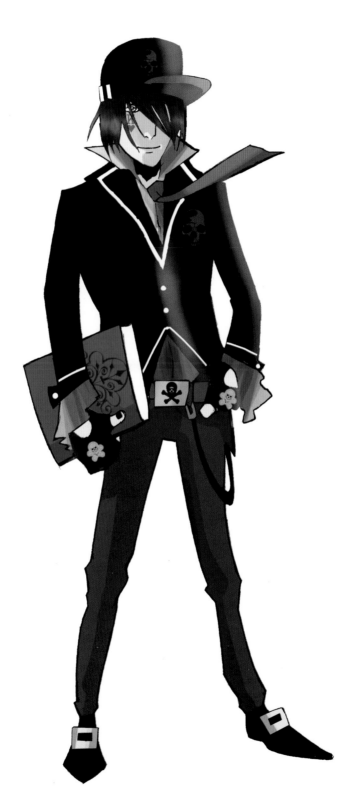

GOTHIC FRIENDS

Puk, Tod, and Marly are lifelong friends. They live on the same apartment block and their passion is gothic style, goth music, and festivals. They have the most fun at the Black Queen pub and go there as often as they can.

Create an outline of the three guys
using blue pencil. We're going to
draw two of them in front and the
third behind.

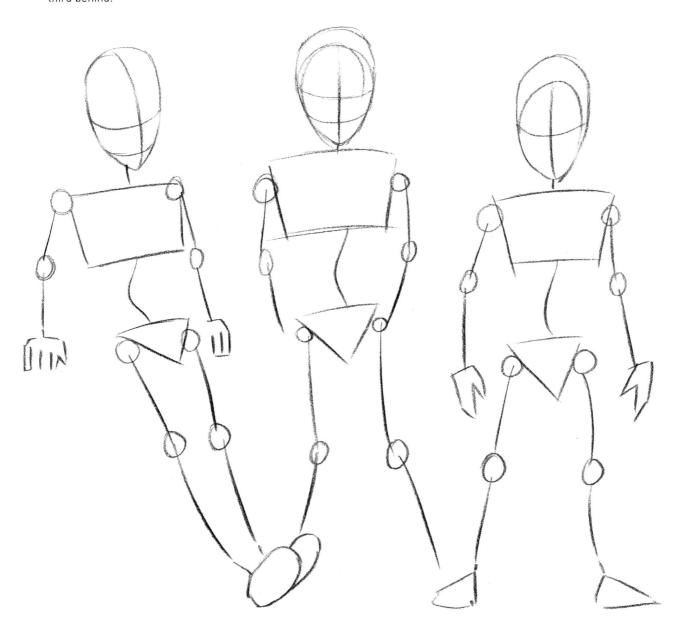

With a 2H pencil, shape the
contours of the figures. Make
sure their skeletons fit into the
contours.

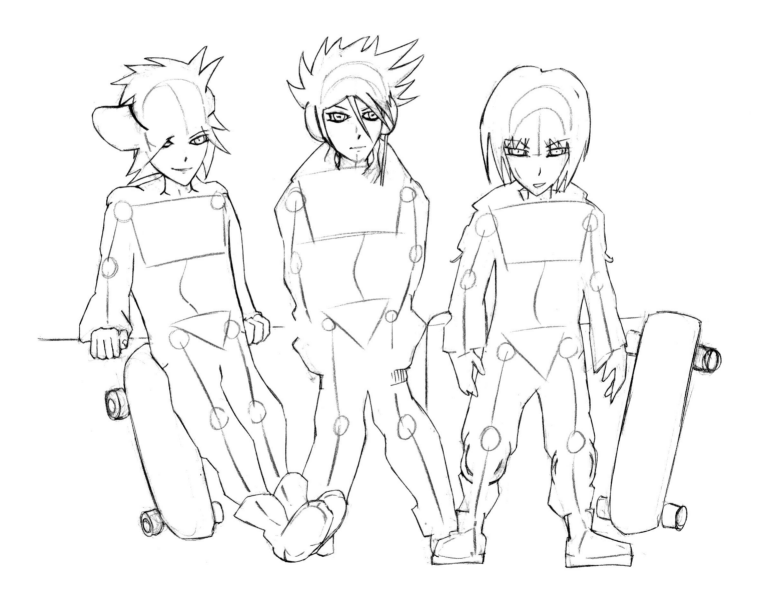

Draw the boys with a sharp pencil
or an 05 caliber mechanical pencil,
paying particular attention to the
details of their clothes, jackets,
boots, and accessories.

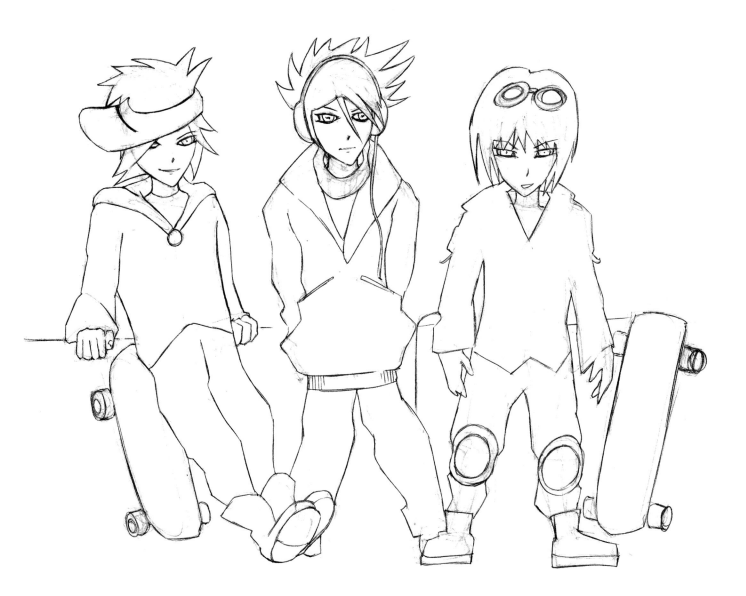

For this illustration, we are going to use markers to fill the large areas and stylographs with fine 02 or 04 size nibs for the contours and details. Use the 04 for the contours of the black jackets and the 08 for the interiors, as well as the pants.

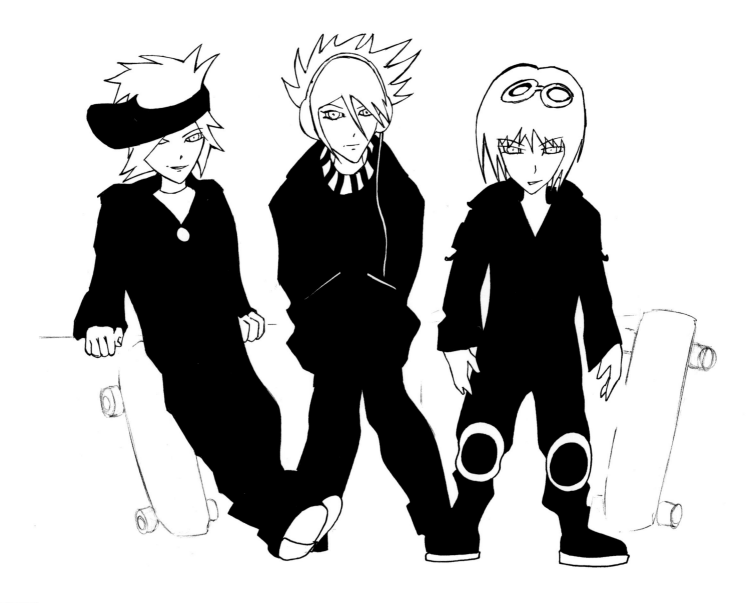

The ambient light on the street is a
soft light that will project from left
to right.

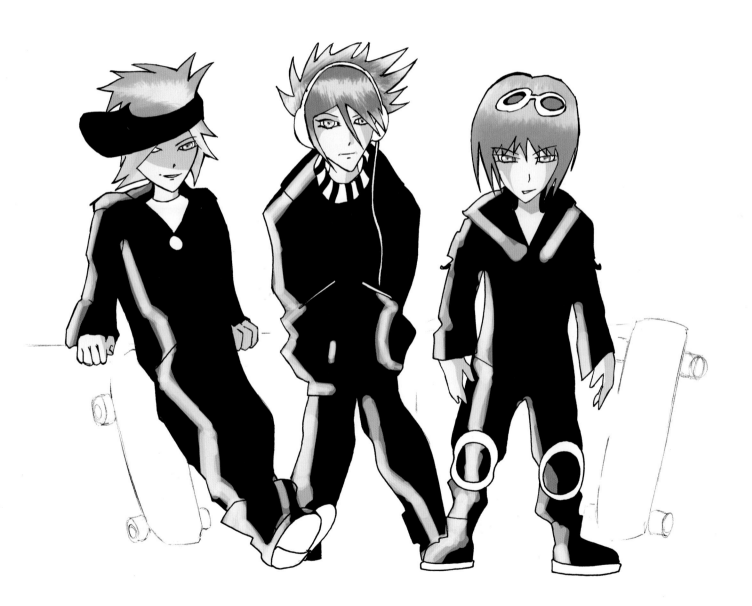

We're going to reverse the traditional process, using dark shades first then adding light ones with colored pencils.
Also add shine to the jackets, sunglasses, and hats.

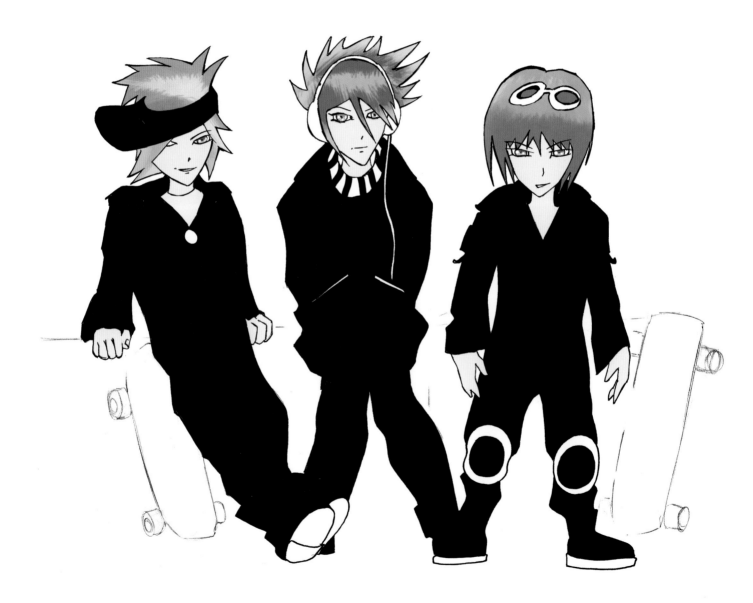

Add light shades from the same
range as the base to provide volume
and tattoos, and then decorate the
pants and shirts with gothic details.

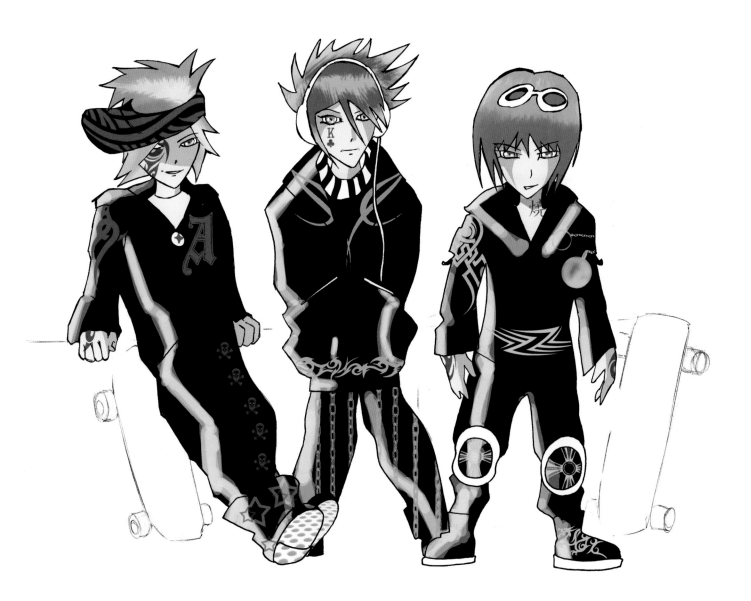

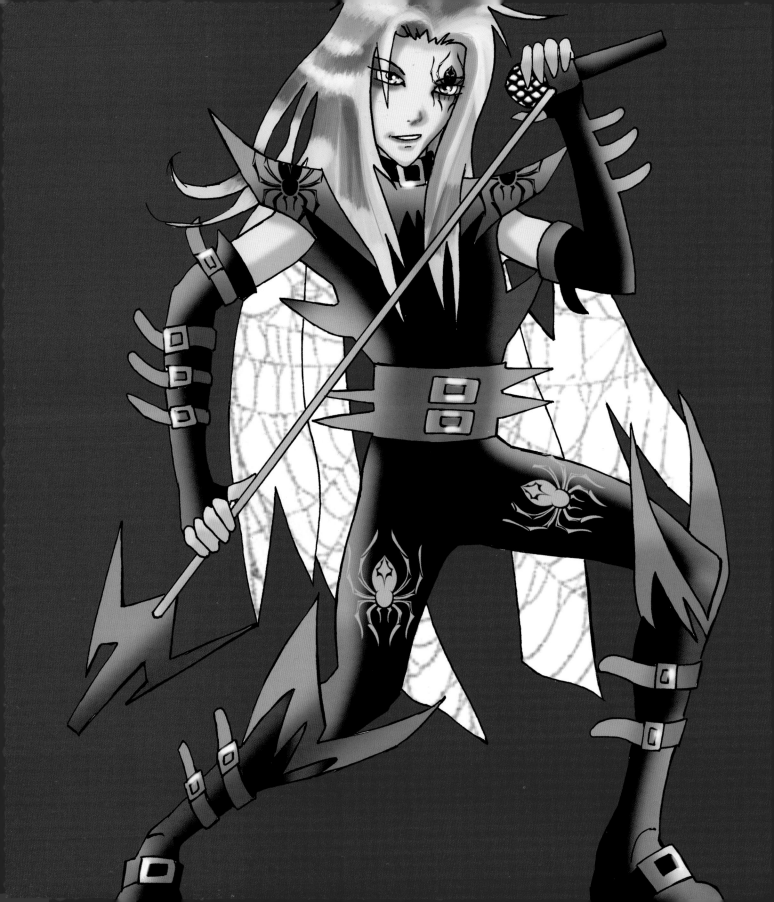

MUSIC

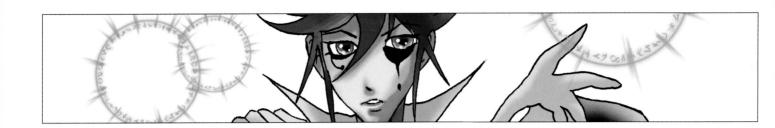

GOTHIC POP SINGER

Jade the gothic pop star is an attractive and melancholy singer who rocks every concert she performs in. While she sings, we can see magical rings of light around her. It is rumored that she is the last of a dynasty of magicians.

Draw the outline for the character's skeleton. Take care to ensure that it is not rigid, and that her hips are not too parallel to the rest of her body.

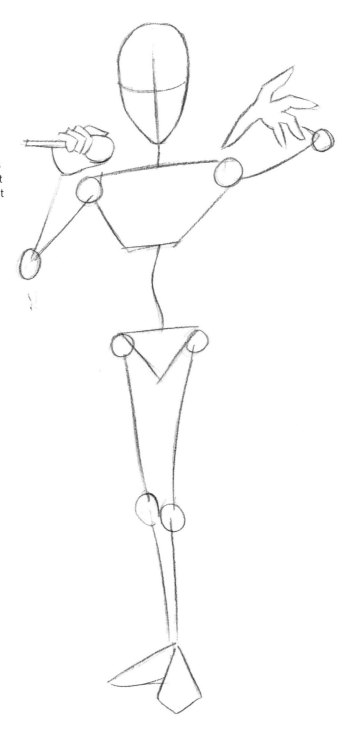

With a 2H pencil, mark the contours on the skeleton.

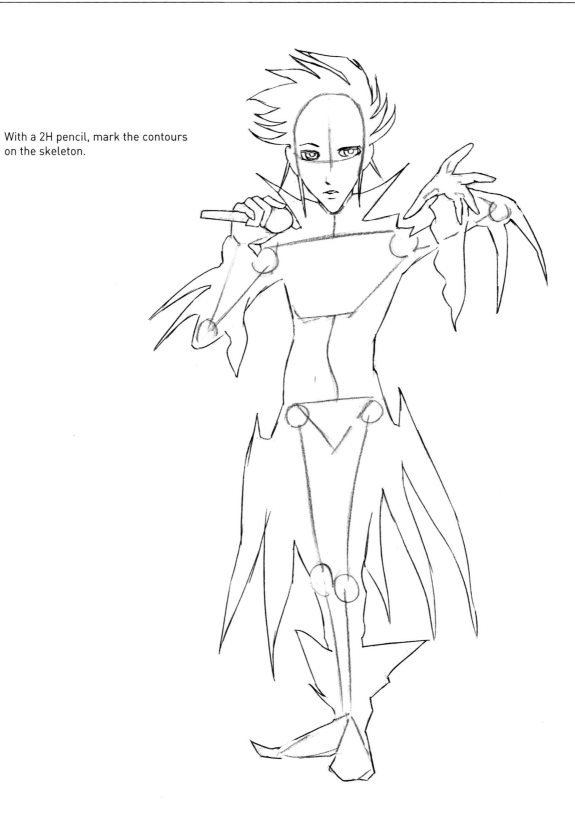

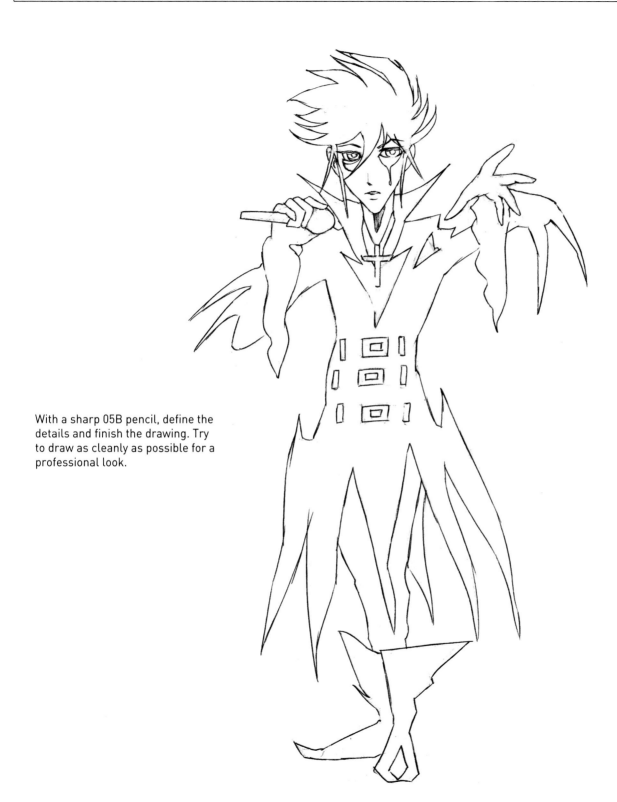

With a sharp 05B pencil, define the details and finish the drawing. Try to draw as cleanly as possible for a professional look.

Using an 02 fine tip pen, ink the entire drawing. Emphasize the contours of the sleeves and hands with an 04 fine tip pen and with an 08 marker pen. I like to fill in the black areas of the jacket and boots at this stage.

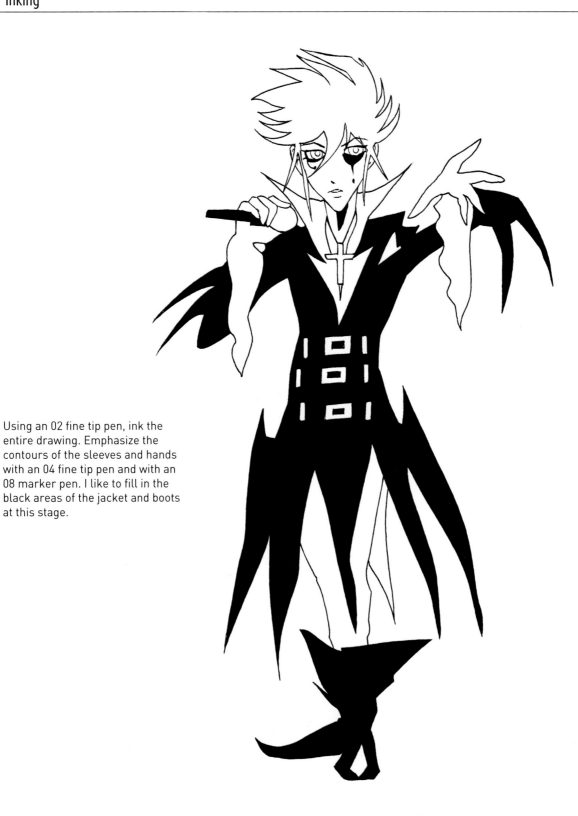

For this drawing, the light comes from the left. It shines most intensely in the shadows of the character's face and hair. The rest of the image is then blended to soften it.

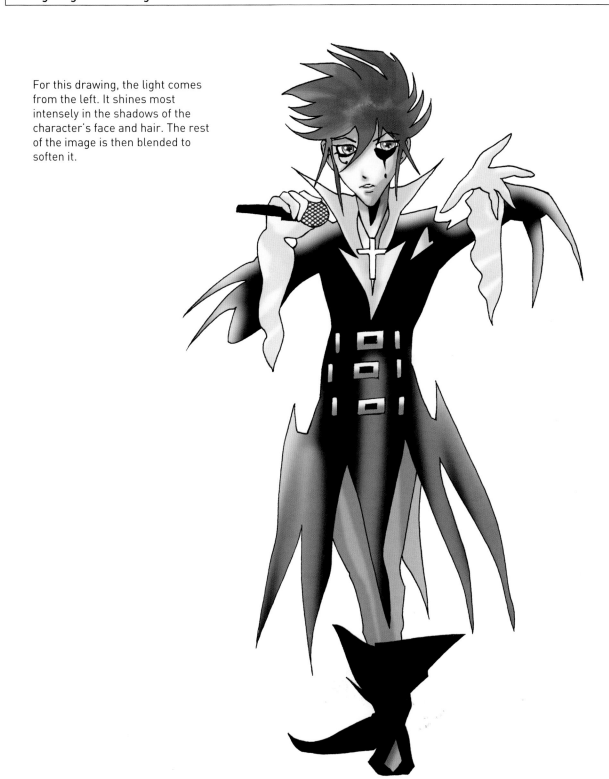

I have chosen red and yellow for this design. These colors provide passion and strength even when the character is still.

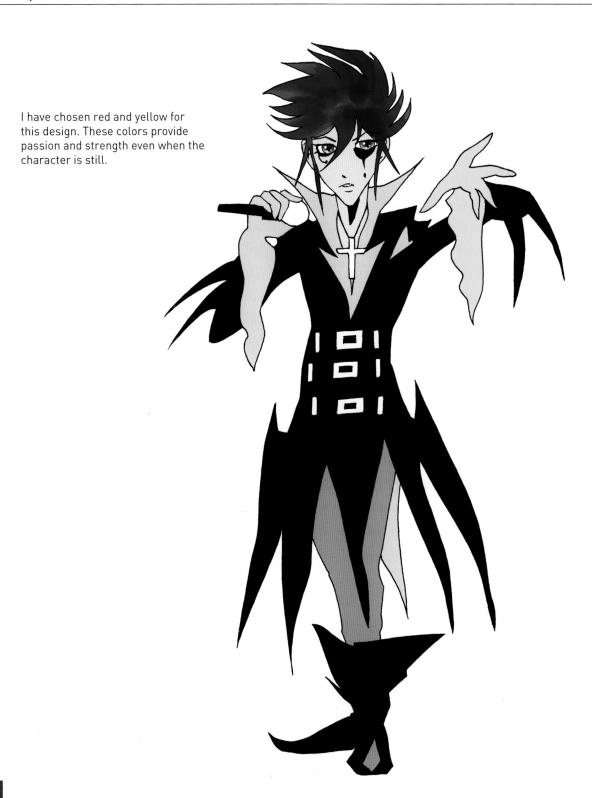

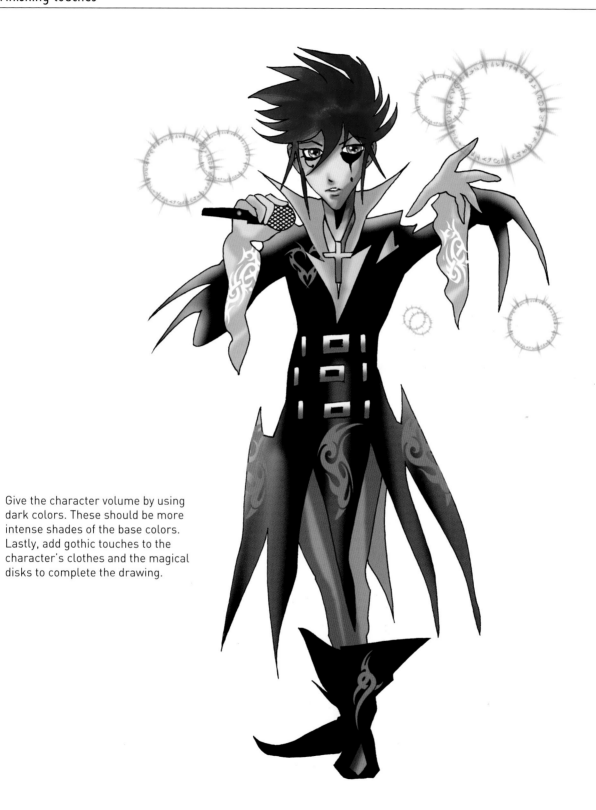

Give the character volume by using dark colors. These should be more intense shades of the base colors. Lastly, add gothic touches to the character's clothes and the magical disks to complete the drawing.

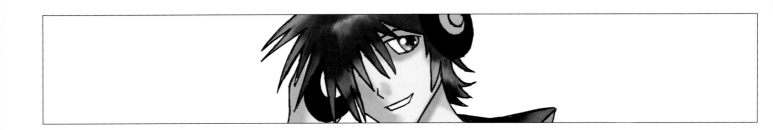

GOTH DJ

DJ Adler is a fantastic disc jockey. His mixes and music are brilliant for parties, and his specialty is gothic dance music.

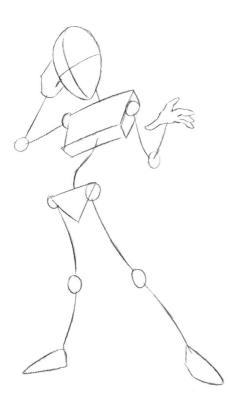

A good outline in blue pencil gives shape to a skeleton in a disc jockey pose.

2. Sketching

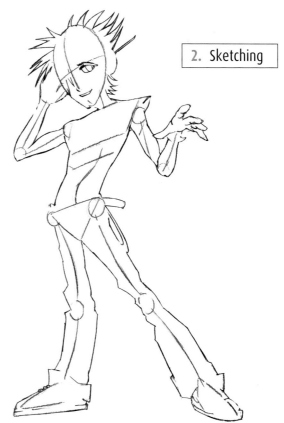

It is important that you make sure the outline and contours fit together perfectly. To do this, draw one on top of another on different pages, and then hold them together in front of a light to see the result.

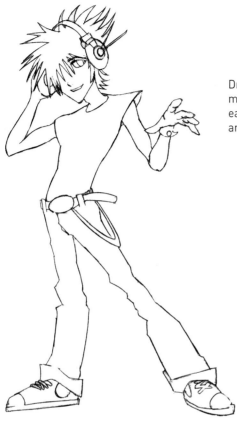

Draw the character using an 05B mechanical pencil. If you find it easier, use a softer 2H pencil first and then go over it with the 05B.

4. Inking

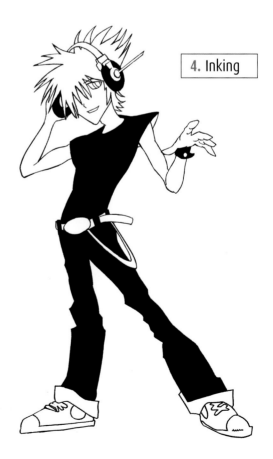

Inking the drawing is easy and only requires a few strokes if the pencil is sharp enough. Always be careful to avoid it becoming overly thick. Use an 02 for contours, 04 for details, and 08 for large areas of black. If you like, you can use fountain pens or a fine brush for contours and details, but you must have a good hand and practice first.

Several points of light illuminate the character from above, creating shadows on his legs and arms. Think of the character being in a disco, surrounded by flashing lights.

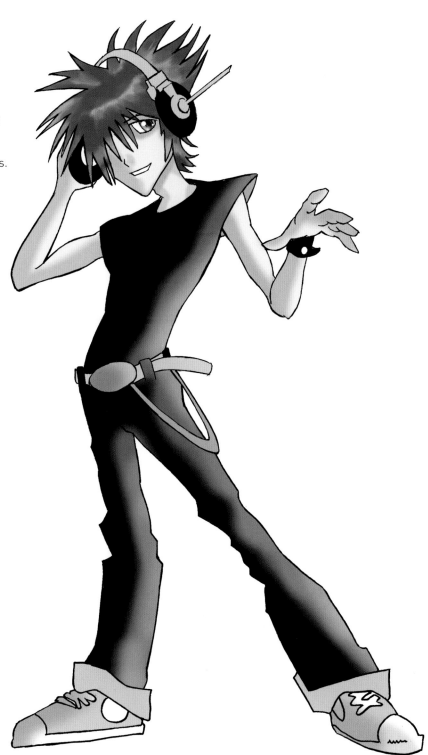

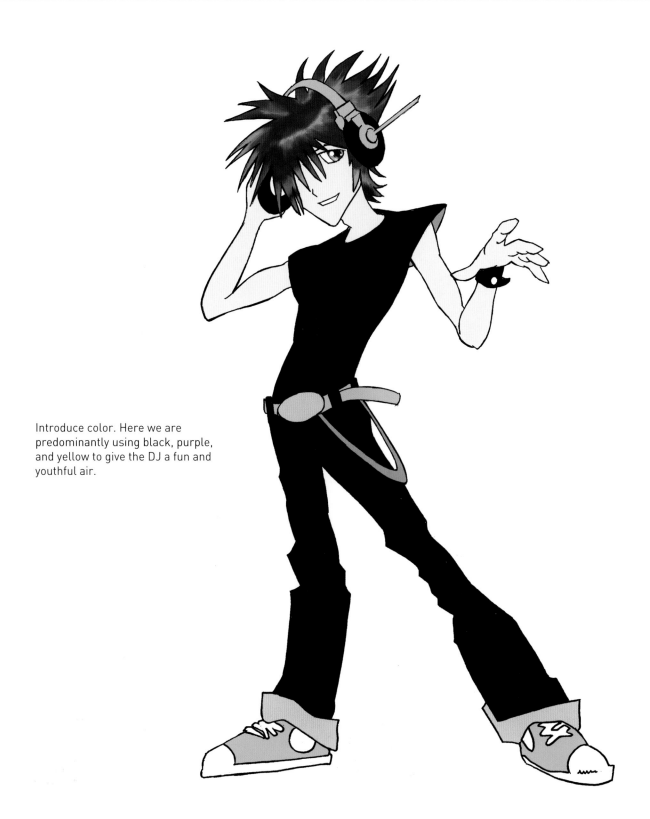

Introduce color. Here we are predominantly using black, purple, and yellow to give the DJ a fun and youthful air.

A few discs of light highlight the mixing area, giving it a futuristic vibe. I have also added a few skeletal hands and leg bones to add a gothic touch.

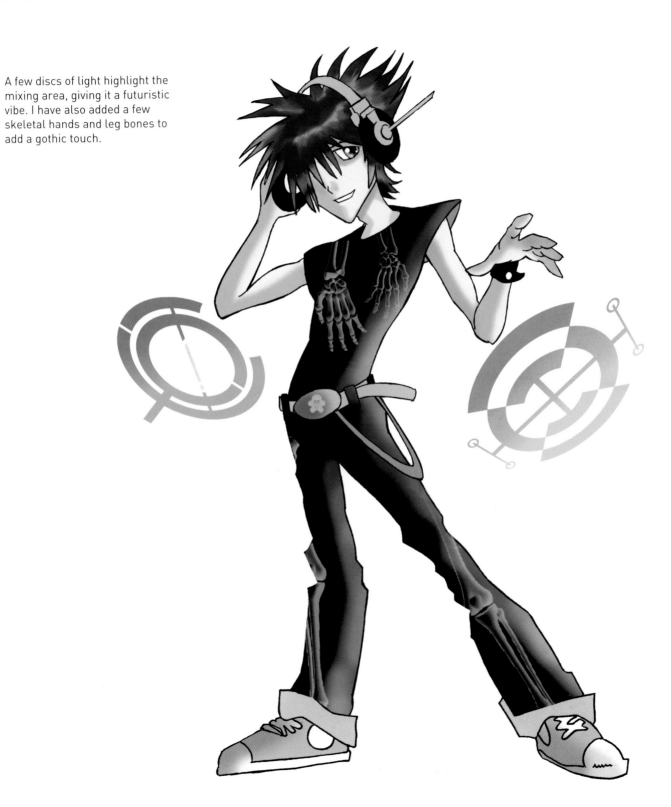

GOTHIC ROCK STAR

Byron Drake is a super gothic rock singer. With his band Tarantula Blue, he plays at big stadiums around the world. They are famous for giving tarantulas to their closest fans.

Use blue pencil to give the singer a cool pose. A ruler will help you mark the straight lines of the microphone.

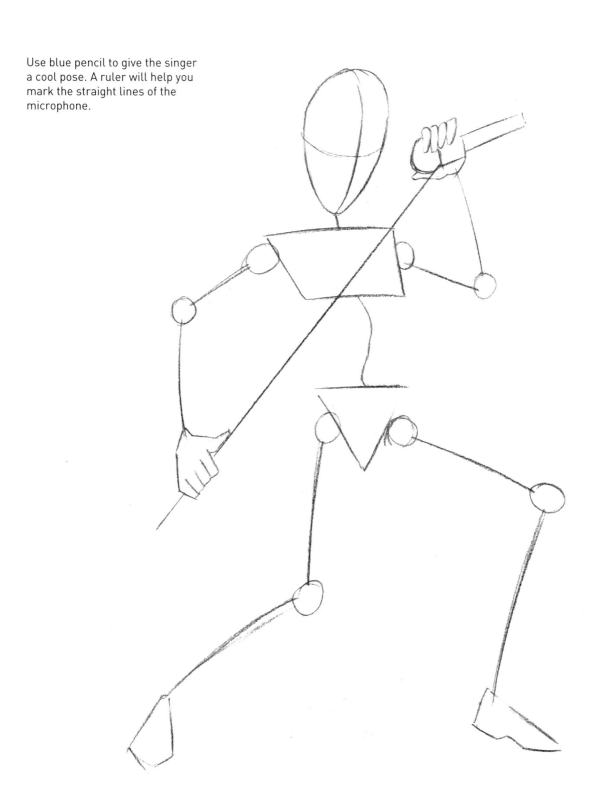

With a soft 2H pencil, shape the contours of the figure and make sure they fit the skeleton.

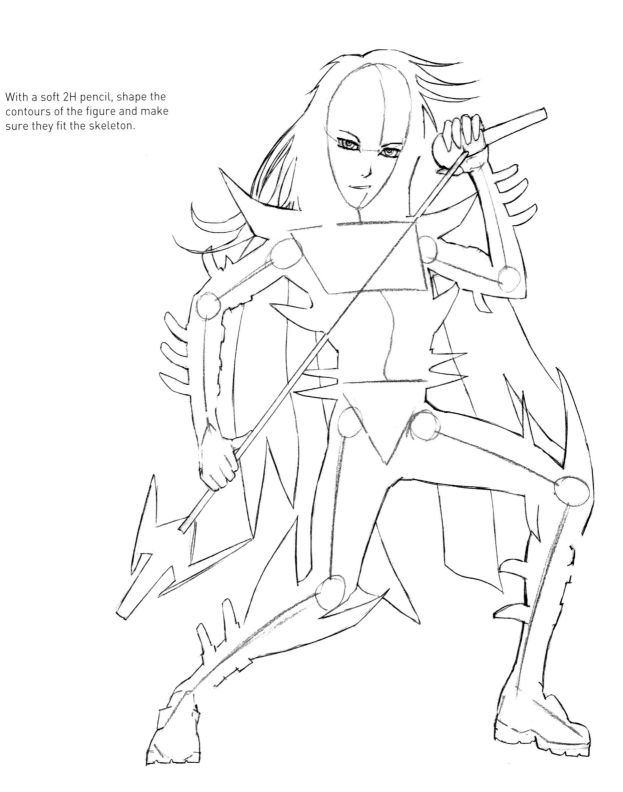

Add belts and details to Byron's clothing with an 05B fine tip pen.

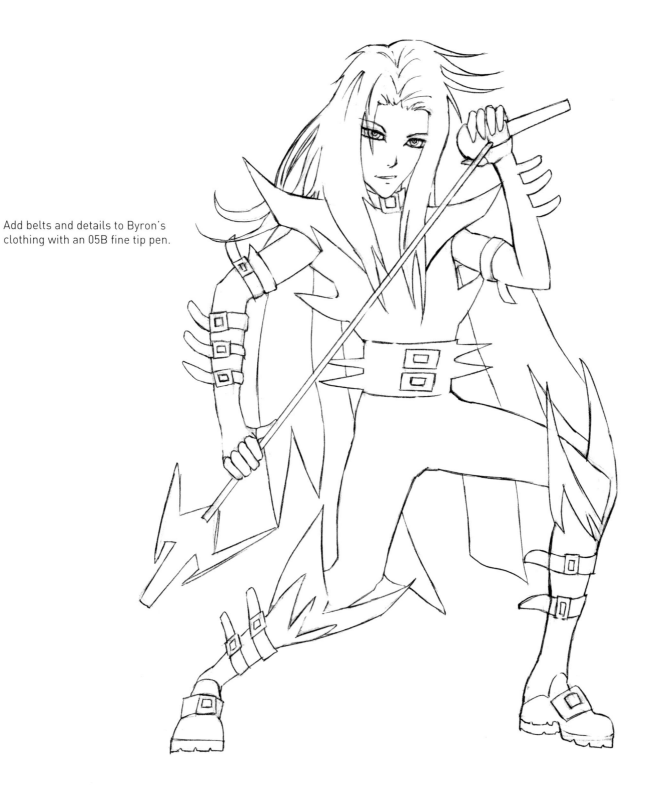

Use 02 and 04 markers for the contour and details, and an 08 marker for all the large black areas of the costume.

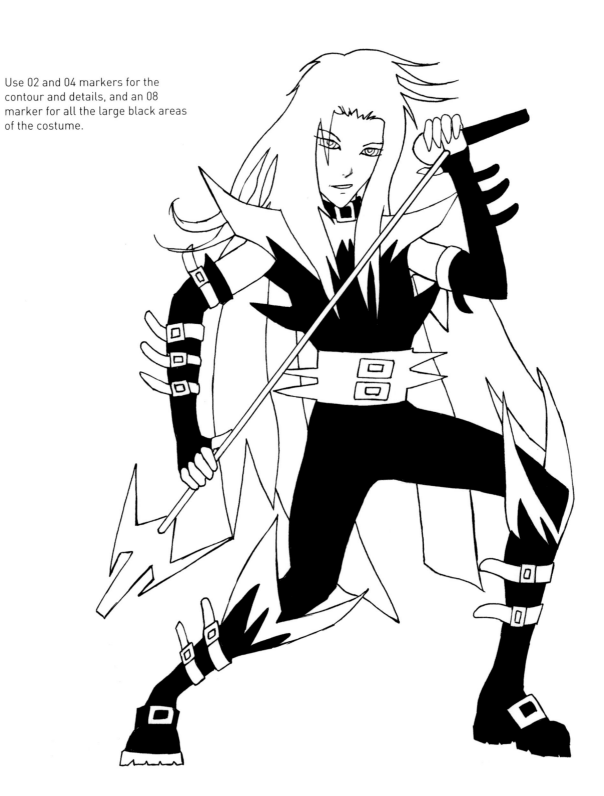

Large spotlights on the left and right bathe Byron in light. He is on a large stage and needs to be very visible. Don't forget the shine on the buckles.

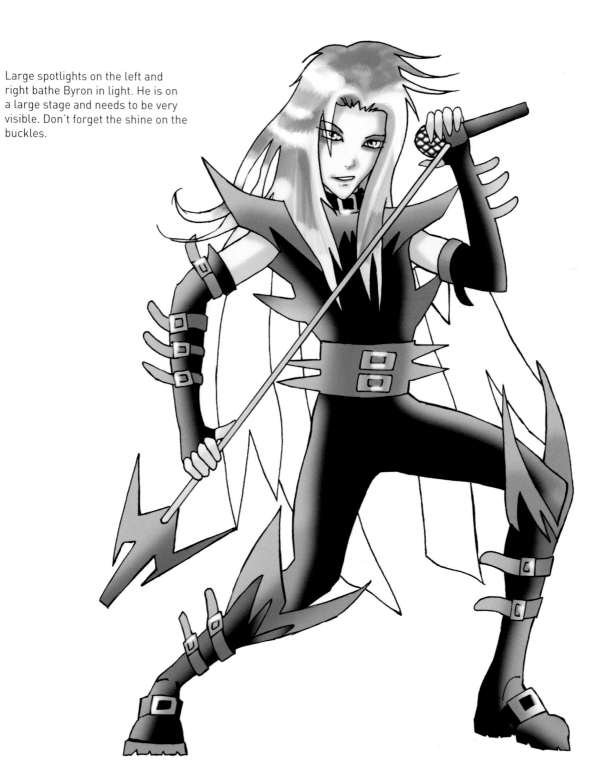

Add blue to the character and microphone, and use purple for the eyes and green for the hair.

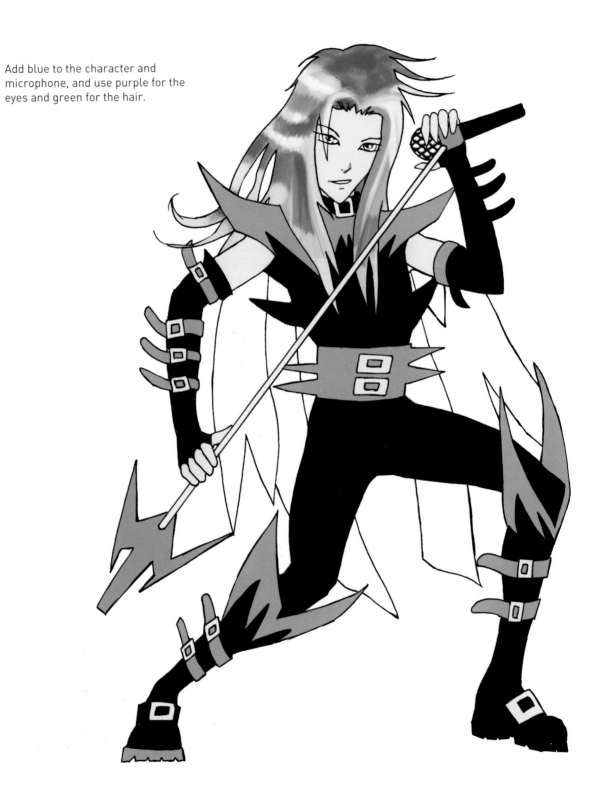

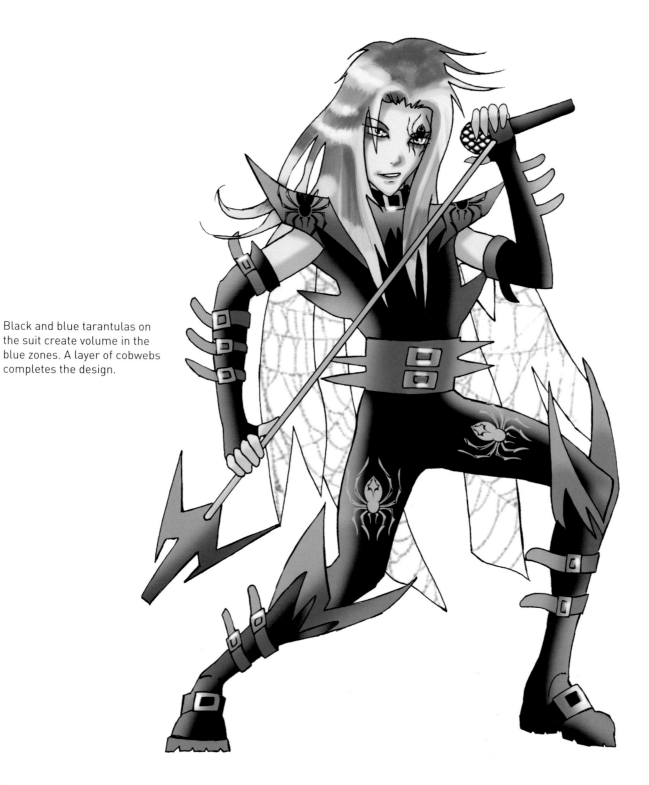

Black and blue tarantulas on the suit create volume in the blue zones. A layer of cobwebs completes the design.

HARD ROCKER

This is a hard rock singer whose music reflects brutality and darkness. He is angry at the world and uses his outfit, music, and attitude to show this.

Draw the character's outline in blue
pencil. Give him a twisted stance.

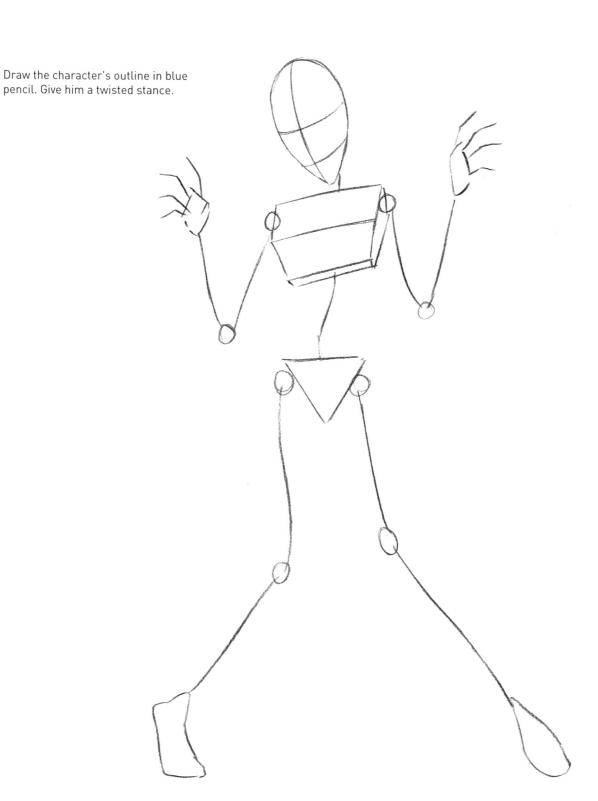

Use a soft 2H pencil to sketch the singer's silhouette, making sure it fits the skeleton well and that the proportions are correct.

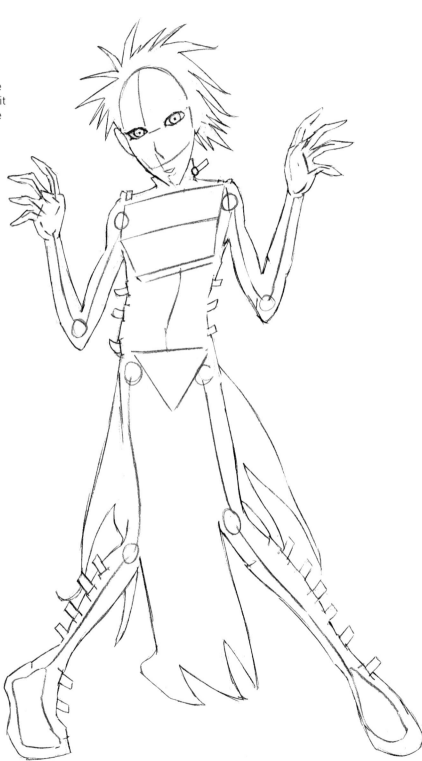

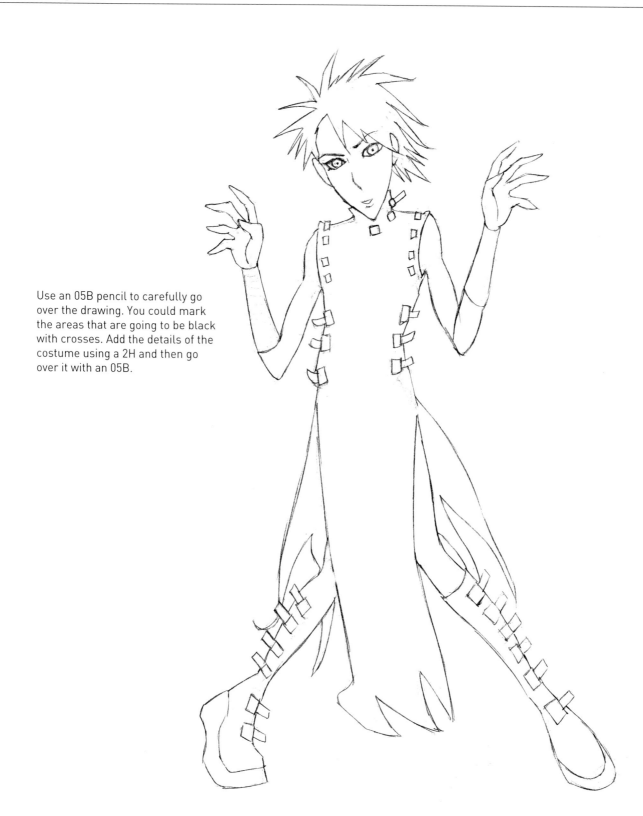

Use an 05B pencil to carefully go over the drawing. You could mark the areas that are going to be black with crosses. Add the details of the costume using a 2H and then go over it with an 05B.

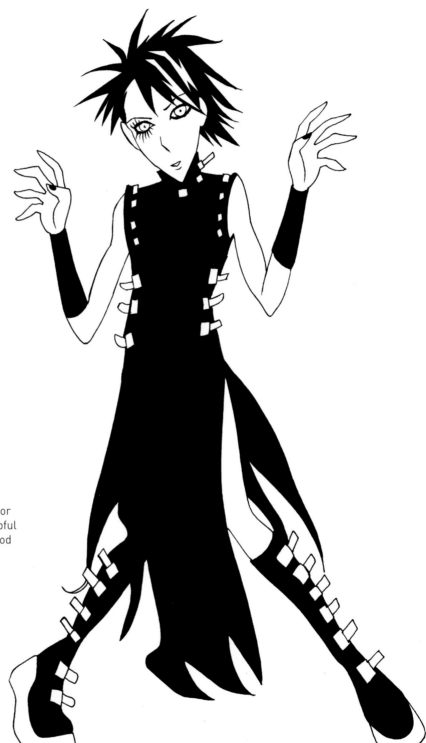

Use a stylograph or 02 fine nib for the entire drawing. An 04 is helpful for the contours and an 08 is good for the inside.

The character is onstage, so he is
illuminated from many angles. Add
volume to his clothes by creating
different shadows.

As this hard rocker loves black, use this for the base color and add only a few splashes of color. Consider having colored lenses for the eyes and purple and red streaks in the hair. You may also want to use color for the outline of the eyes and lips, and metallic shades for the buckles.

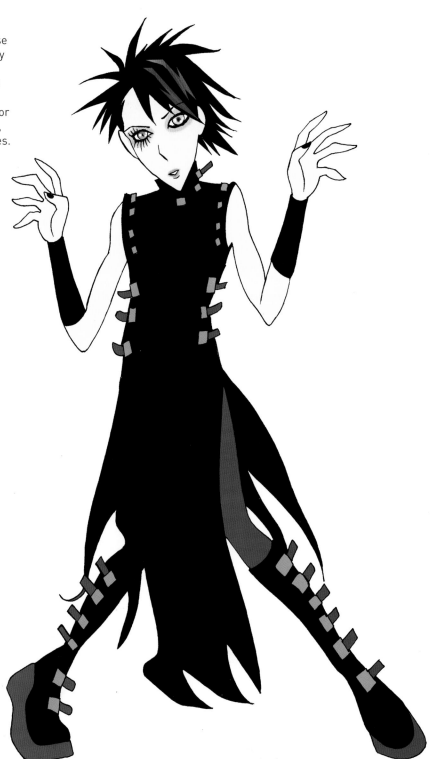

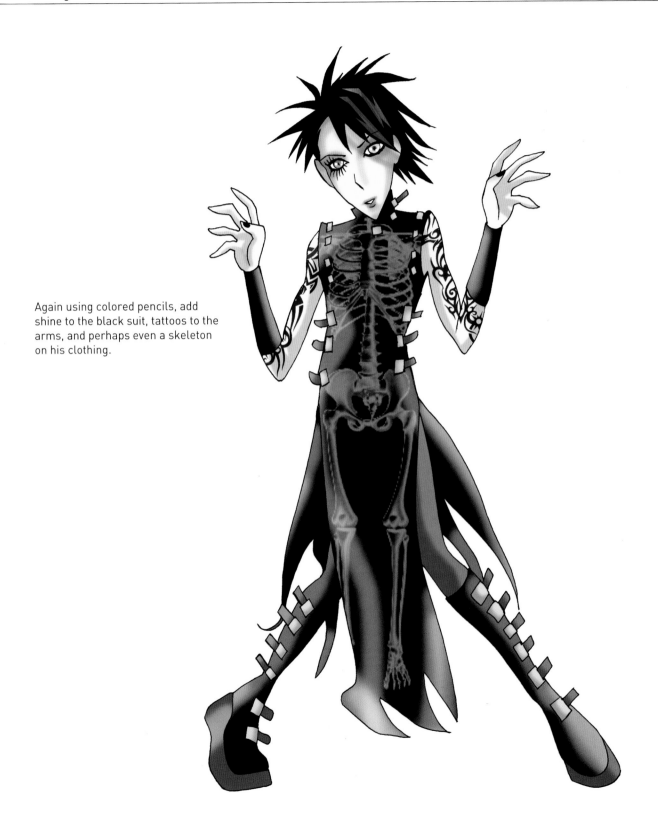

Again using colored pencils, add shine to the black suit, tattoos to the arms, and perhaps even a skeleton on his clothing.

GOTHIC ROCK BAND

Amber, Lola, and Damien are an all-star gothic rock band called Fly Tattoo. They play in all of the city's music venues and are about to release a highly anticipated album.

When there are several characters, start with the main ones, maintaining space between their skeletons as you draw them. This composition of three characters should be balanced, so it is a good idea to mark out the proportions in blue pencil.

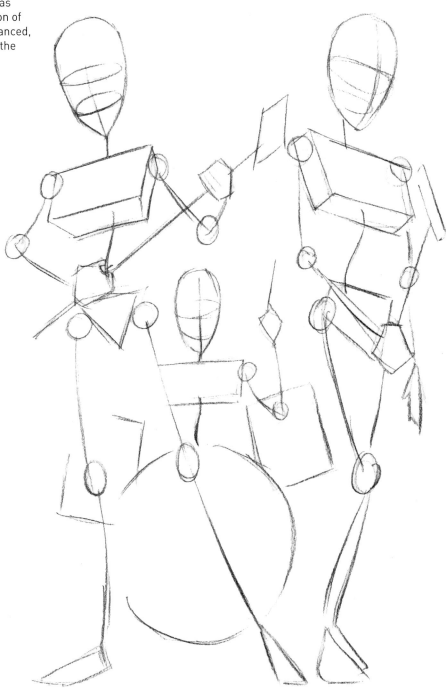

Draw the figures with a 2H pencil, making sure that no character goes over the frame. This is the most difficult part of the drawing.

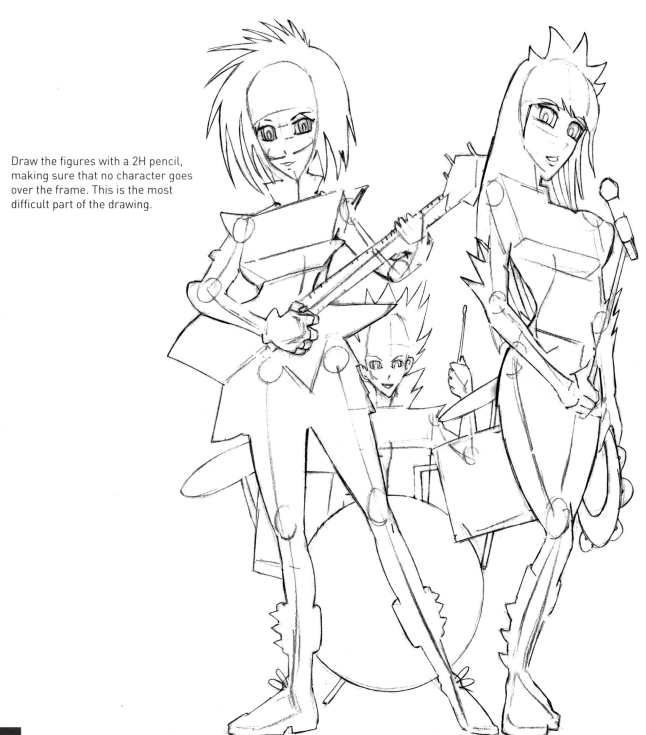

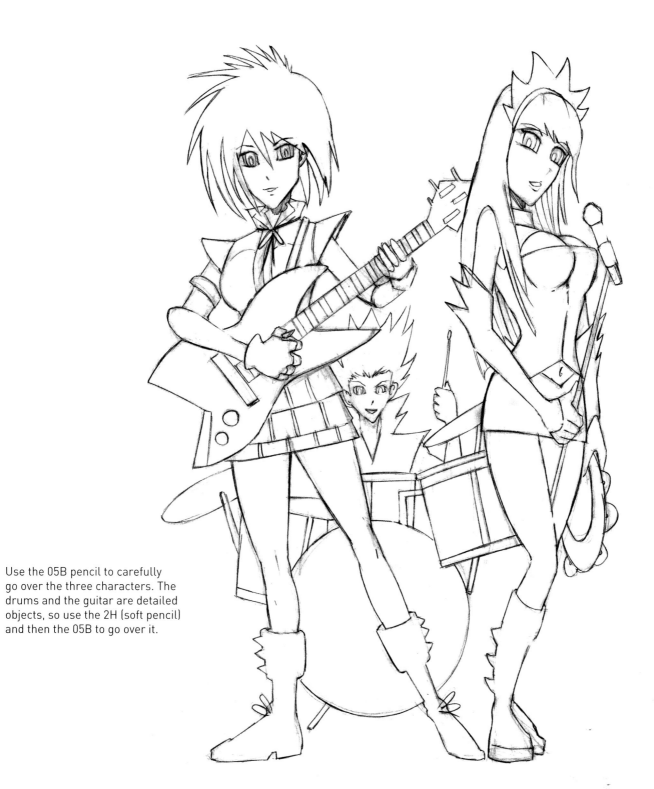

Use the 05B pencil to carefully
go over the three characters. The
drums and the guitar are detailed
objects, so use the 2H (soft pencil)
and then the 05B to go over it.

Use an 02 fine tip pen or stylograph for the entire drawing. Then with the 04, go over the outline of each girl; this will highlight the two girls in the foreground, creating depth. Use an 08 for the black areas.

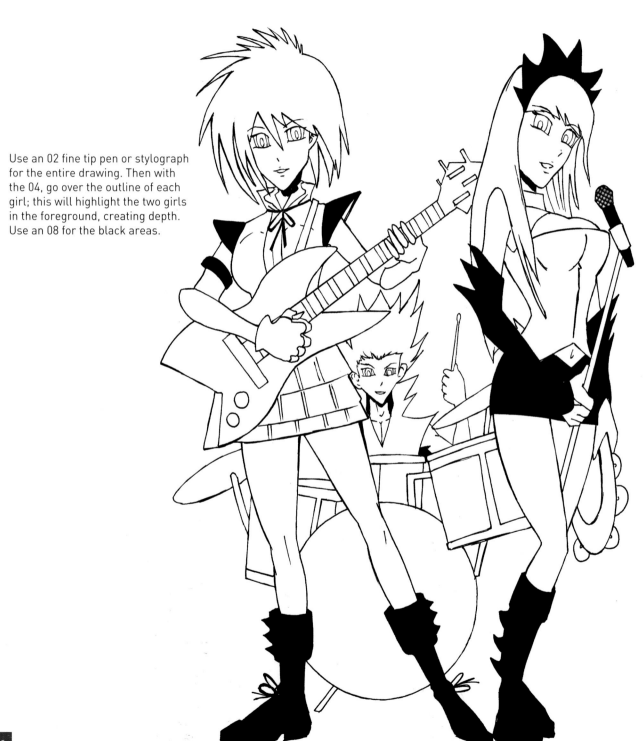

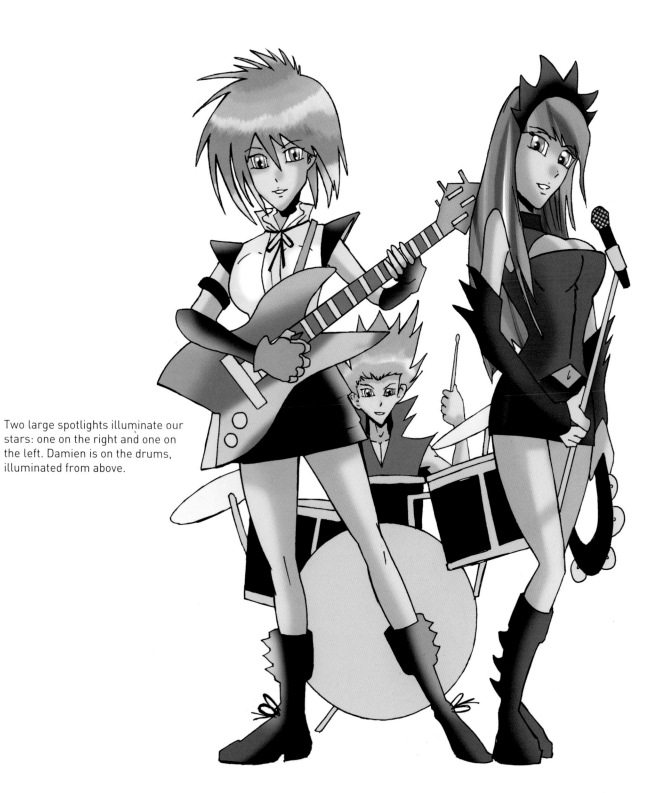

Two large spotlights illuminate our stars: one on the right and one on the left. Damien is on the drums, illuminated from above.

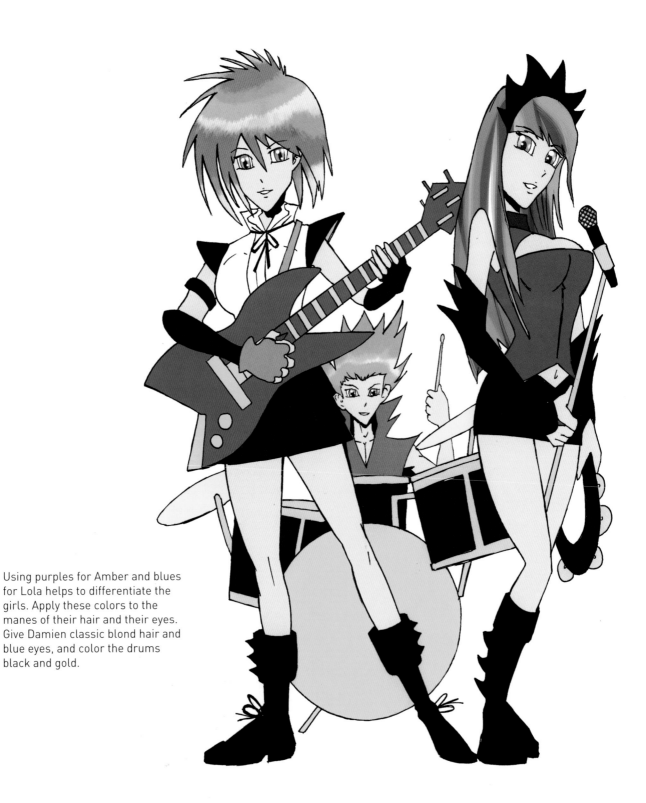

Using purples for Amber and blues for Lola helps to differentiate the girls. Apply these colors to the manes of their hair and their eyes. Give Damien classic blond hair and blue eyes, and color the drums black and gold.

Finish by using dark shades to add volume. Embellish the image with fishnet stockings and gothic details, such as the drum kit design and the skulls on Amber's guitar.

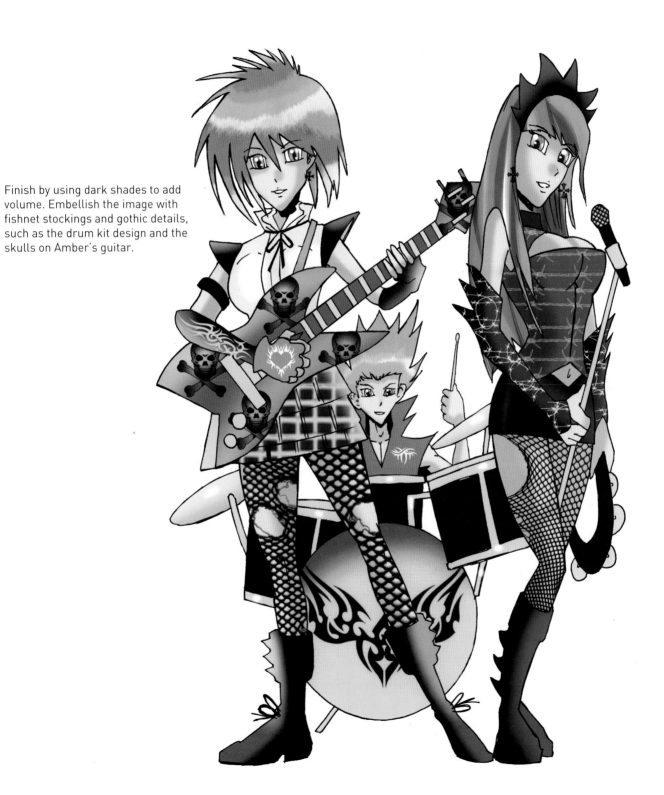

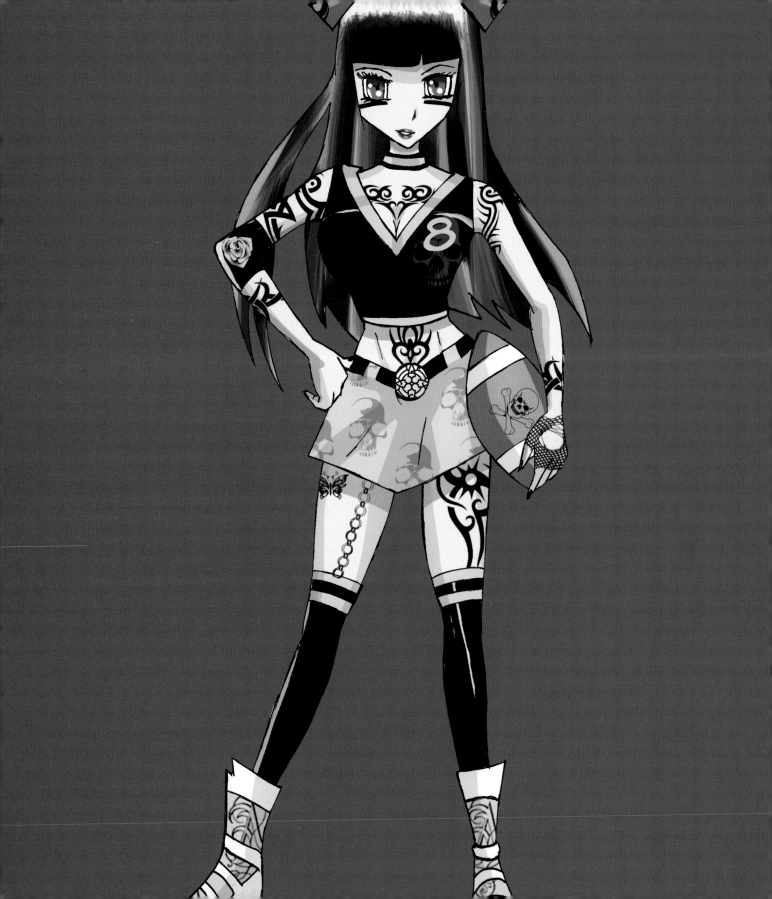

GIRLS

GOTHIC COWGIRL

Sophie is a Texas cowgirl. She competes in lasso championships, showing off her dancing skills and amazing audiences by jumping in and out of the lasso so skillfully. Her ambition is to be a star of the great Cirque du Soleil.

Draw the outline in blue,
positioning the character in
a jumping movement.

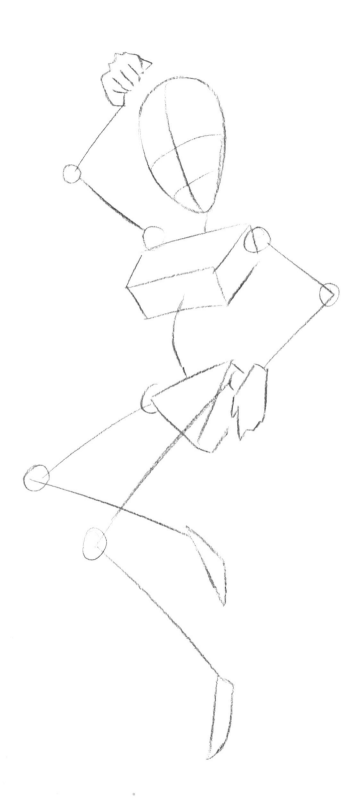

With a 2H pencil, mark out the
contours of the character's skeleton
and add the lasso to the illustration.

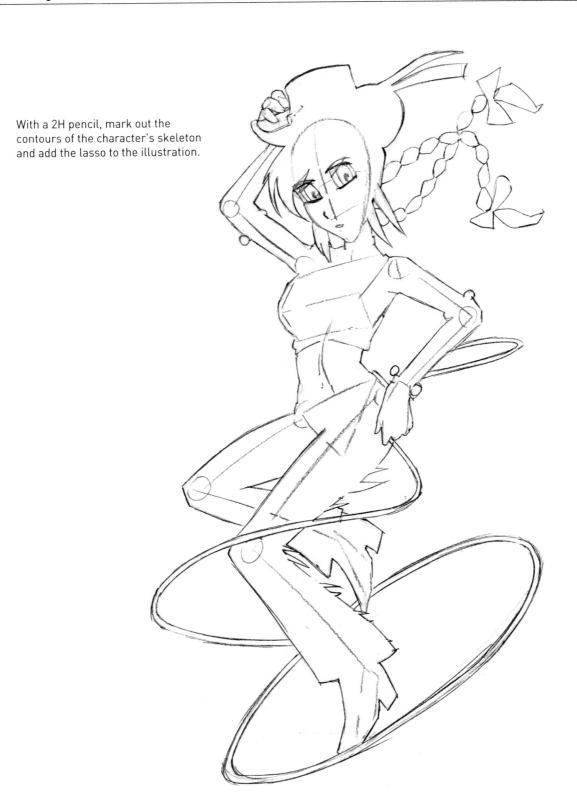

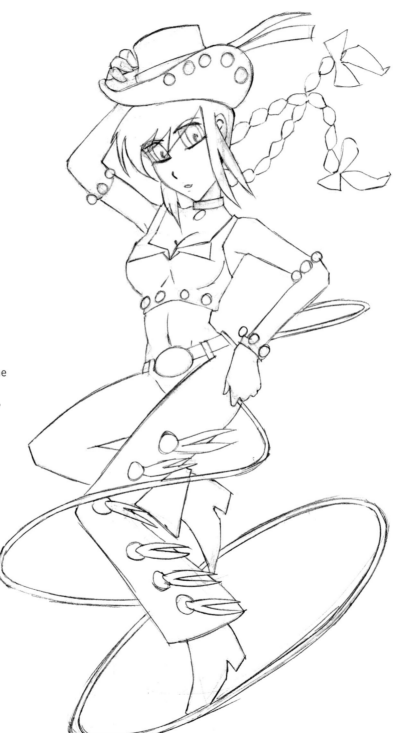

Using a fine tip 05B pencil, define the details of the character and add designs to the pants, jacket, and hat.

With the fine tip 02 pen, ink the entire drawing. The design should be virtually covered in black. Use an 04 to fill in the contours and an 08 for the large internal areas. Make sure you don't go outside the lines.

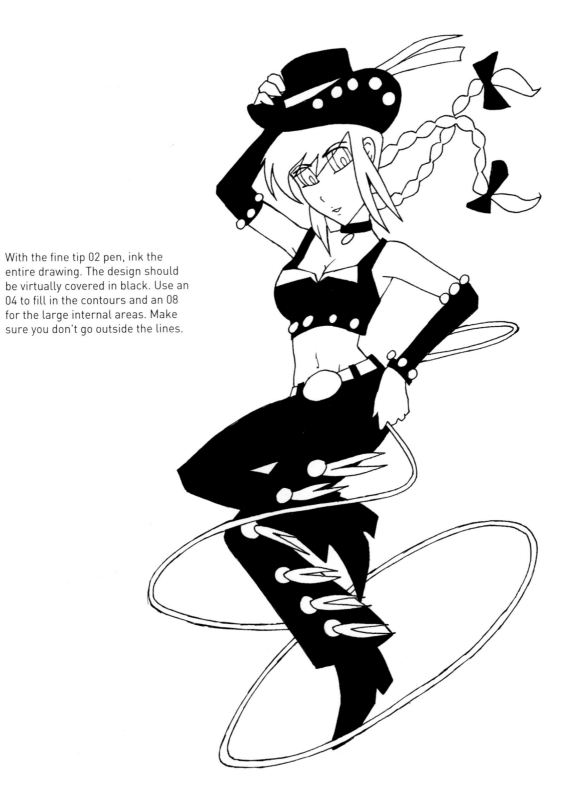

The light comes from the right, so it gives volume to the face and body. You could add a small shadow under the foot that is touching the floor.

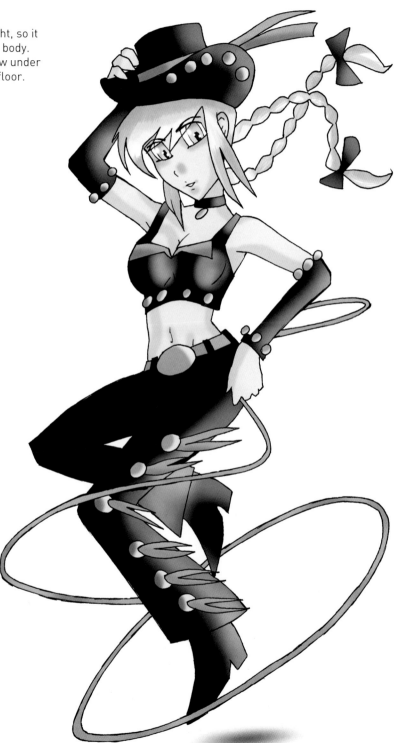

Use a combination of orange and silver for the studs, then color the blond hair and blue eyes. Add the shadow of the hat to the hair, and give it volume with a darker shade of blond.

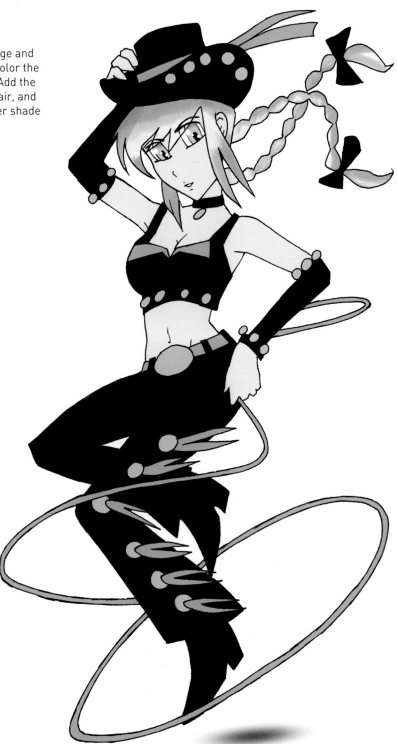

Add stars and tattoos. A butterfly and a cross will complete this character's gothic cowgirl look.

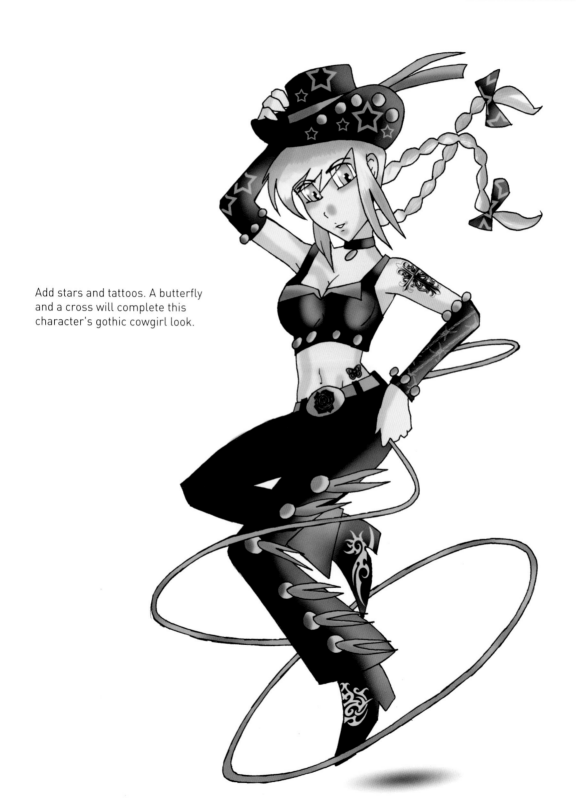

GOTHIC SPORTS GIRL

Alexia is a super athlete. She loves all kinds of sports and is great at football, tennis, and basketball. She combines all this with her love of everything goth, so she has designed gothic versions of her sports equipment to unite her two passions.

Draw the outline of the design with a blue pencil, giving the character a sporty pose.

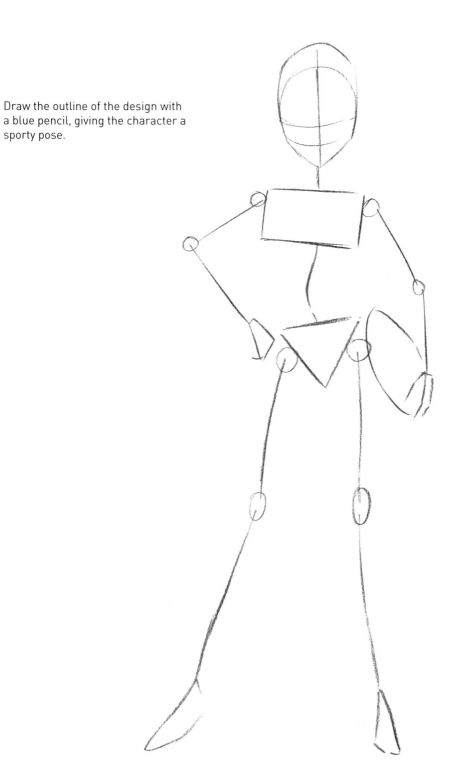

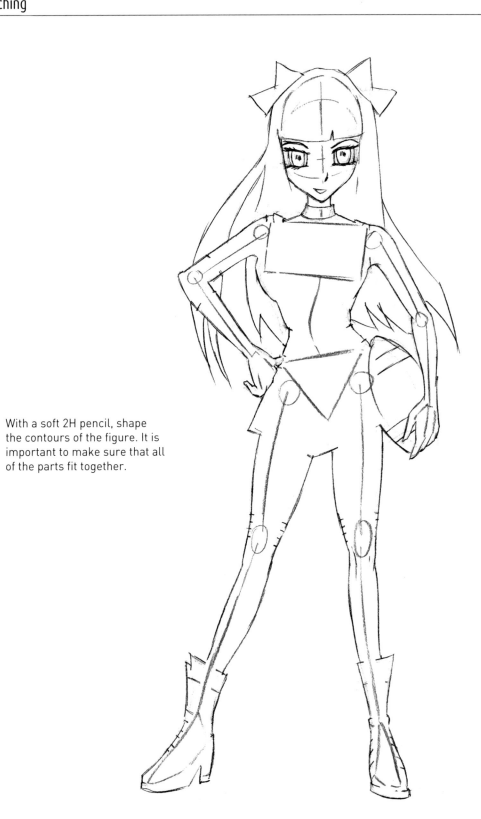

With a soft 2H pencil, shape the contours of the figure. It is important to make sure that all of the parts fit together.

Using a sharp 05B pencil, draw as cleanly as possible. The character needs to be well-defined in preparation for inking.

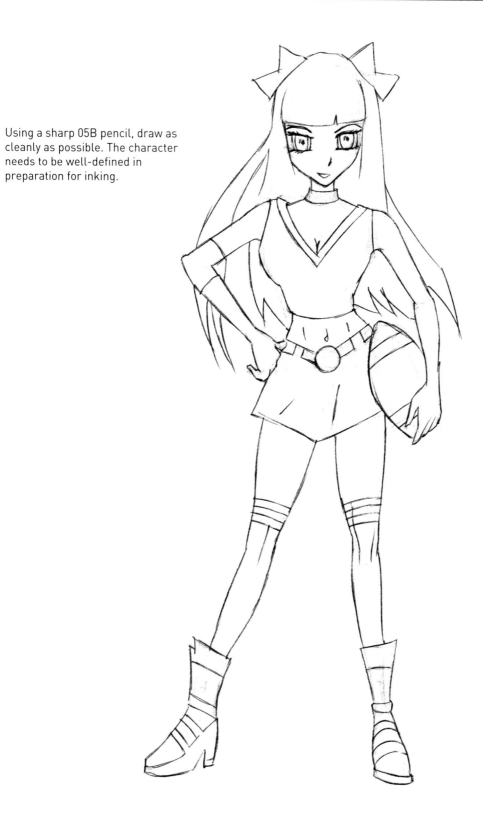

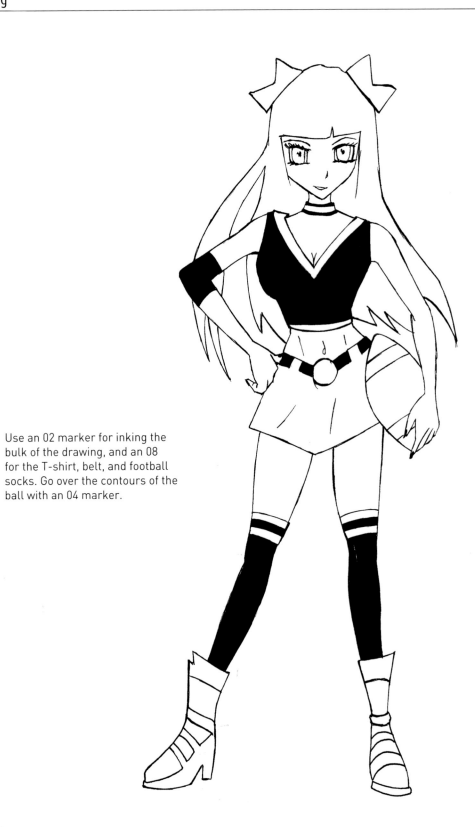

Use an 02 marker for inking the bulk of the drawing, and an 08 for the T-shirt, belt, and football socks. Go over the contours of the ball with an 04 marker.

The light comes from above and is projected from the right to left of our design. This gives a nice sense of volume to all elements of the image.

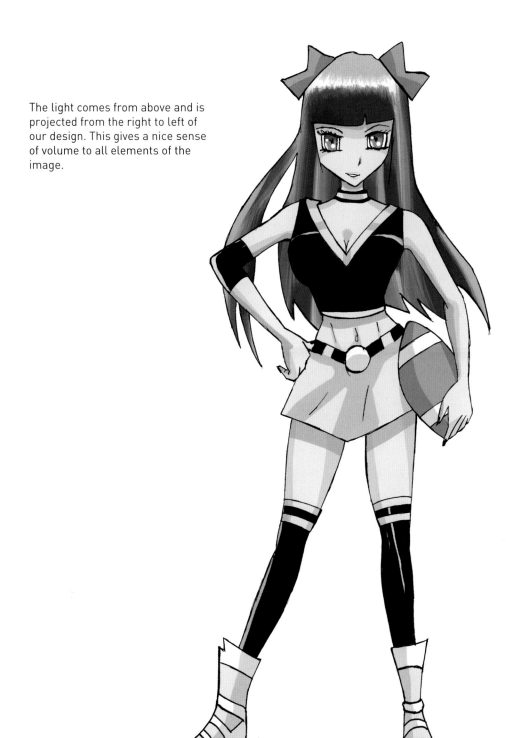

I have chosen yellow and black for the base shades. Her hair is black with bright blue highlights and she has fuchsia eyes. Her ball is pink.

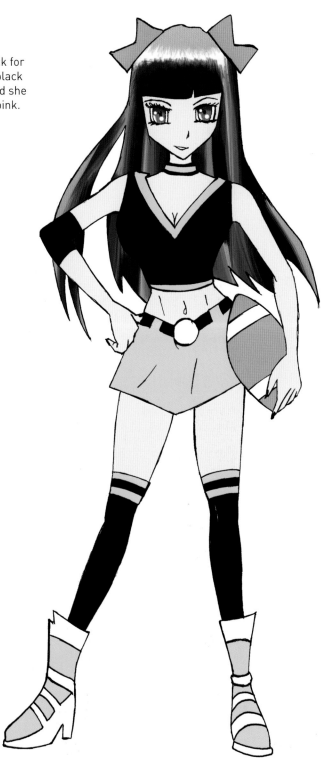

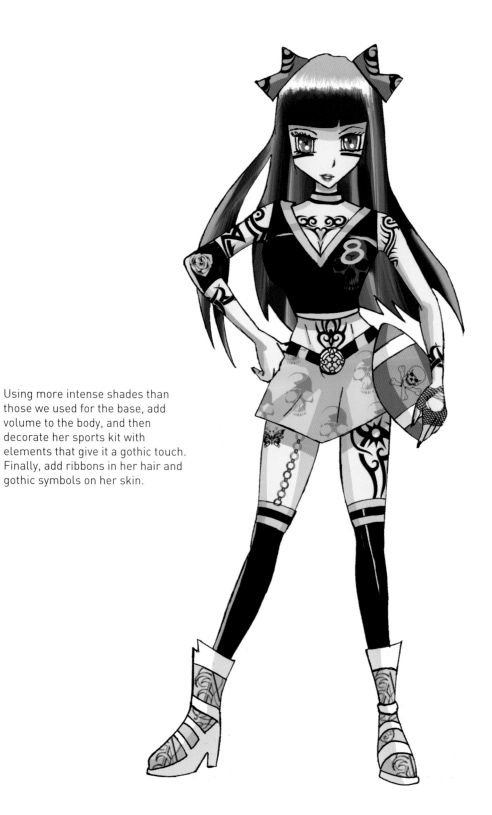

Using more intense shades than those we used for the base, add volume to the body, and then decorate her sports kit with elements that give it a gothic touch. Finally, add ribbons in her hair and gothic symbols on her skin.

GOTHIC CHEERLEADER

Alira is the leader of the Purple Yellow Spiders, the best acrobatic cheerleaders in the region. This year, they are preparing for the state championships in Salem. Their team, the Night Bats, is playing in the finals.

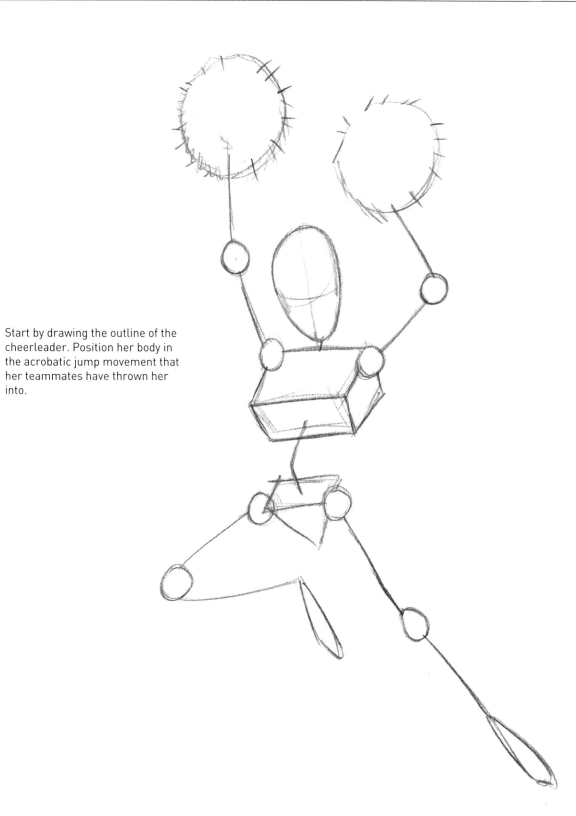

Start by drawing the outline of the cheerleader. Position her body in the acrobatic jump movement that her teammates have thrown her into.

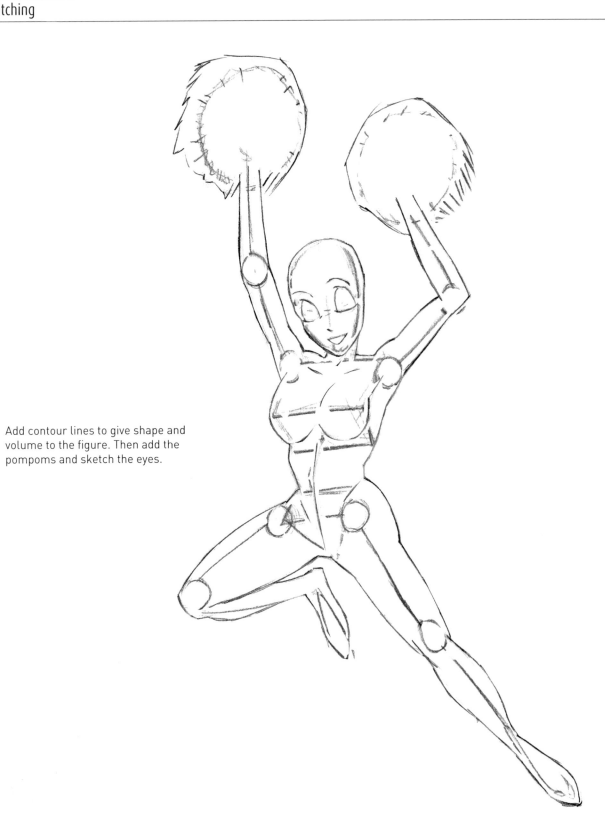

Add contour lines to give shape and volume to the figure. Then add the pompoms and sketch the eyes.

Give shape to the figure with a well-sharpened pencil, marking crosses on the parts that will be covered with black ink.

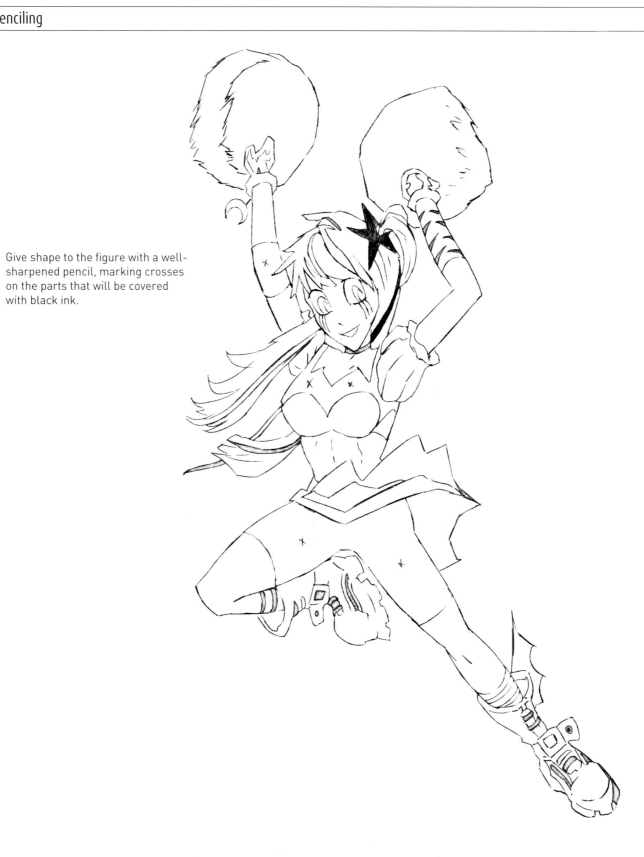

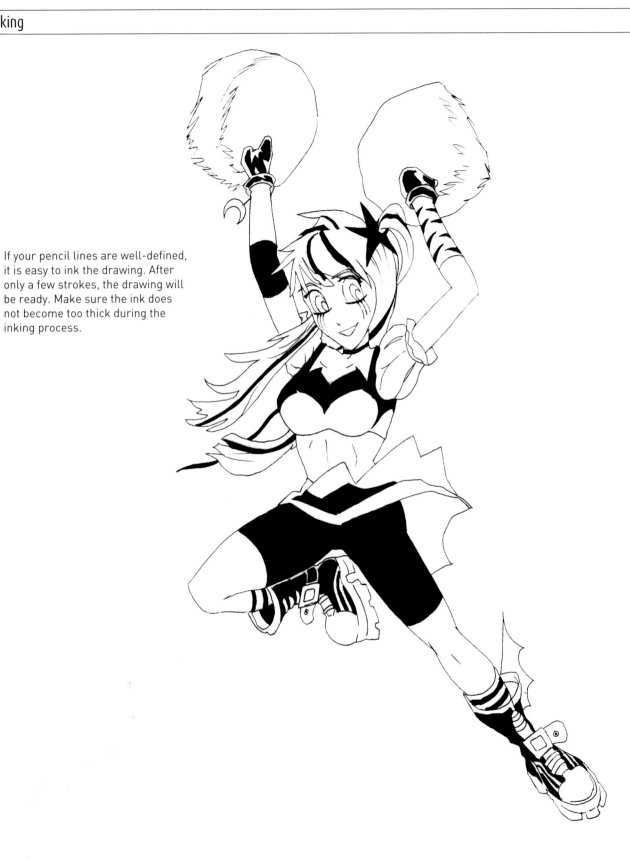

If your pencil lines are well-defined, it is easy to ink the drawing. After only a few strokes, the drawing will be ready. Make sure the ink does not become too thick during the inking process.

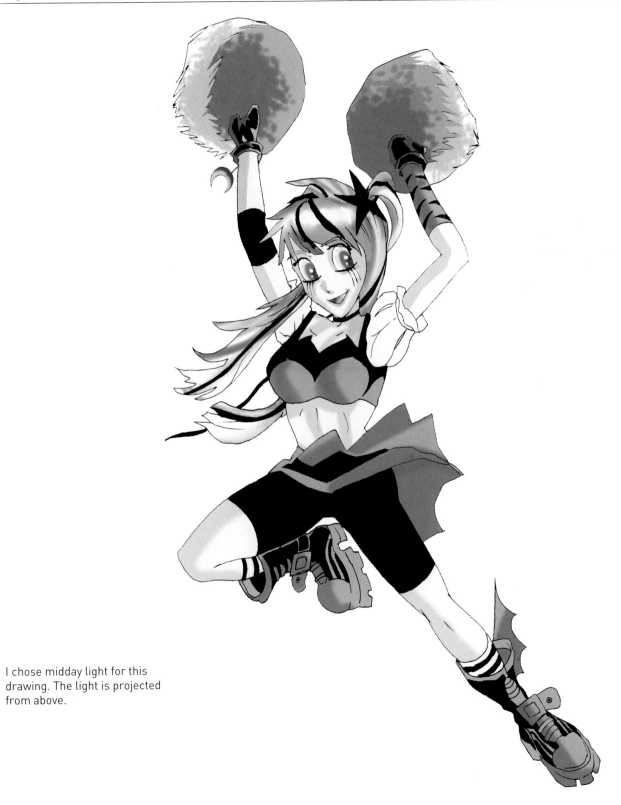

I chose midday light for this
drawing. The light is projected
from above.

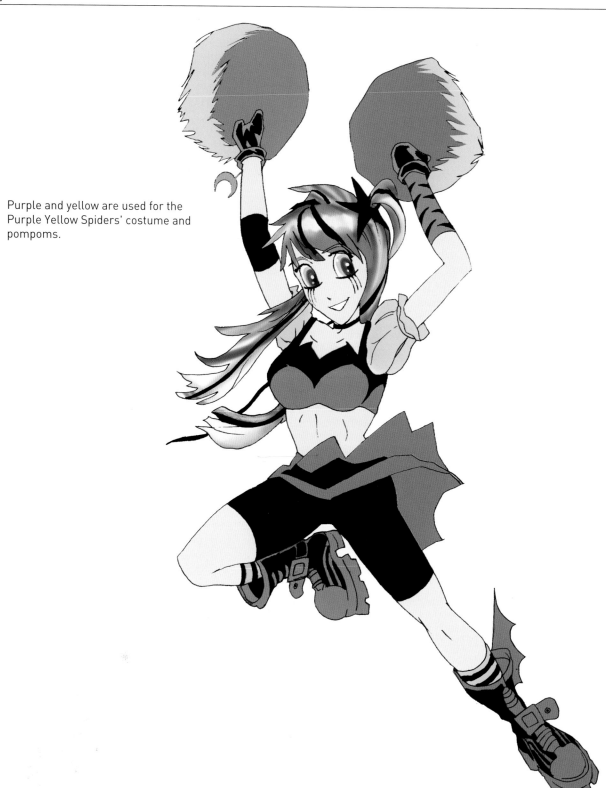

Purple and yellow are used for the Purple Yellow Spiders' costume and pompoms.

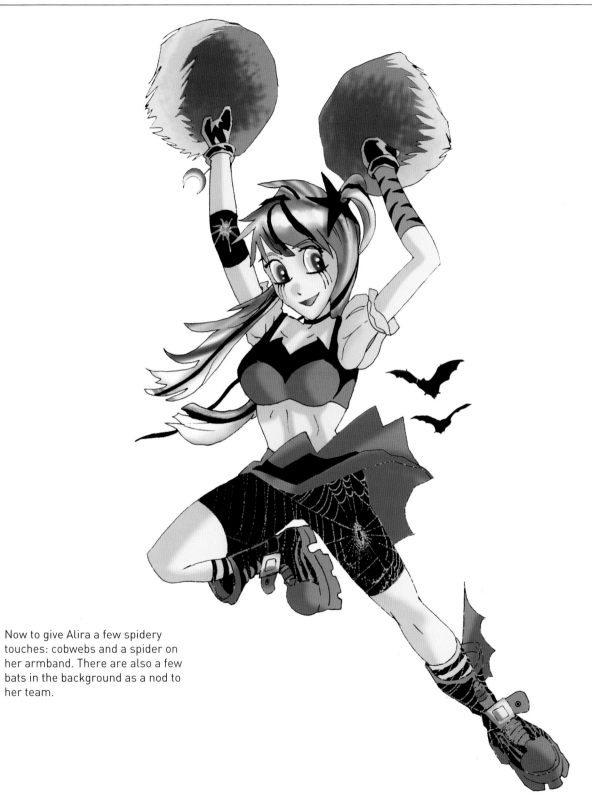

Now to give Alira a few spidery touches: cobwebs and a spider on her armband. There are also a few bats in the background as a nod to her team.

GOTHIC NURSE

Valerie is a nurse at Salem Hospital, but she's certainly not be-loved by her patients. She likes chasing them and throwing a needle at them like a dart.

Using the blue pencil, draw Valerie's outlines. Her skeleton should be set in a "got you!" position. When drawing basic figures, the arms and legs should never be parallel, as this would make the figure too rigid.

Contour lines help set the character's expression. Remember that the better your skeleton is, the better your drawing will be. Sketch Valerie with a 2H pencil, using her skeleton as its support.

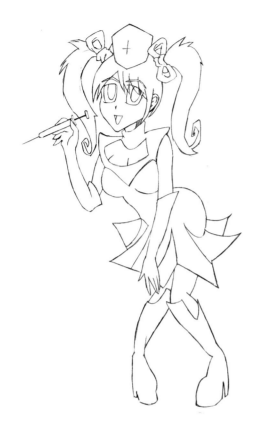

With an 05 pencil, define the details so you can add the ink smoothly. Try to keep the penciling clean; using the softest eraser possible will help.

4. Inking

Using a stylograph with a fine 02 nib, ink the bulk of the drawing, but use an 04 marker for the details on the ribbons and an 08 marker to fill the black areas of the skirt and boots.

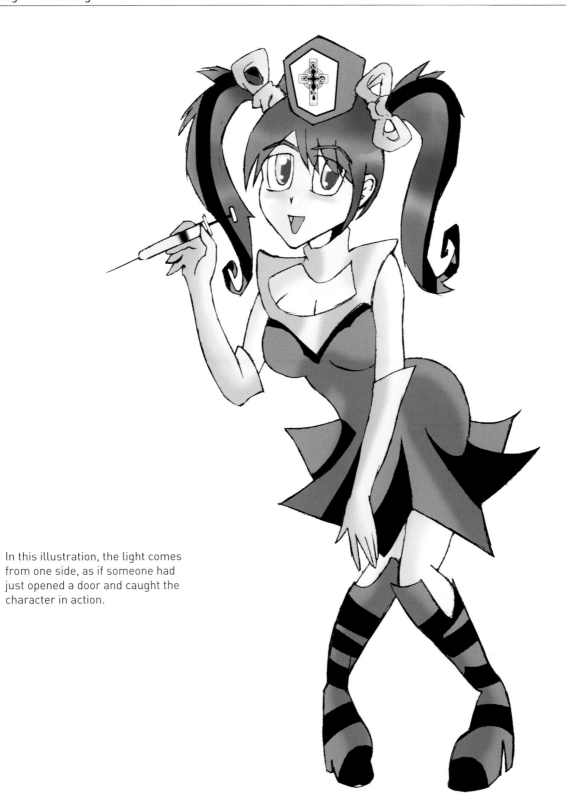

In this illustration, the light comes from one side, as if someone had just opened a door and caught the character in action.

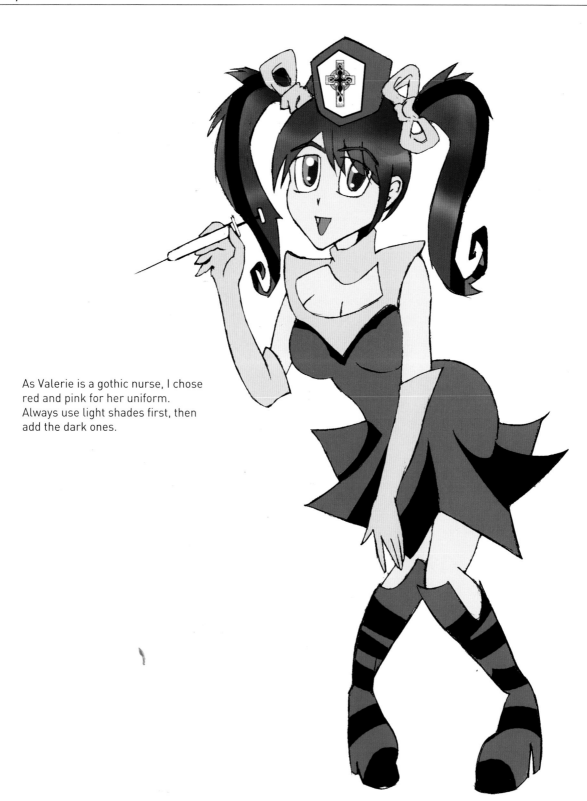

As Valerie is a gothic nurse, I chose red and pink for her uniform. Always use light shades first, then add the dark ones.

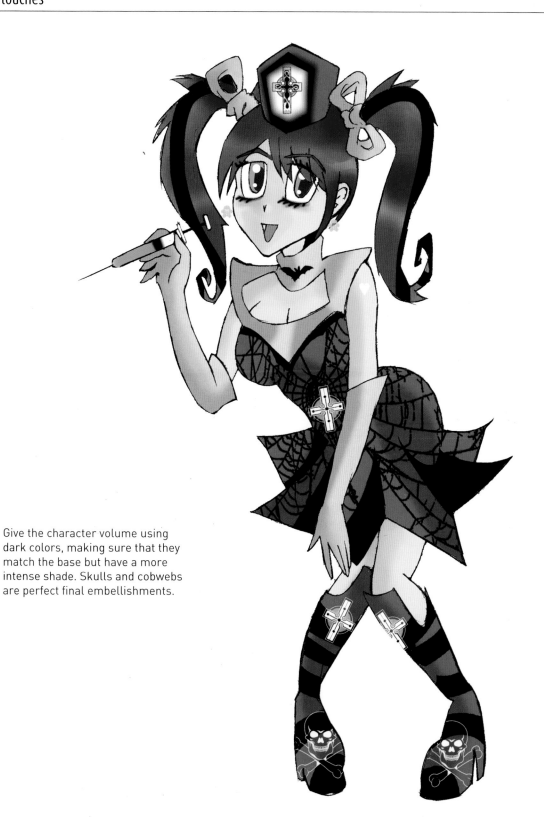

Give the character volume using dark colors, making sure that they match the base but have a more intense shade. Skulls and cobwebs are perfect final embellishments.

GOTHIC MAID

Delilah is the cleaner of a large mansion, and is in charge of making sure the whole house gleams. In some rooms, when she is cleaning, she sometimes hears footsteps and chains. In others, she sometimes hears a girl crying. The house is haunted, but she isn't scared. She wants to find out how to break its spell.

Draw the character's outline in blue. Long legs make her look slender.

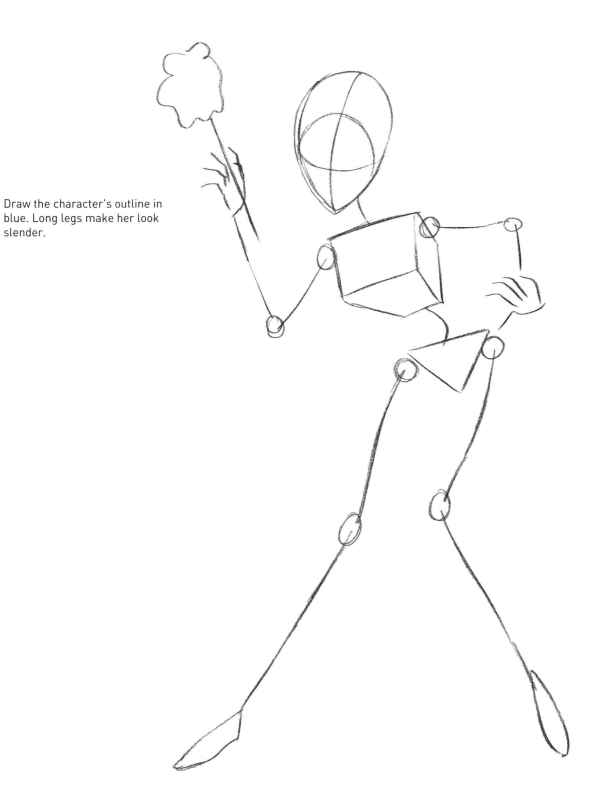

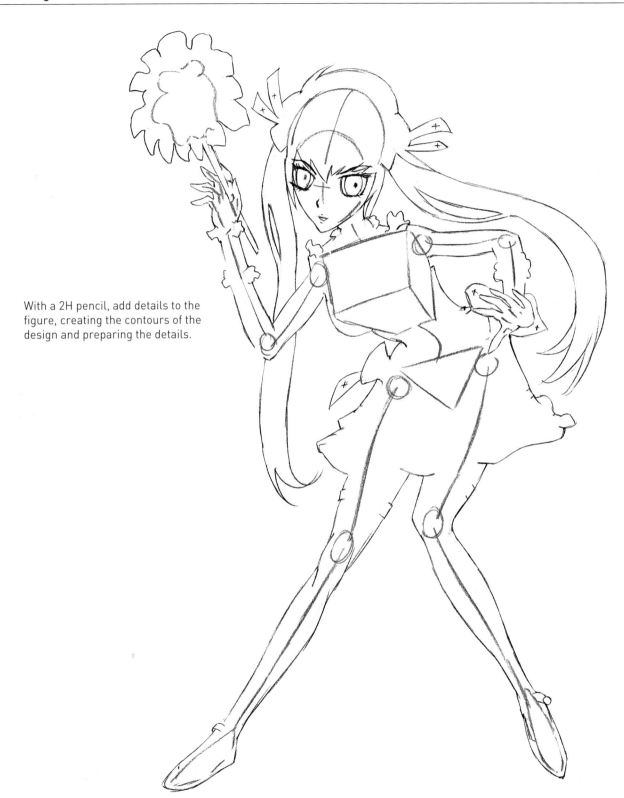

With a 2H pencil, add details to the figure, creating the contours of the design and preparing the details.

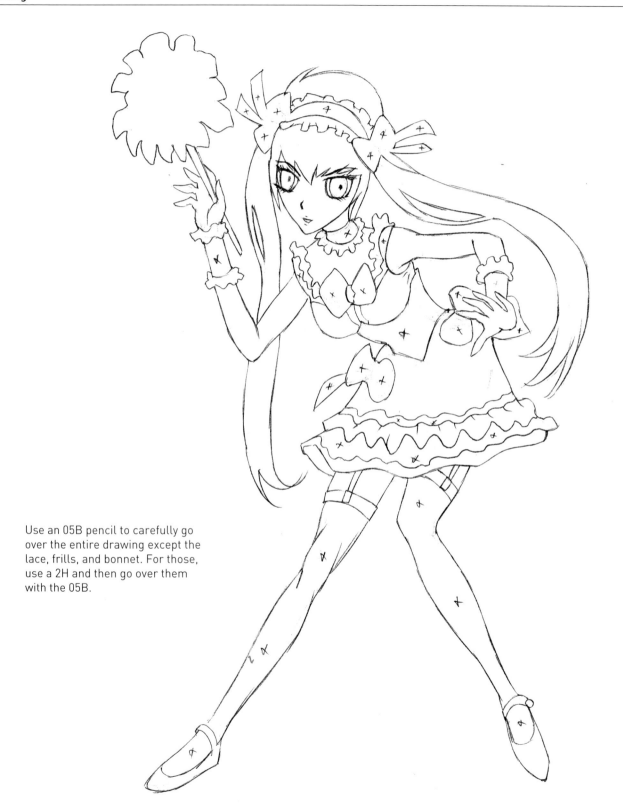

Use an 05B pencil to carefully go
over the entire drawing except the
lace, frills, and bonnet. For those,
use a 2H and then go over them
with the 05B.

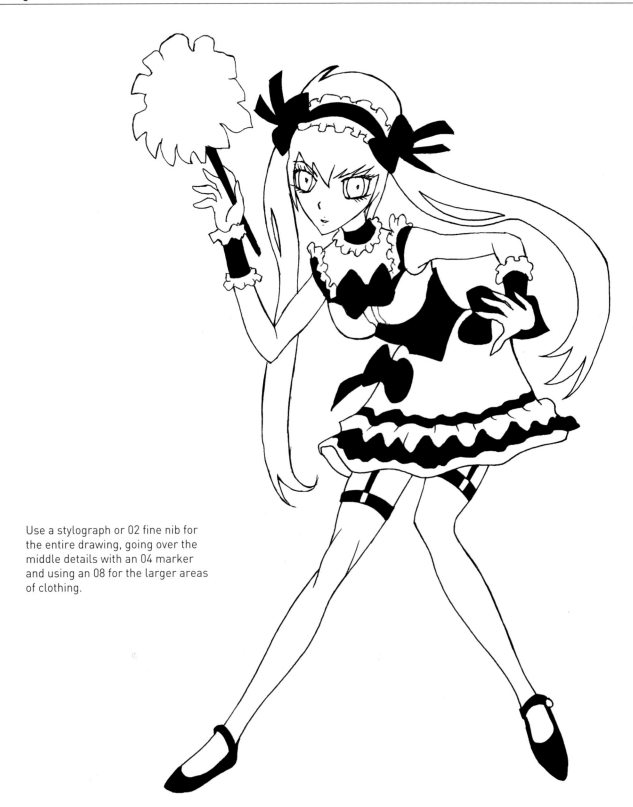

Use a stylograph or 02 fine nib for the entire drawing, going over the middle details with an 04 marker and using an 08 for the larger areas of clothing.

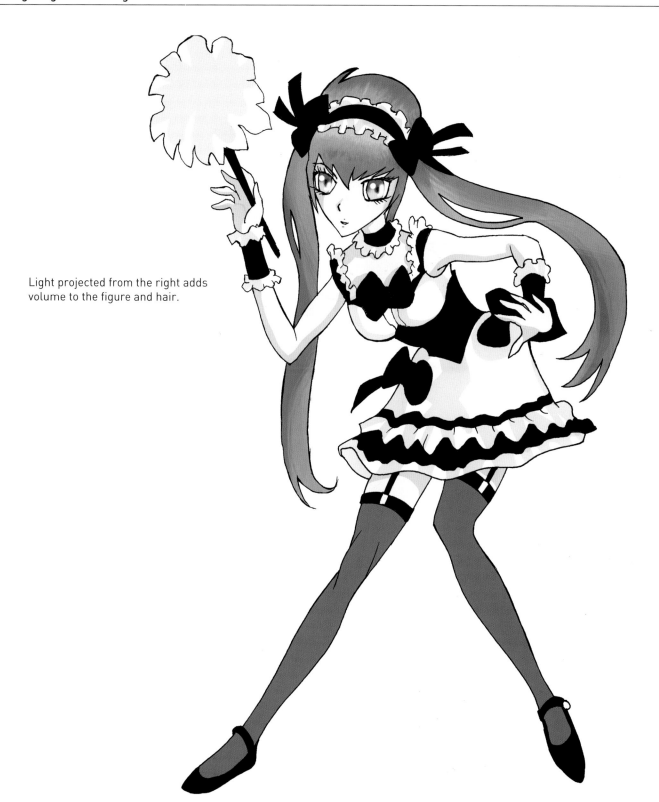

Light projected from the right adds volume to the figure and hair.

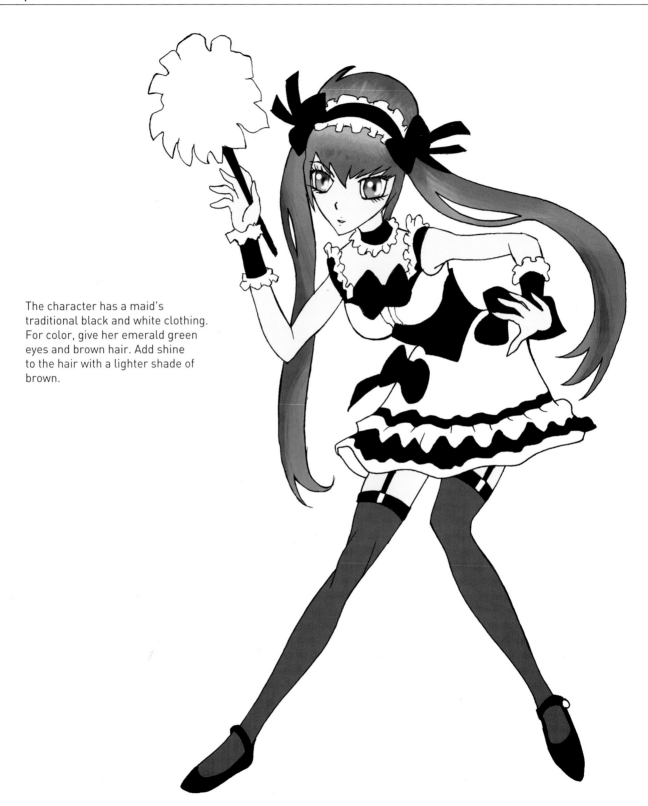

The character has a maid's traditional black and white clothing. For color, give her emerald green eyes and brown hair. Add shine to the hair with a lighter shade of brown.

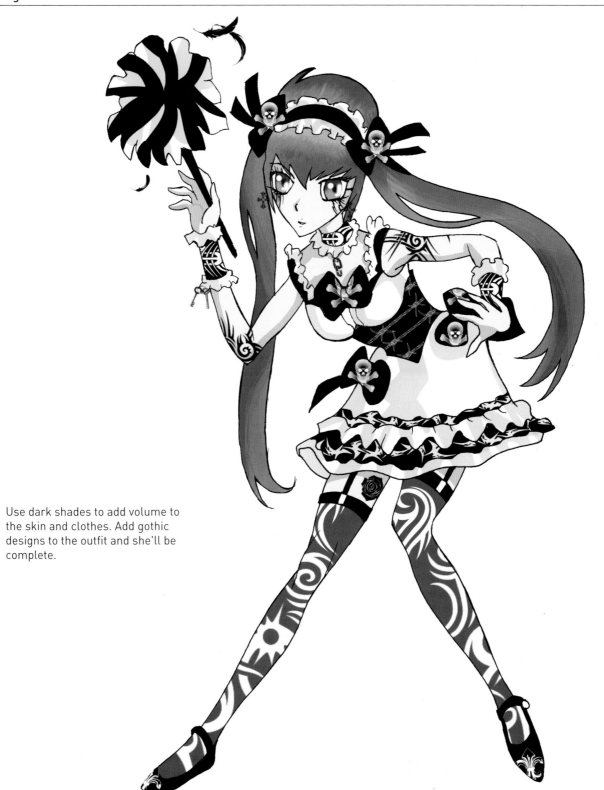

Use dark shades to add volume to the skin and clothes. Add gothic designs to the outfit and she'll be complete.

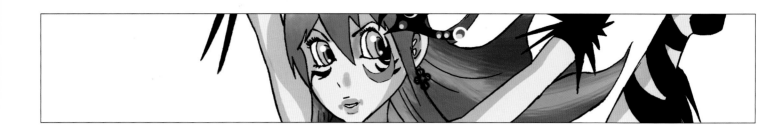

GOTHIC DANCER

Amberlyn is a gothic dancer; dance is her passion and her life. As one of the world's top gothic dancers, she has performed at the best theaters in the world. Her Lady of the Lake dance entrances all who see it.

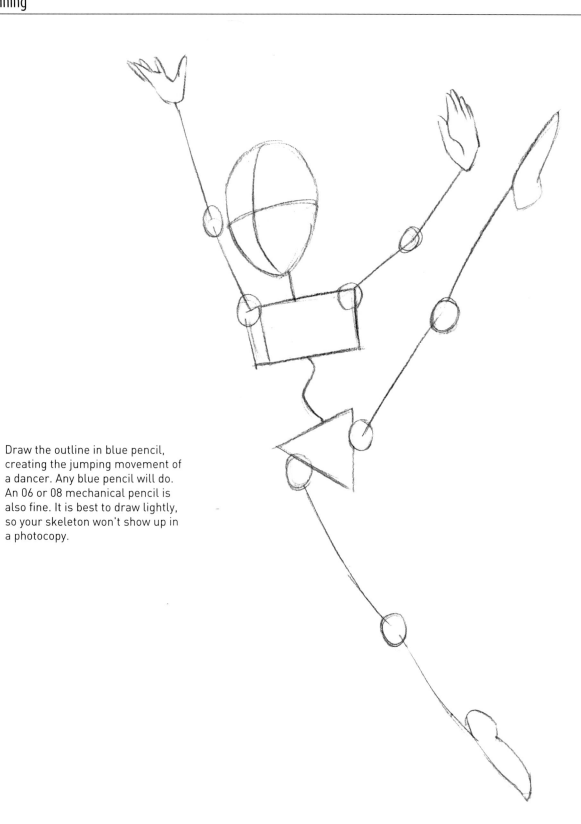

Draw the outline in blue pencil, creating the jumping movement of a dancer. Any blue pencil will do. An 06 or 08 mechanical pencil is also fine. It is best to draw lightly, so your skeleton won't show up in a photocopy.

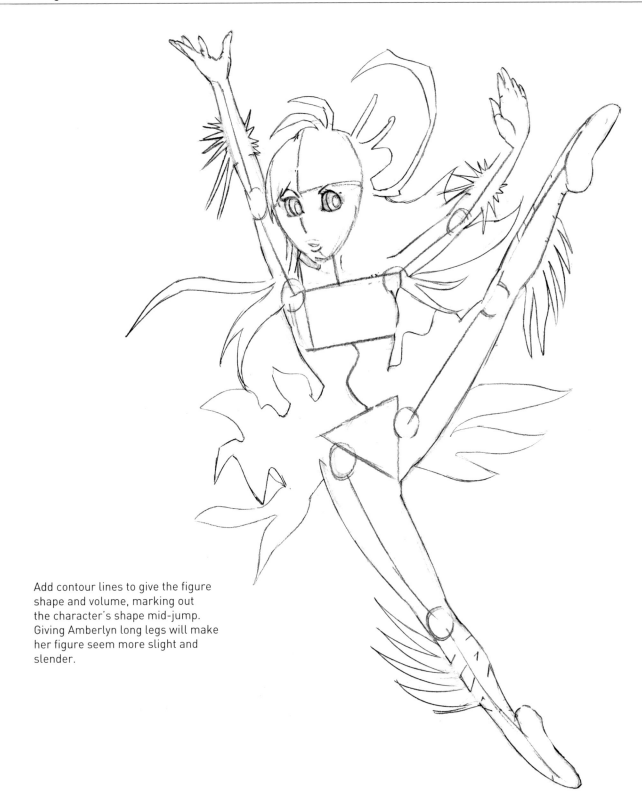

Add contour lines to give the figure shape and volume, marking out the character's shape mid-jump. Giving Amberlyn long legs will make her figure seem more slight and slender.

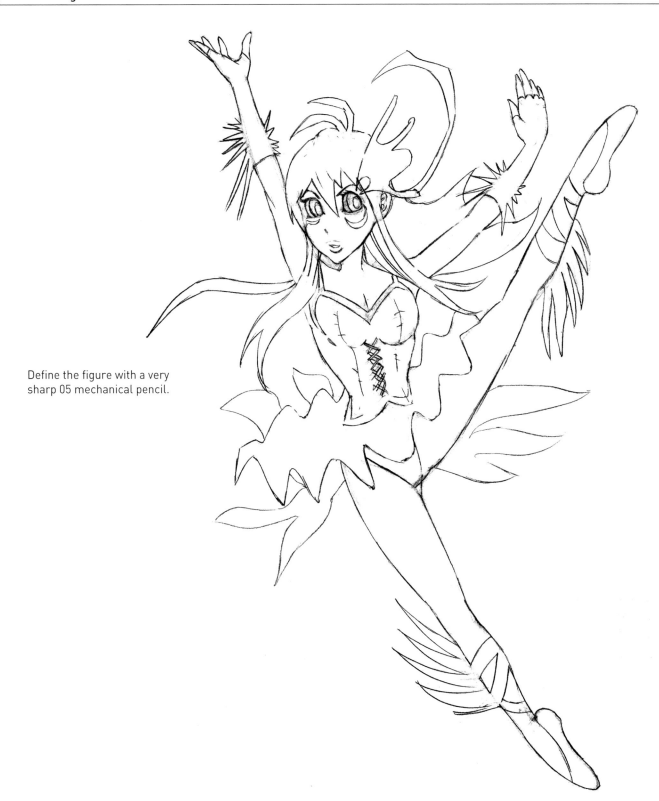

Define the figure with a very
sharp 05 mechanical pencil.

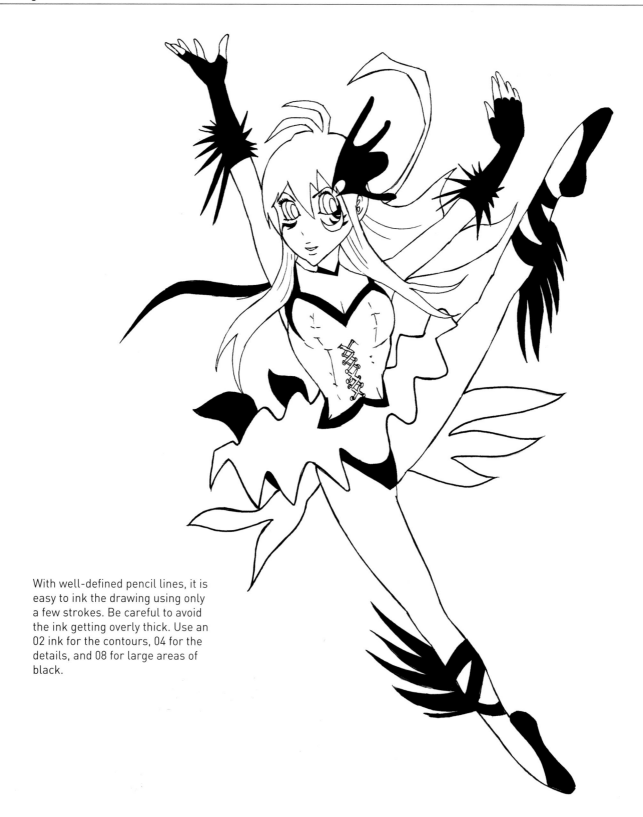

With well-defined pencil lines, it is easy to ink the drawing using only a few strokes. Be careful to avoid the ink getting overly thick. Use an 02 ink for the contours, 04 for the details, and 08 for large areas of black.

Theater spotlights produce multiple points of light. They shine on the character from above, creating shadows on her arms and legs.

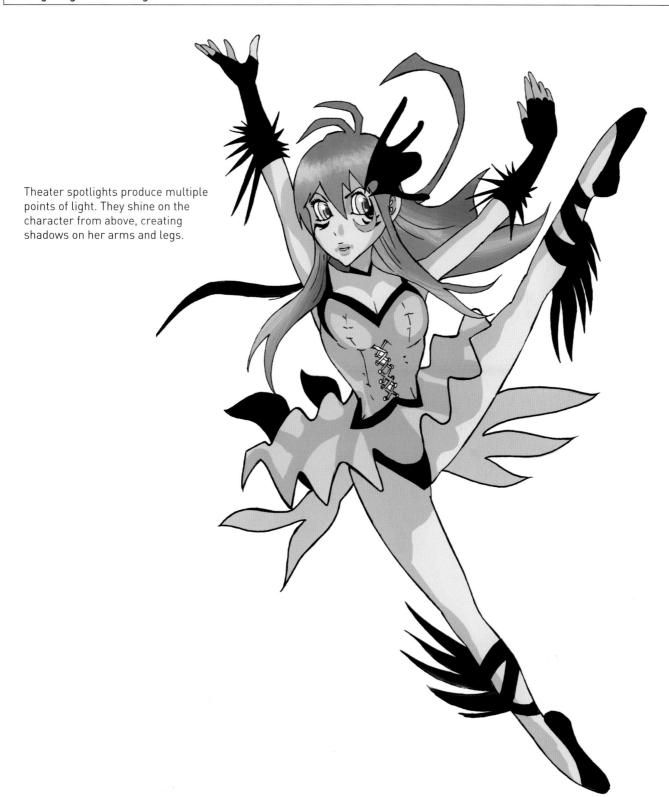

Combine light shades of gray and green as base colors.

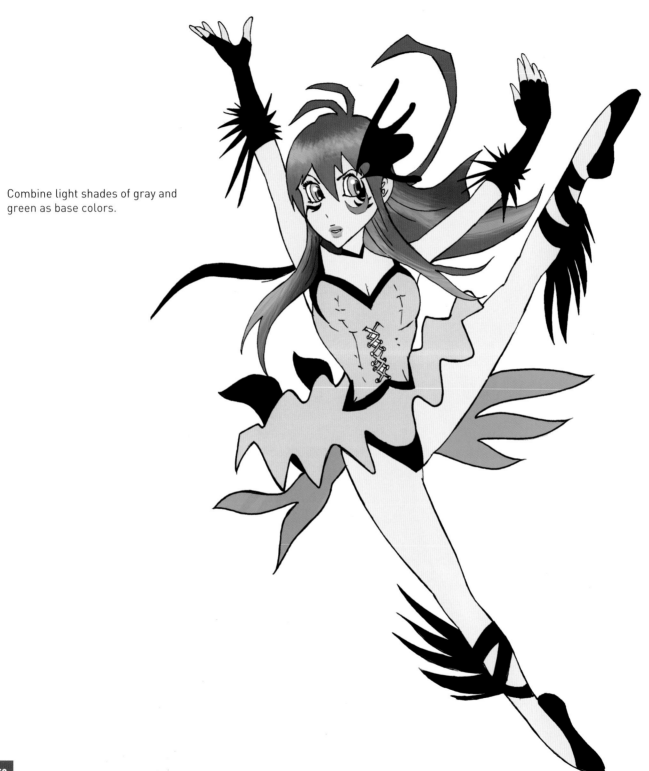

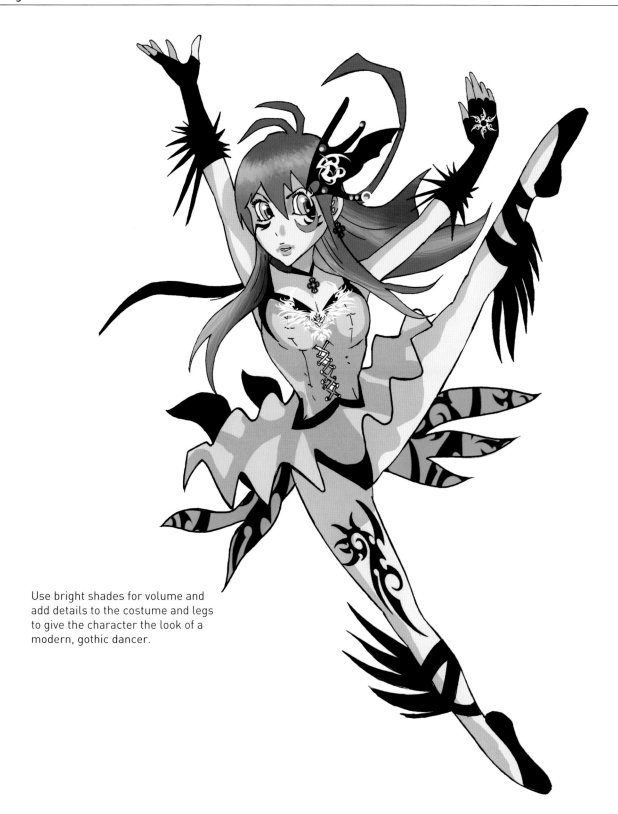

Use bright shades for volume and add details to the costume and legs to give the character the look of a modern, gothic dancer.

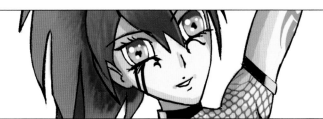

GOTHIC CLUBBER

Brandy is a fan of gothic style and enjoys hanging out with her friends in her club, the Black Queen. She loves to show off her new clothes to them by holding goth parties and gothic costume balls.

Create the character's outline in blue pencil. She should have an excellent figure. Don't forget to draw in her whip.

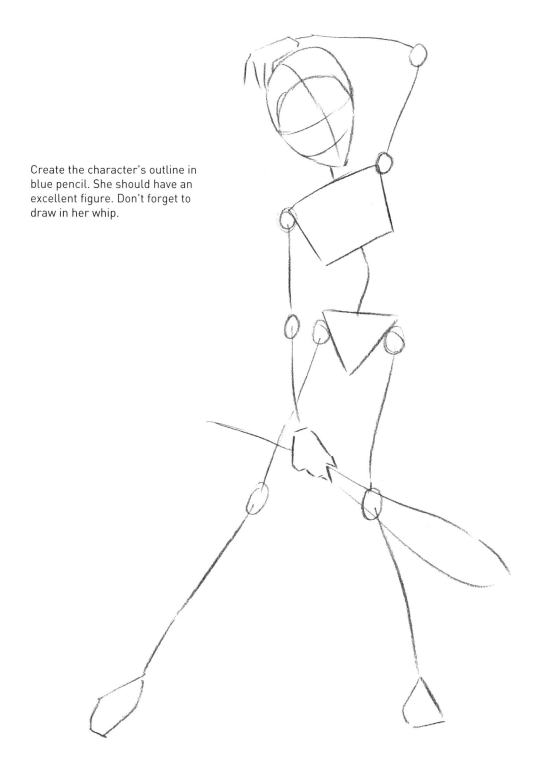

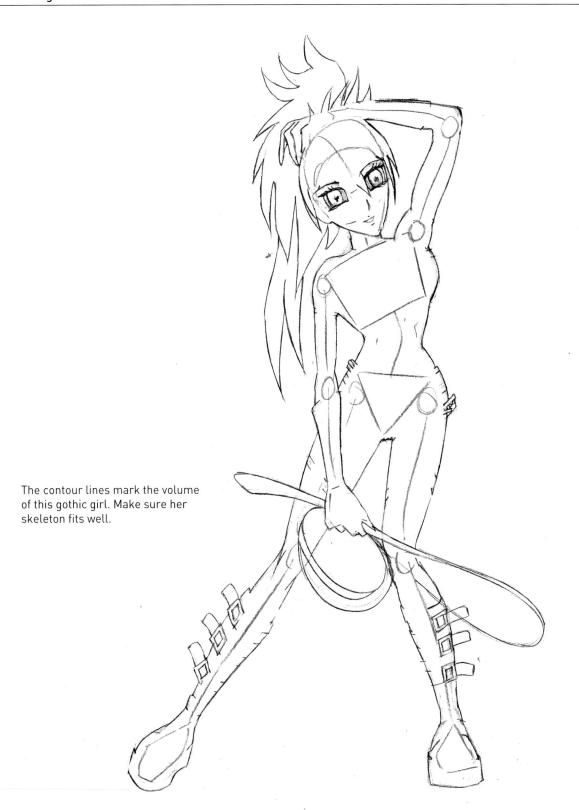

The contour lines mark the volume of this gothic girl. Make sure her skeleton fits well.

Using a 2H pencil, define the details of the boots and gloves, and the chain around the character's waist. Then go over everything with an 05B pencil.

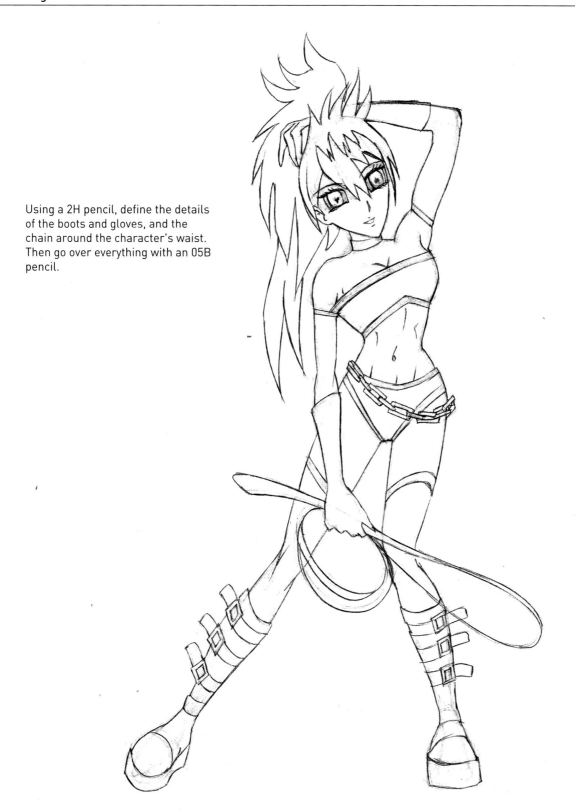

Using a stylograph with a fine 02 nib, ink the entire drawing. Be especially careful when inking the whip. I use an 04 marker to fill in the tricky areas of the eyes, along with the hair and gloves. I use an 08 for the boots.

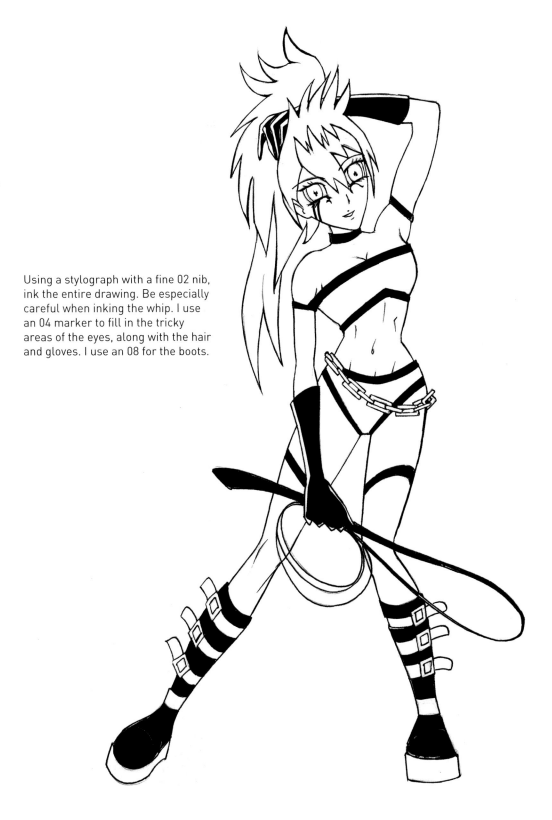

There should be a sidelight that highlights the character's whole body and gives her volume.

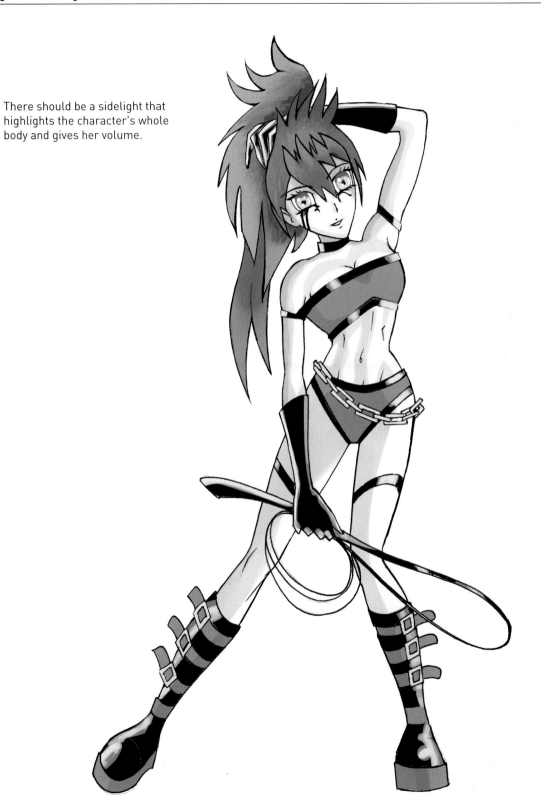

The base consists of fuchsia and red shades for the hair, white for the face, and pink for the eyes. Red is for the top and shorts.

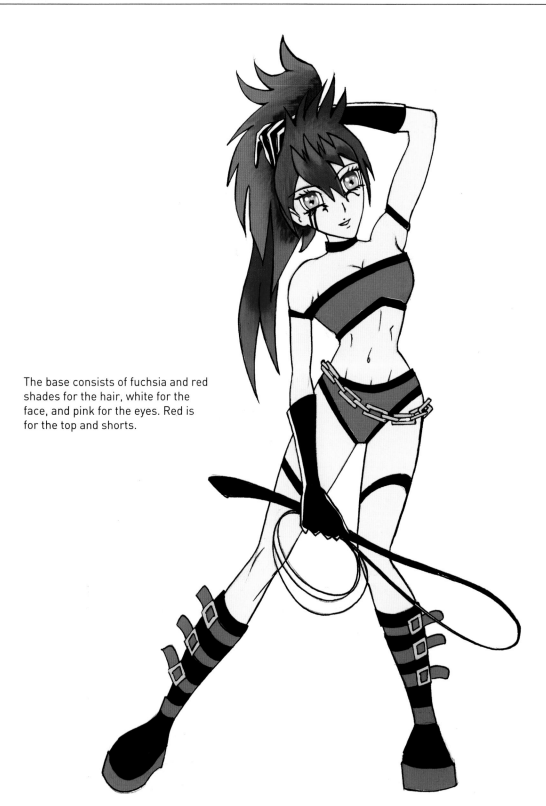

Use a dark red on the red clothing and a light-colored pencil on the black clothing to give volume to the character. Lastly, adorn the clubber with tattoos and give her fishnet stockings.

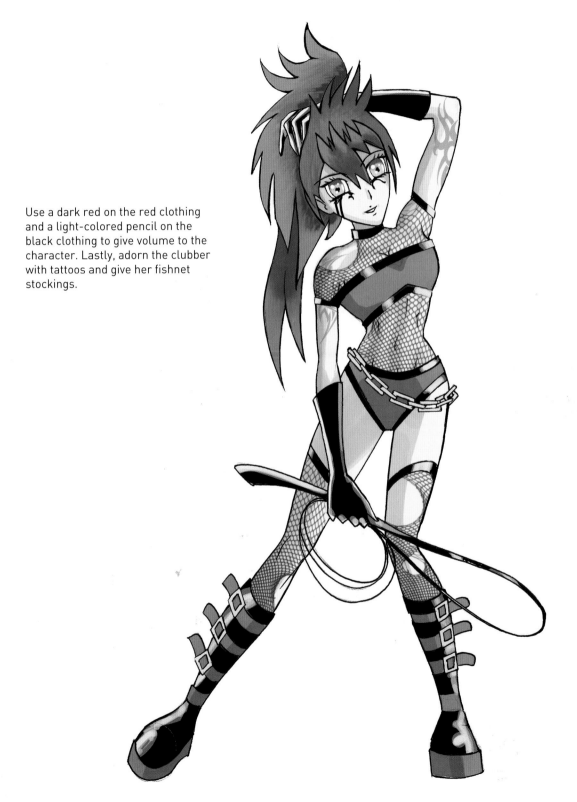

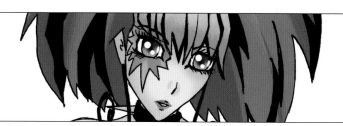

GOTHIC LOLITA

Trinity is a gothic disco dancer. Disco dancing and gothic techno music are her passion. She loves to go and see her favorite DJ on the weekends, and dances on the podium all night long.

Draw the outline in blue pencil. Any
blue pencil will do. If you are using
a mechanical pencil, an 06 or 08 is
fine.

Add contour lines to give the figure shape and volume. Creating long legs will give the character a slender figure.

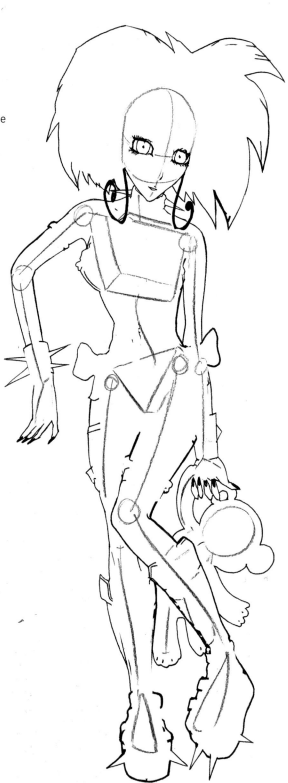

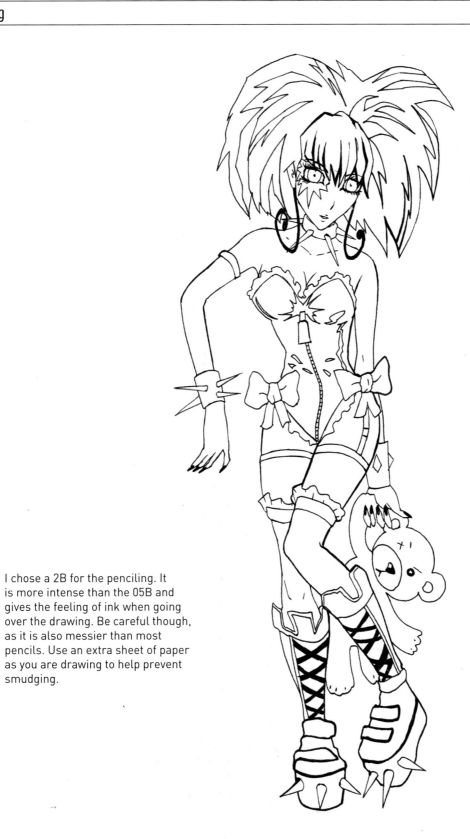

I chose a 2B for the penciling. It is more intense than the 05B and gives the feeling of ink when going over the drawing. Be careful though, as it is also messier than most pencils. Use an extra sheet of paper as you are drawing to help prevent smudging.

With well-defined pencil lines, it is easy to ink the drawing using only a few strokes. Use an 02 for the contours, an 04 for the details, and an 08 for large areas of black. Make sure the ink does not get too thick.

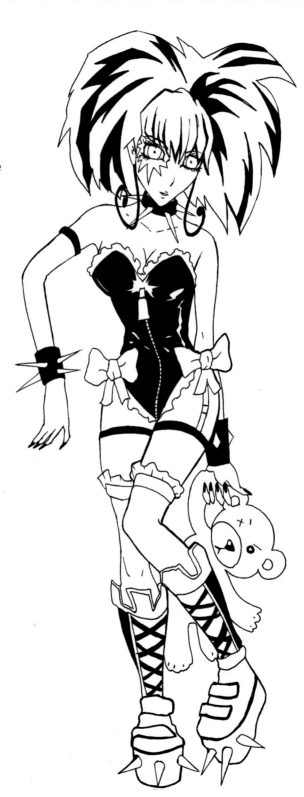

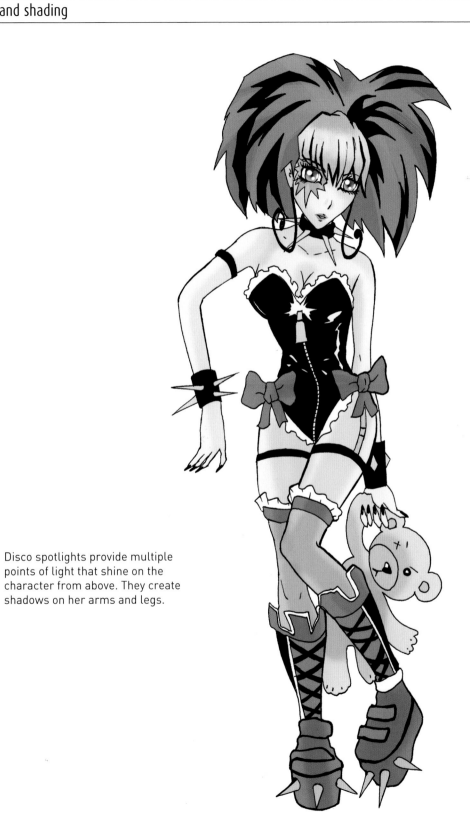

Disco spotlights provide multiple points of light that shine on the character from above. They create shadows on her arms and legs.

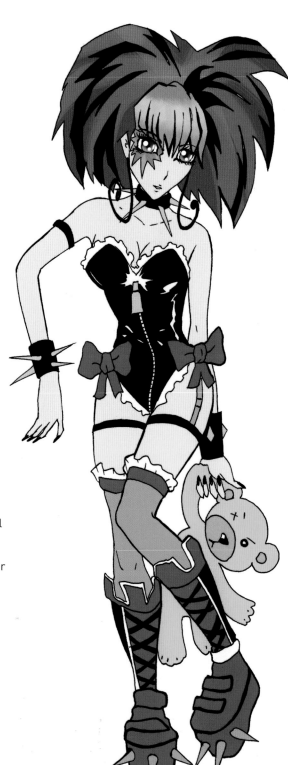

Blue, green, and purple go well together, and a yellow bear complements them. Purple eyes and hair give the character edginess.

Using bright shades for volume and a white pencil for glow, add details to the dress, tights, and tattoos.

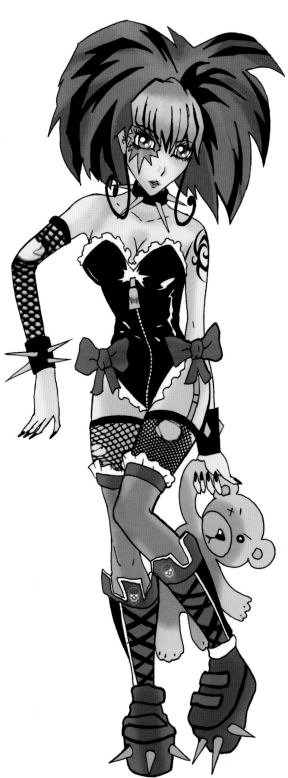

GOTHIC STUDENT

Talya is a student at the Kaneda Institute. She likes gothic cloth-
ing, but her uniform doesn't allow much leeway. Nonetheless,
she has managed to make minor modifications that give it a dif-
ferent look than her peers' uniforms. The look is bold and bright,
so teachers let her get away with it.

1. Outlining

Draw the outline of the skeleton in blue, taking care with proportion and size.

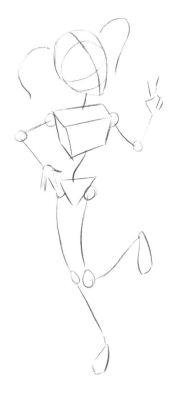

2. Sketching

With a 2H pencil, mark the volume and contours of the design.

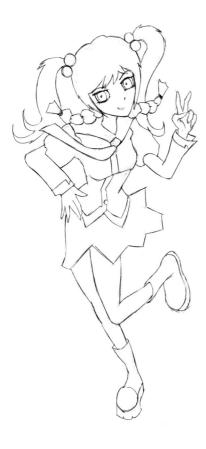

Again using the 2H pencil, draw the tie and skirt. Next, go over the whole drawing with an 05B to add definition.

4. Inking

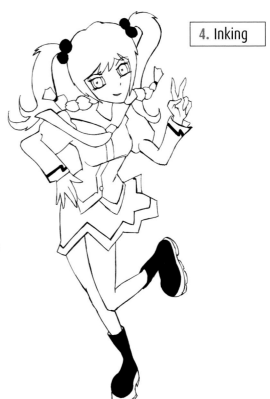

Using the stylograph with 02 fine nibs, ink the entire drawing. Then use an 08 on the boots.

The light comes from above, so it adds volume to the character's face, chest, skirt, and legs.

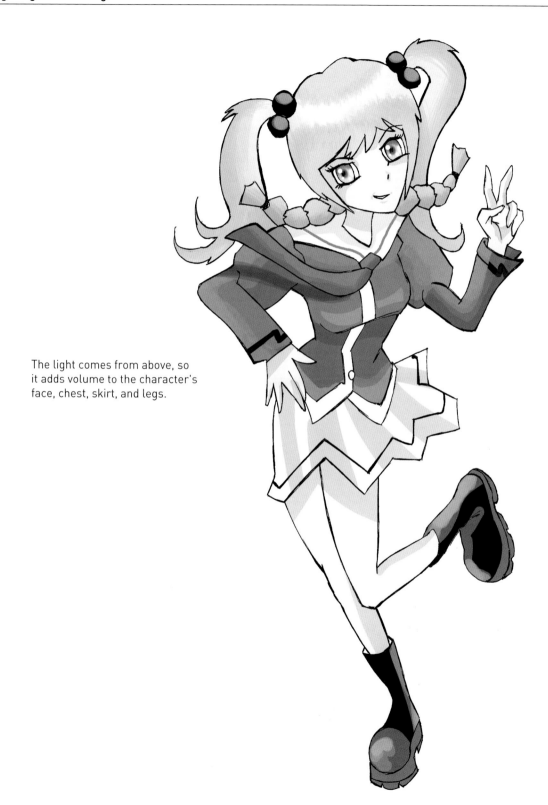

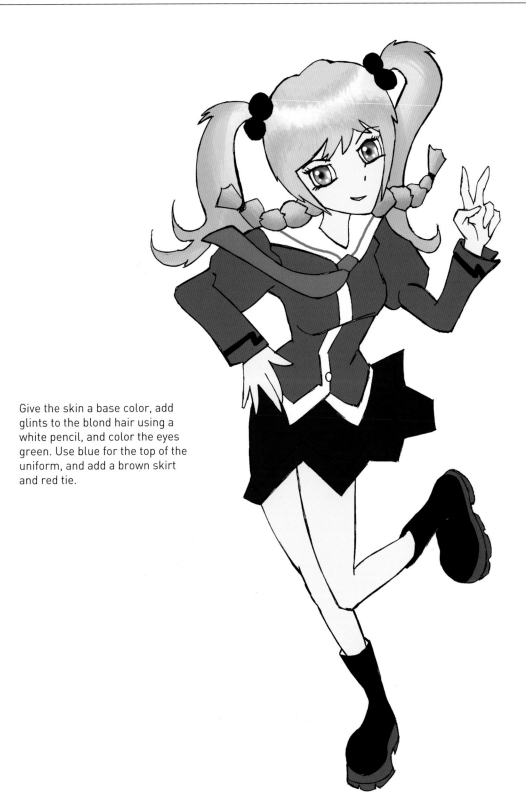

Give the skin a base color, add glints to the blond hair using a white pencil, and color the eyes green. Use blue for the top of the uniform, and add a brown skirt and red tie.

To finish, add volume with dark shades, decorate the socks, hair ribbons, and accessories, and adorn the clothes with gothic symbols.

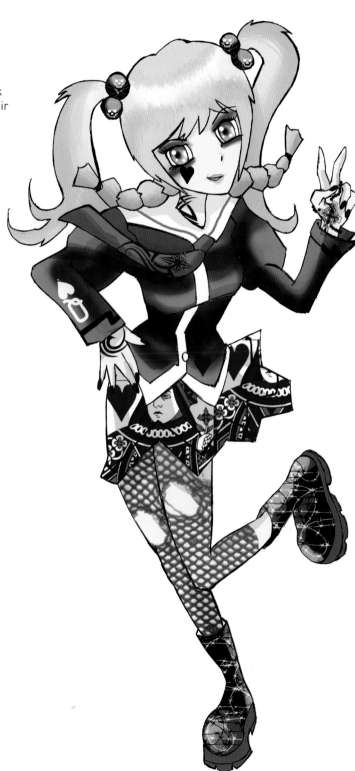

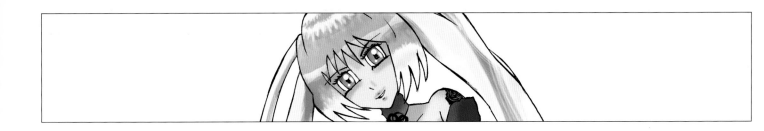

GOTHIC VAMPIRE GIRL

Isis is a vampire who was banished from the Mornai clan. Since then, she has spent her time searching for other banished vampires like herself. Now, side by side with Nikolay Ulivanoph, she faces the Mornai vampires and defends the exiles.

Draw the outline of Isis in blue pencil. Any blue pencil with a sharp point will do. The character should have a vigilant pose and be sitting on a ledge.

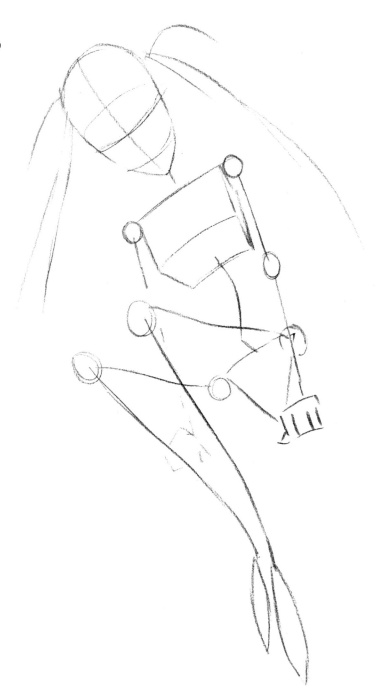

Use a 2H pencil to add contour
lines, giving the figure shape and
volume. Sketch the lines of her
diaphanous clothing.

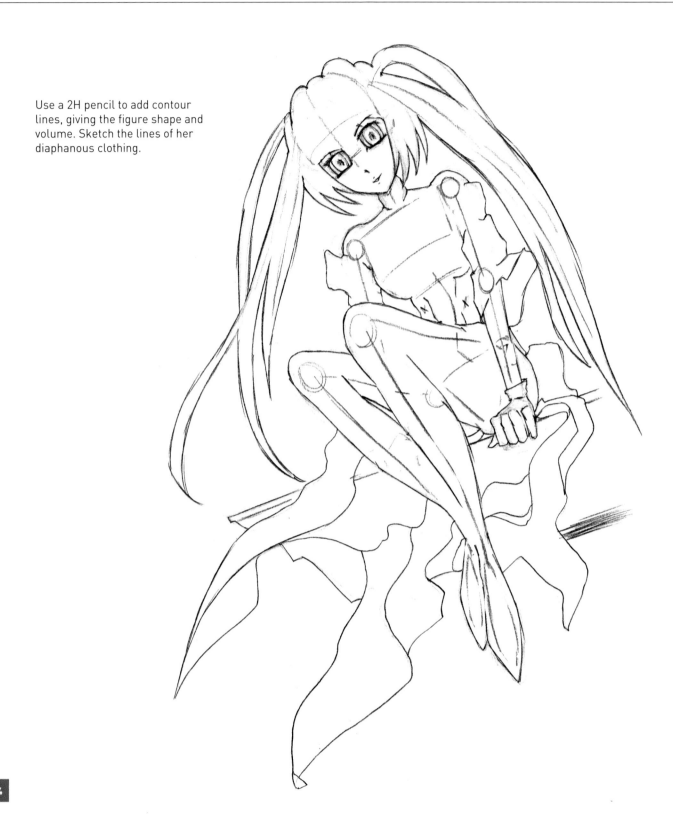

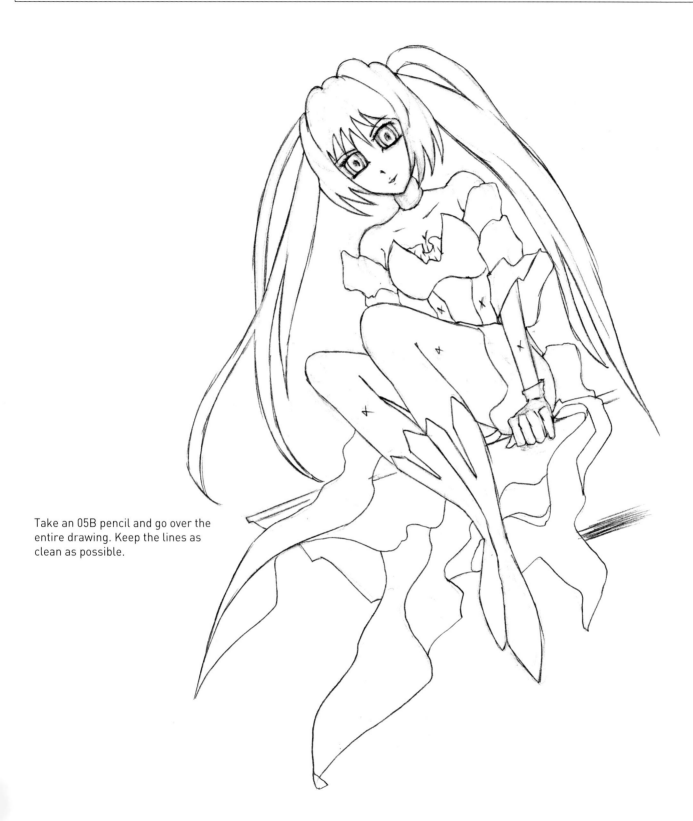

Take an 05B pencil and go over the entire drawing. Keep the lines as clean as possible.

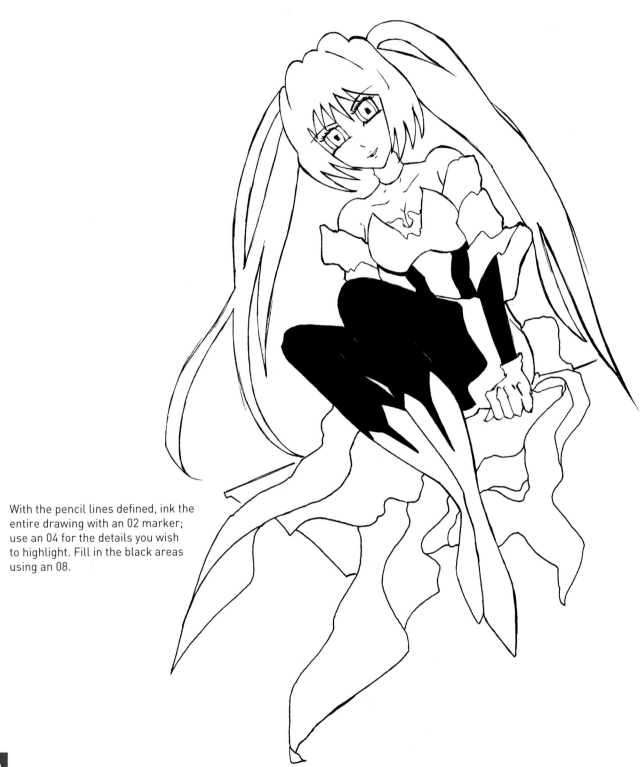

With the pencil lines defined, ink the entire drawing with an 02 marker; use an 04 for the details you wish to highlight. Fill in the black areas using an 08.

Moonlight will create shadows on Isis' clothing, and add lightness and volume to the design.

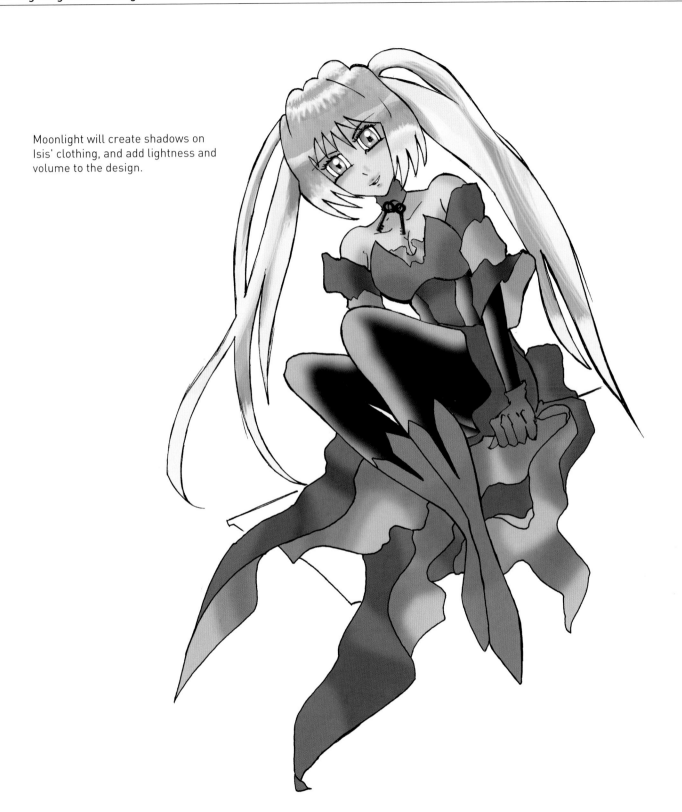

Use shades of red, burgundy, and blue for the clothing. The hair should be off-white. Add shine to it with a blue-purple color, and add emerald-colored eyes.

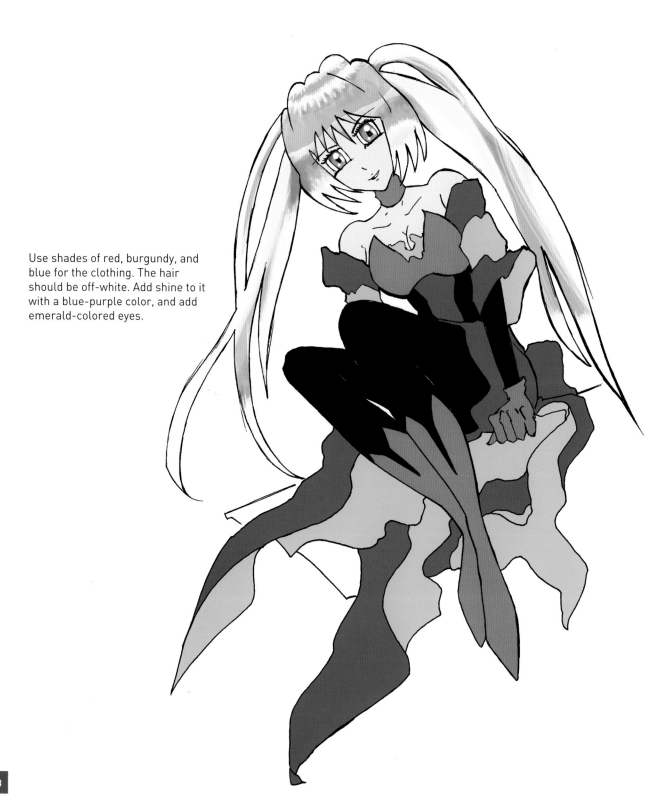

Use bright shades to add volume to the clothing, then add details to the stockings with white pencil. Feel free to also add crosses or gothic elements.

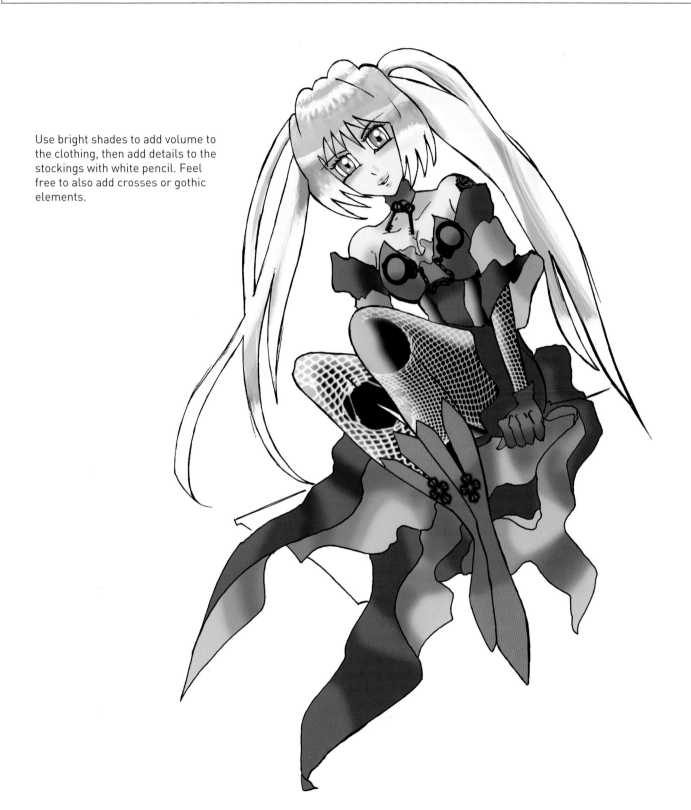

CYBERPUNK GIRL

Ici is a Mighty City cyberpunk. She fights alongside her clan to cleanse the city of the police robots that were changed by a wave of solar radiation and are trying to enslave the humans.

Create the figure's skeleton
using a blue pencil.

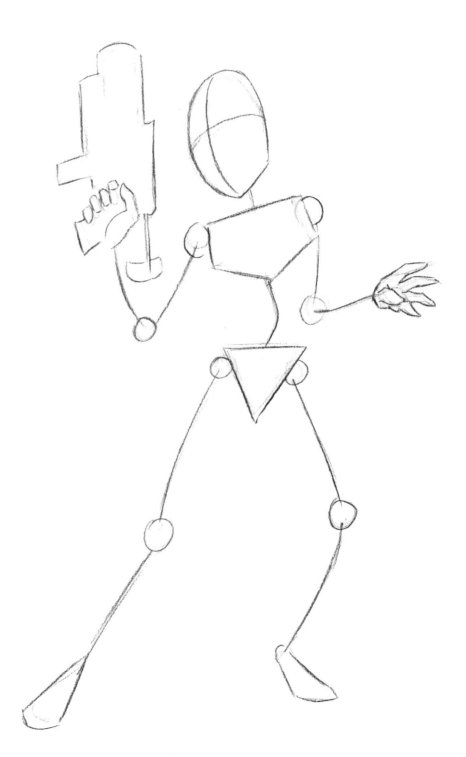

With a soft pencil (I used a 2H), shape the contours of the figure and make sure the skeleton is appropriately sized.

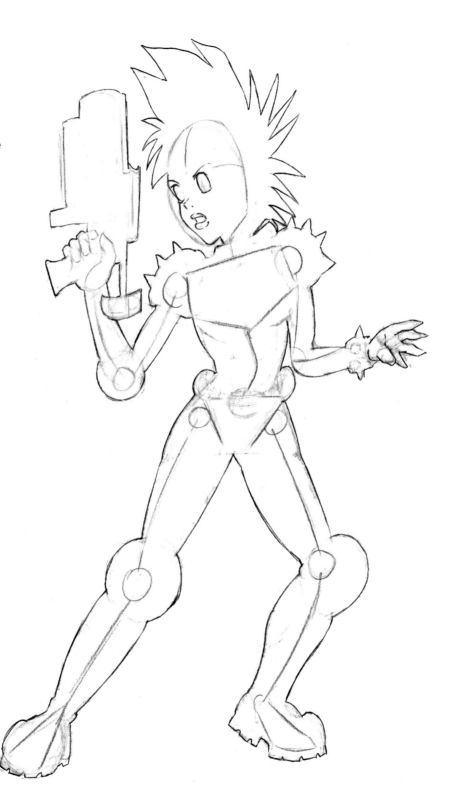

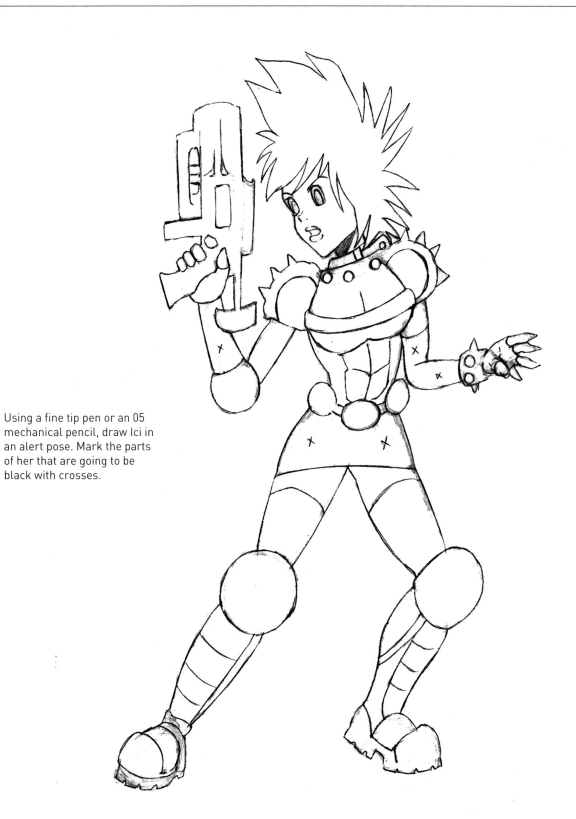

Using a fine tip pen or an 05 mechanical pencil, draw Ici in an alert pose. Mark the parts of her that are going to be black with crosses.

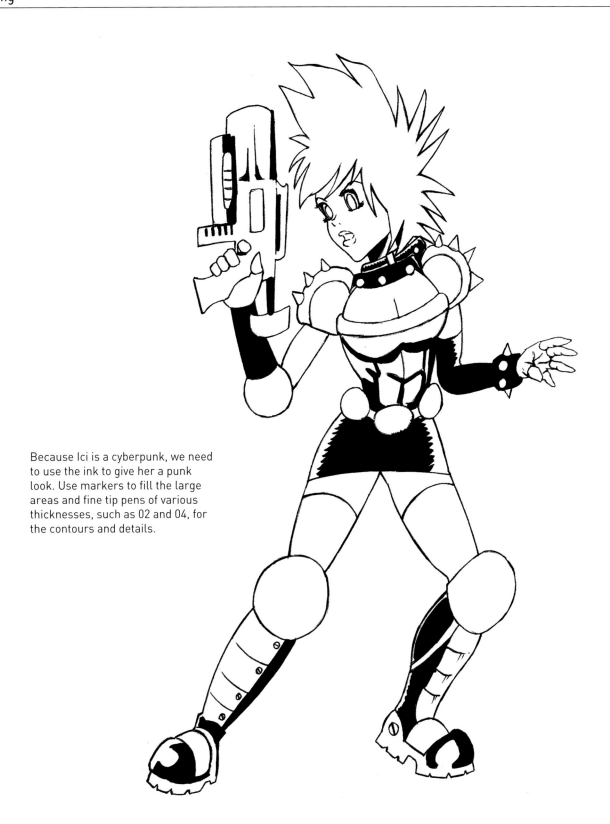

Because Ici is a cyberpunk, we need to use the ink to give her a punk look. Use markers to fill the large areas and fine tip pens of various thicknesses, such as 02 and 04, for the contours and details.

The light for Ici comes from above like a streetlight, giving the drawing an urban atmosphere. Create volume by adding light to all the parts you want to highlight, such as the legs, face, and chest.

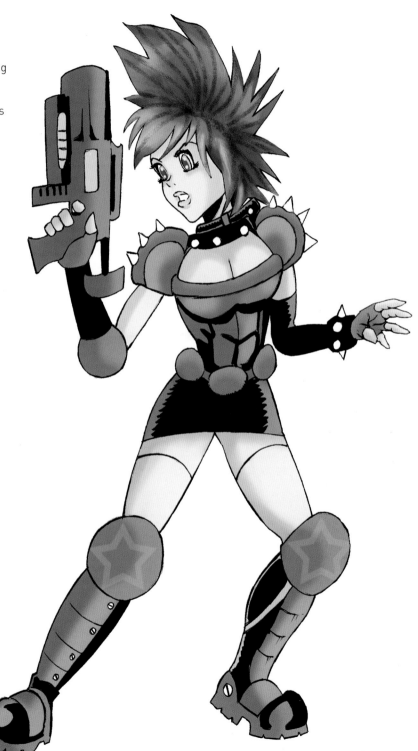

Add the base colors. It is important not to add any very dark colors yet because later we are going to add intense shades to give volume to the entire design.

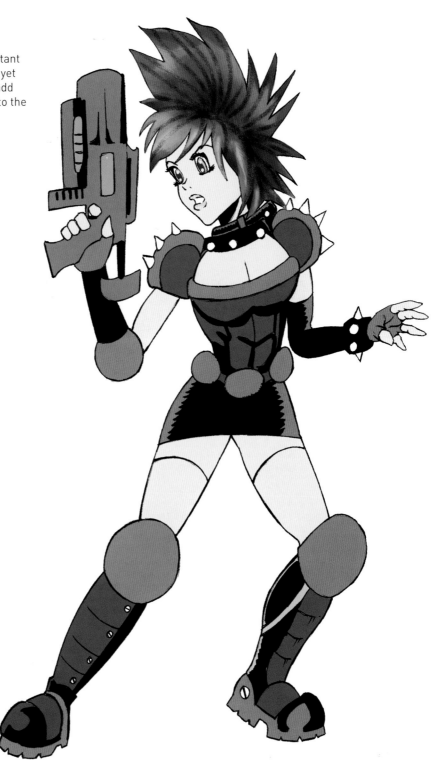

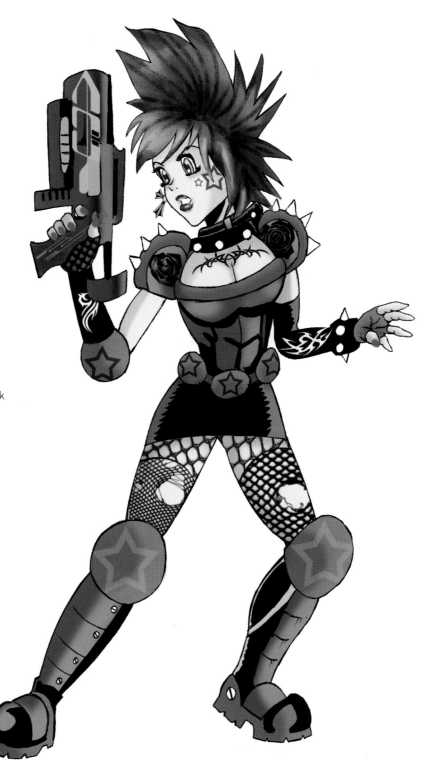

Give Ici her final look. Use dark
shades from the same range
as the base, but with volume.
Add tattoos to her body and
decorations to her clothes.

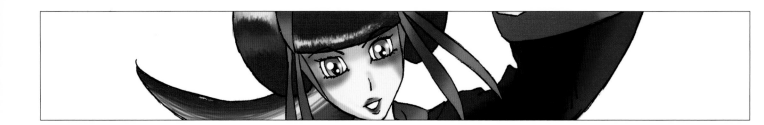

GOTHIC GEISHA

Shanai-Lin is a geisha, a martial arts and fan fighting expert, and a great warrior and protector of her people. She is known as "Deadly Dance" by those who have faced her in martial arts world championships.

Using a blue pencil, draw the
character in a combat jump pose.

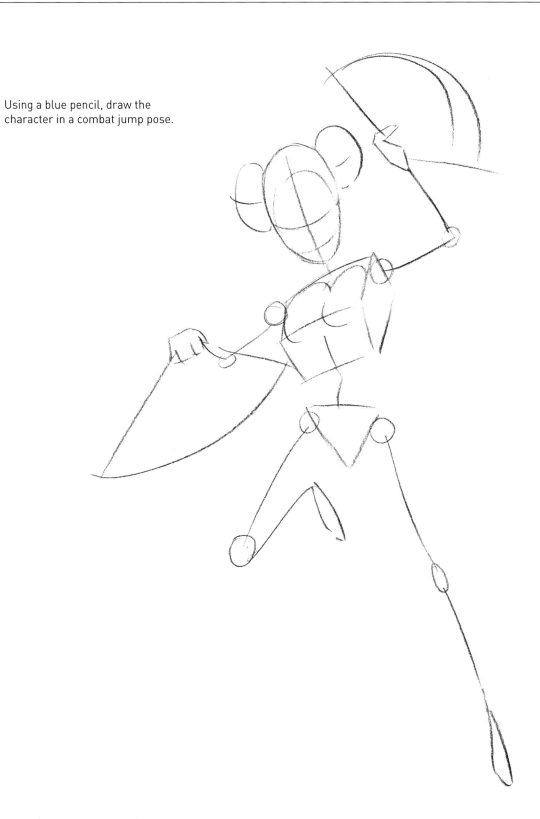

Shape the contours of the figure
with a 2H pencil.

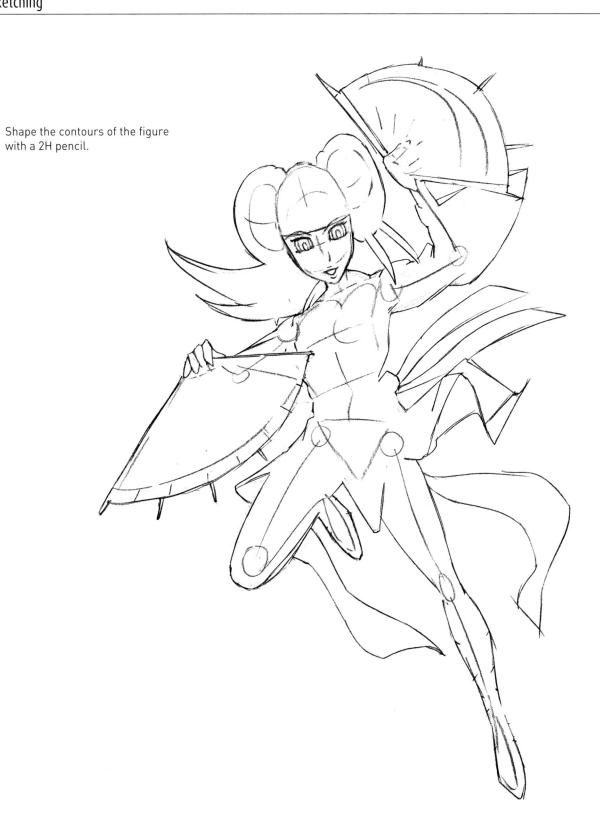

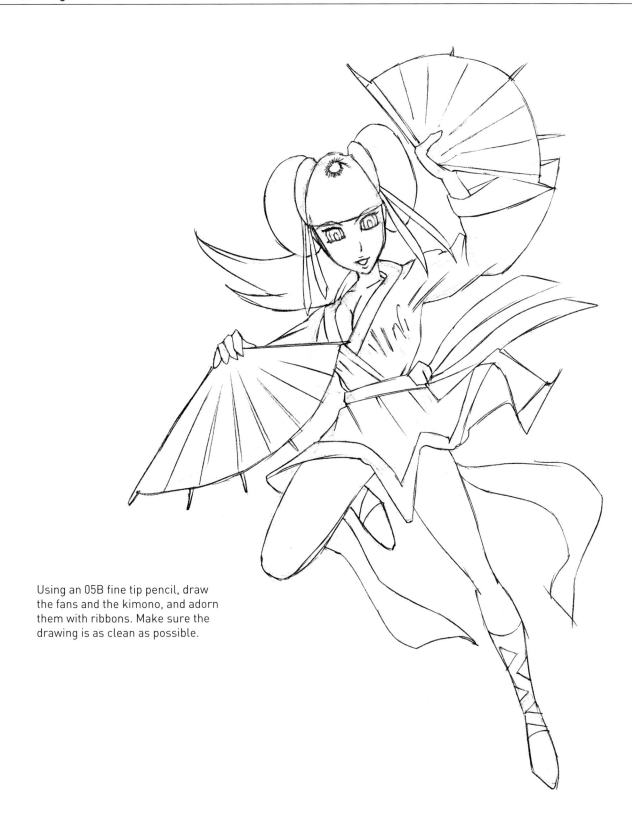

Using an 05B fine tip pencil, draw
the fans and the kimono, and adorn
them with ribbons. Make sure the
drawing is as clean as possible.

Use the fine 02 marker for the entire drawing and go over the contours of the fans with the 04.

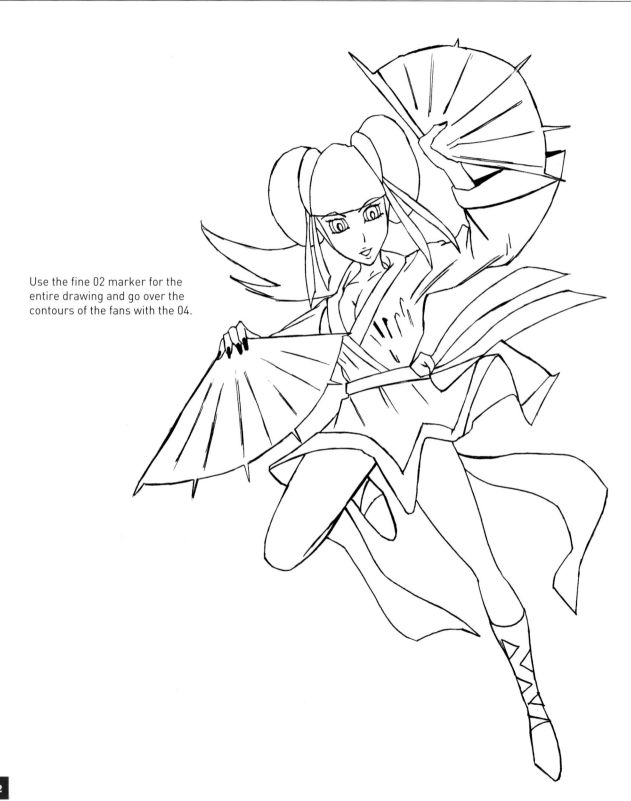

The light comes from the right.
It gives volume to the ties and
folds of the kimono.

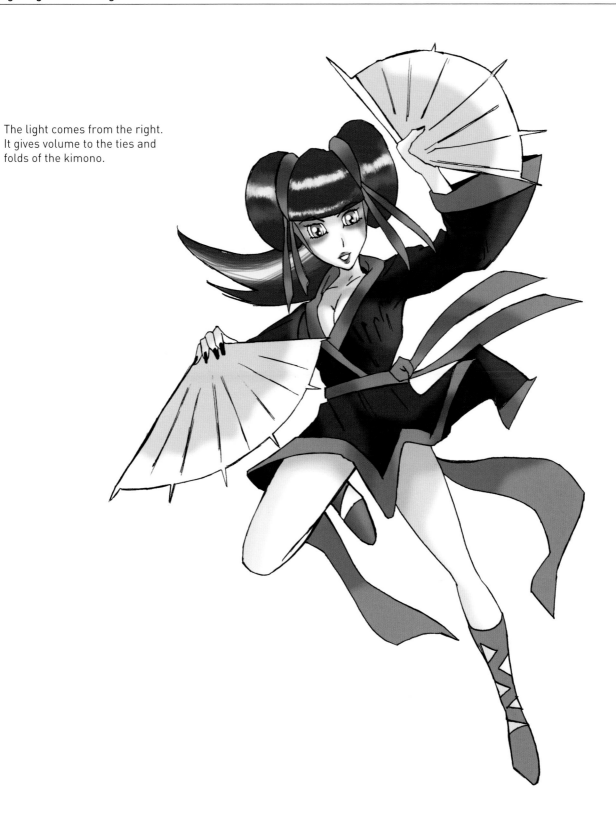

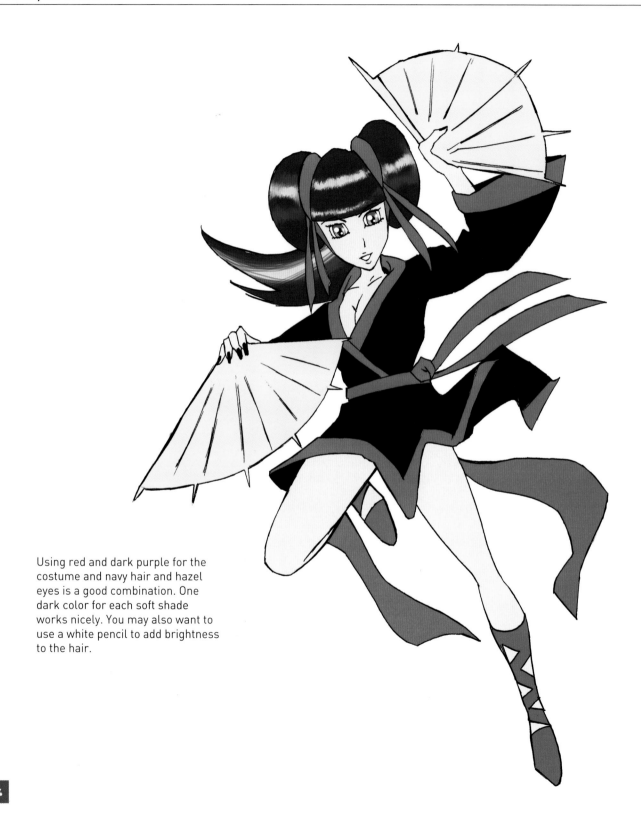

Using red and dark purple for the costume and navy hair and hazel eyes is a good combination. One dark color for each soft shade works nicely. You may also want to use a white pencil to add brightness to the hair.

I've decorated the fans with letters. The letters on the left combine to mean "Dance;" the ones on the right mean "Deadly." Use a purple pencil for the shapes of the kimono, and a dark shade of red on the ribbons. To finish, I've added a "bad girl" emblem on the character's chest, as well as a dragon tattoo on her leg.

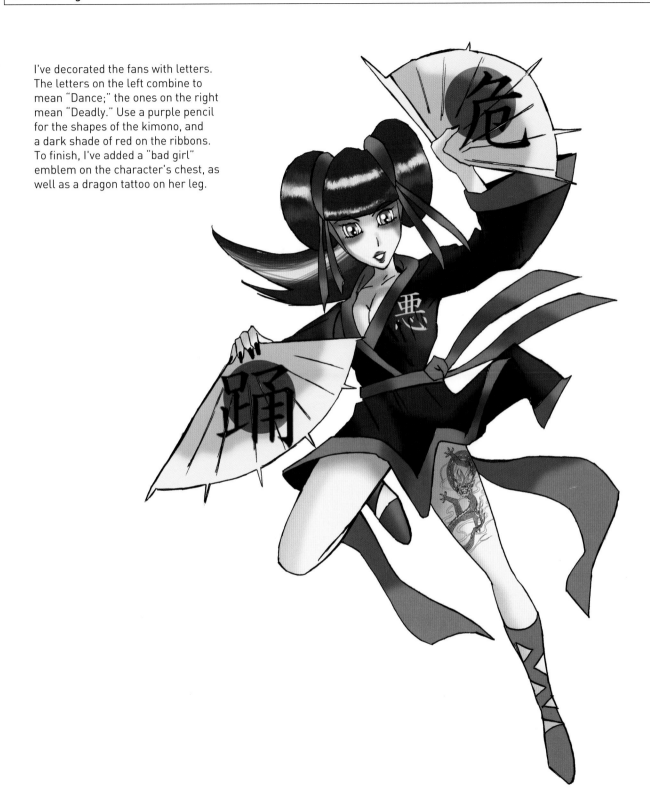

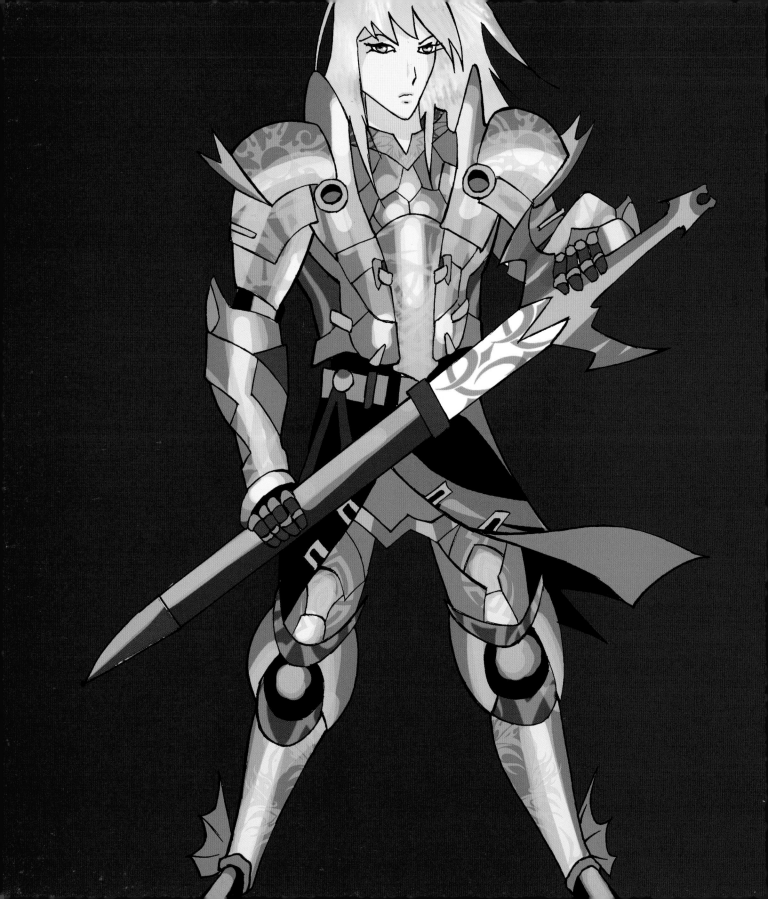

FANTASY

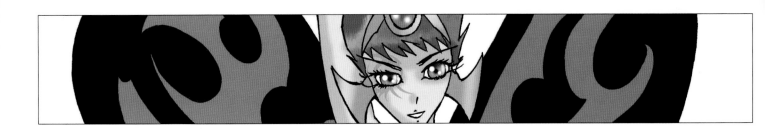

GOTHIC FAIRY

Avy Lynd is a fairy of the enchanted forest, pollen collector, and great expert in magic potions. She is always wandering through the forest in search of adventure, and helping travelers.

Draw the outline of the design in
blue pencil. The image is of a forest
fairy on a flower.

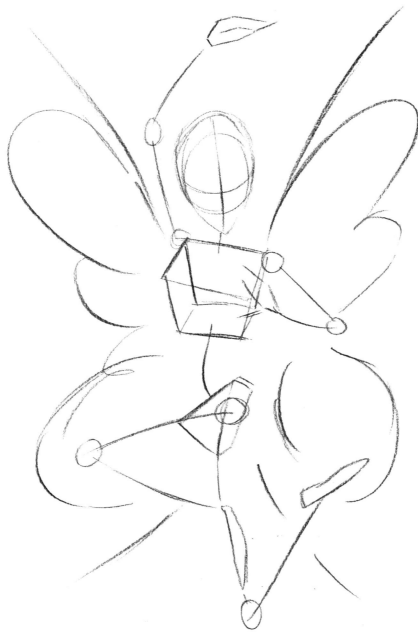

With a soft 2H pencil, shape the contours of the figure and make sure it fits the skeleton. It is a complicated figure, so work slowly and carefully.

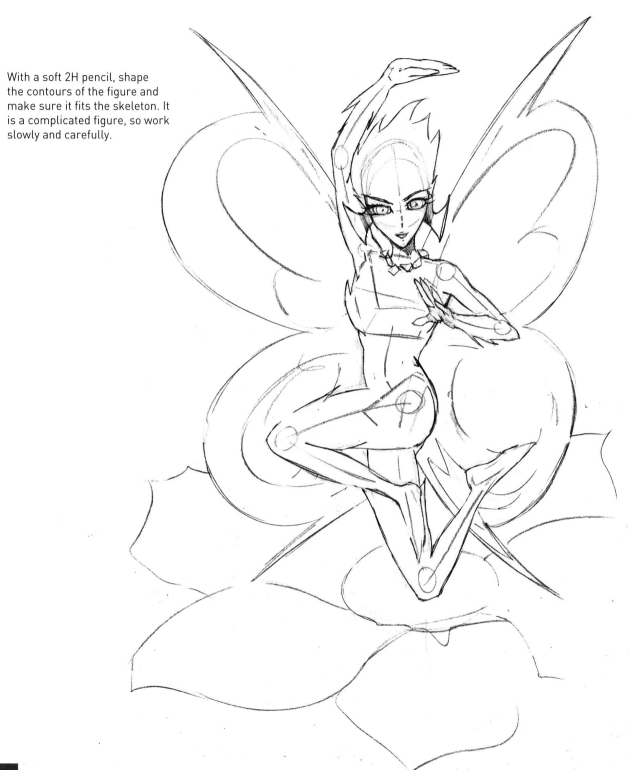

Using a 05B fine tip pencil, draw as cleanly as possible. This design will have large areas of black and needs to be well-defined.

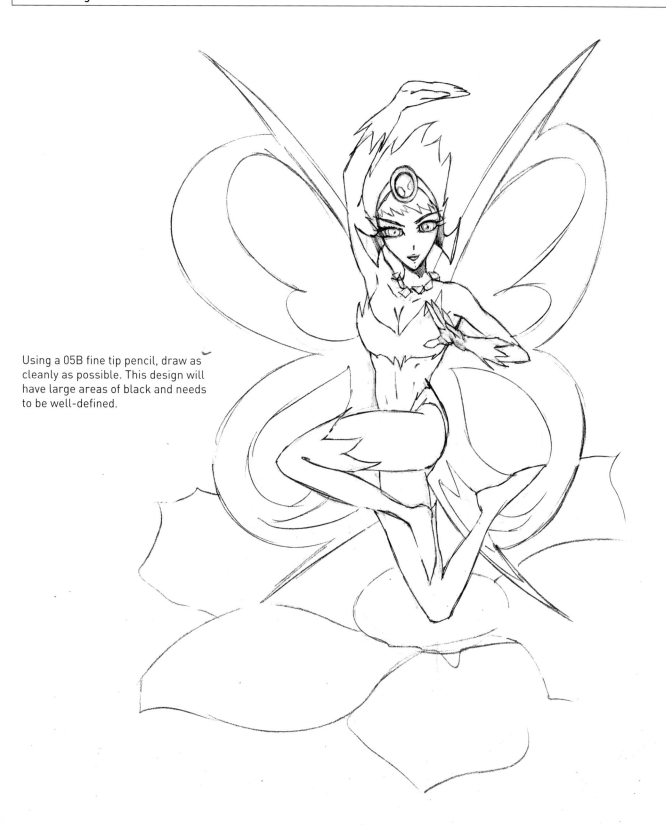

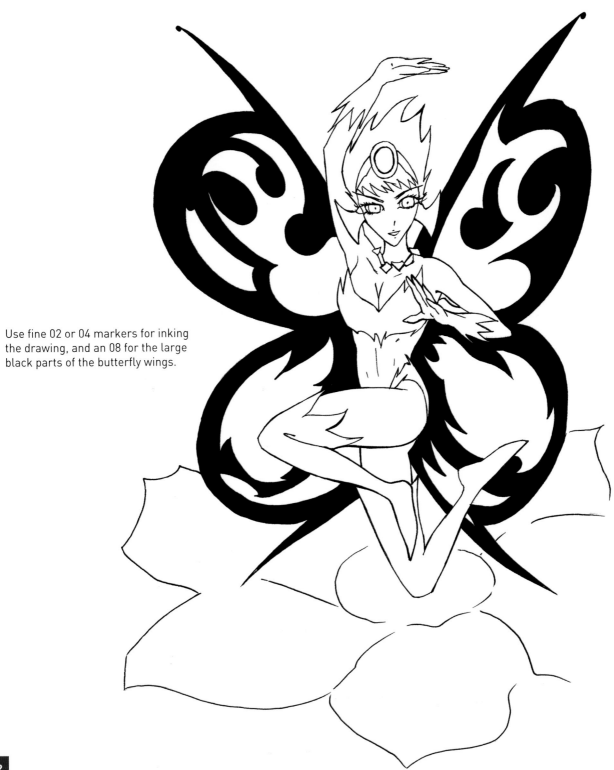

Use fine 02 or 04 markers for inking the drawing, and an 08 for the large black parts of the butterfly wings.

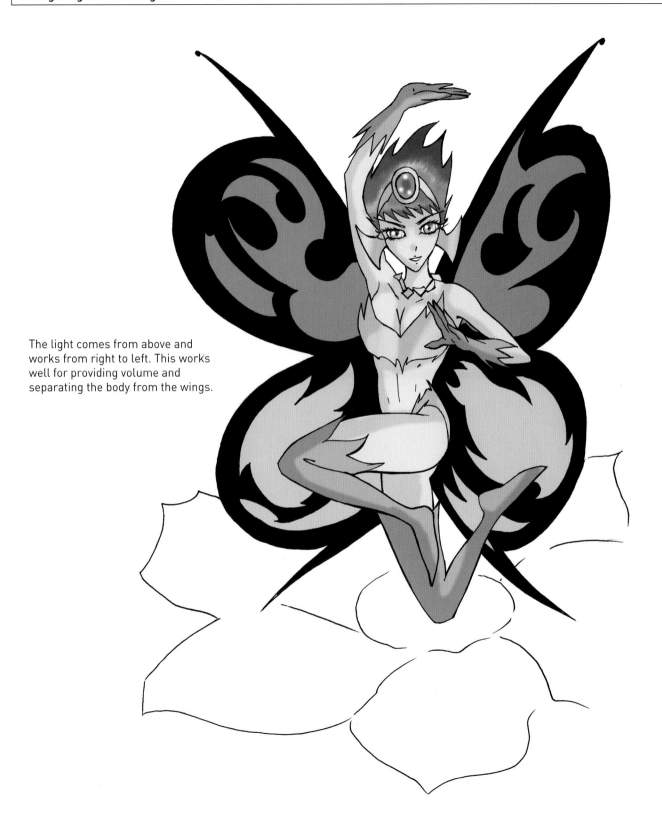

The light comes from above and works from right to left. This works well for providing volume and separating the body from the wings.

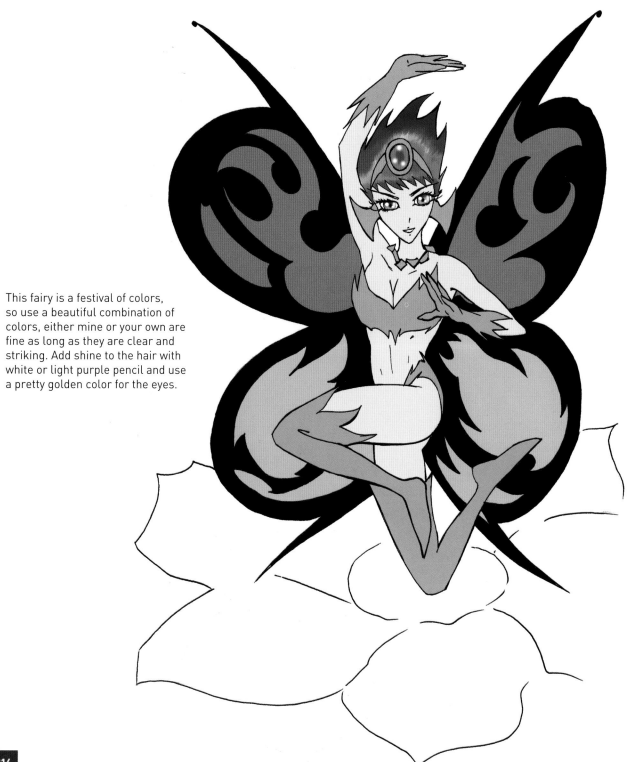

This fairy is a festival of colors, so use a beautiful combination of colors, either mine or your own are fine as long as they are clear and striking. Add shine to the hair with white or light purple pencil and use a pretty golden color for the eyes.

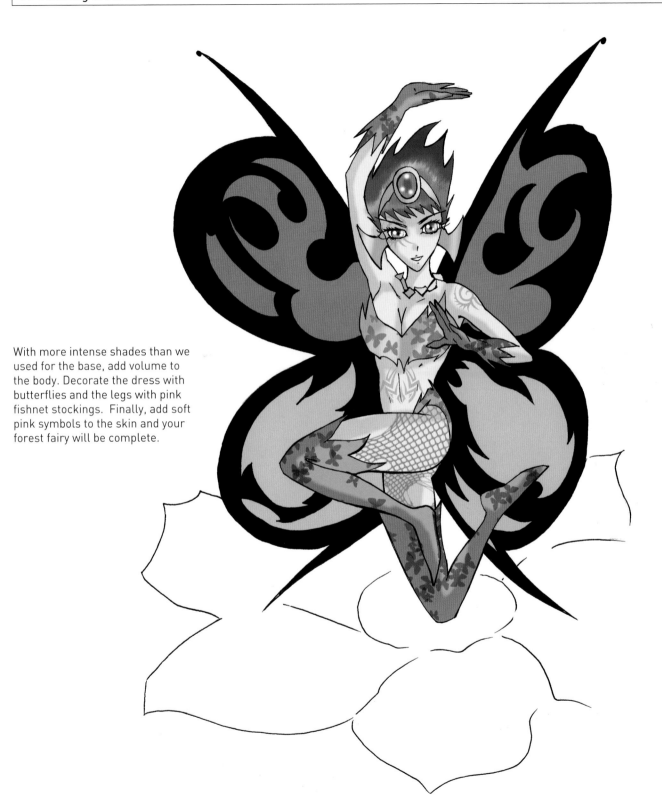

With more intense shades than we used for the base, add volume to the body. Decorate the dress with butterflies and the legs with pink fishnet stockings. Finally, add soft pink symbols to the skin and your forest fairy will be complete.

GOTHIC ANGEL

Heaven is a gothic angel who serves the Lord of Light in the realms of heaven. Her powerful black wings allow her to be an amazing acrobat. She is also a protector of good and justice, and is always on the side of the weakest creatures in their fight against evil.

1. Outlining

Draw the outline of the skeleton
in blue and then add her wings.
Be careful when you design their
proportion and size.

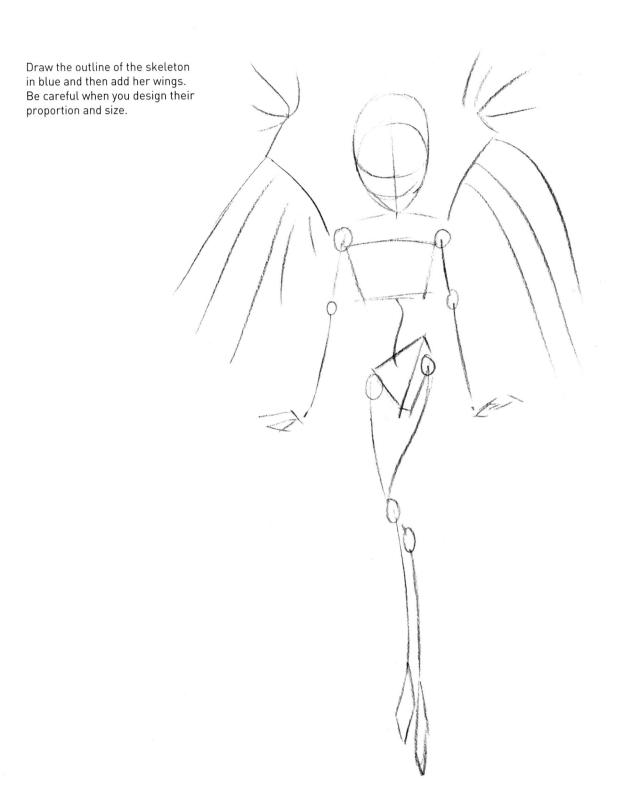

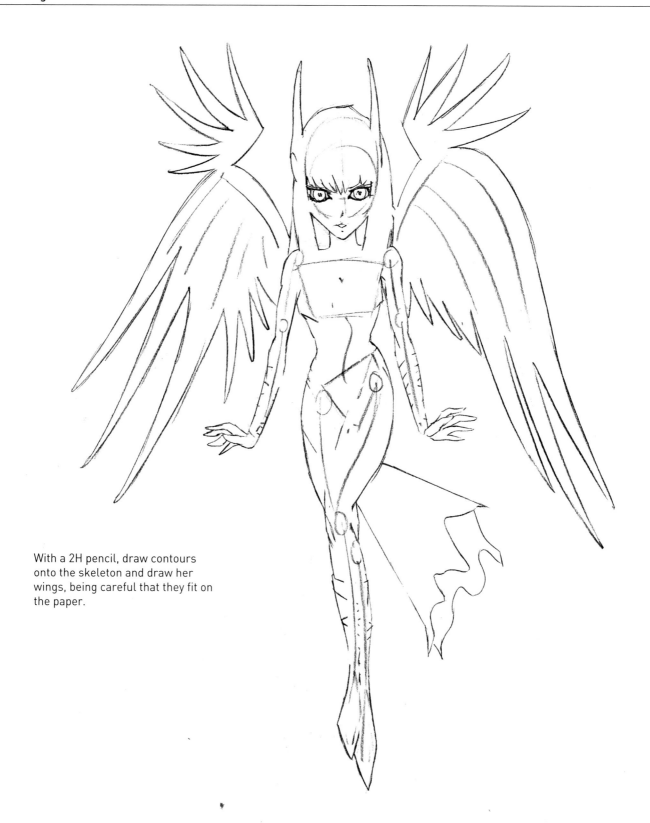

With a 2H pencil, draw contours
onto the skeleton and draw her
wings, being careful that they fit on
the paper.

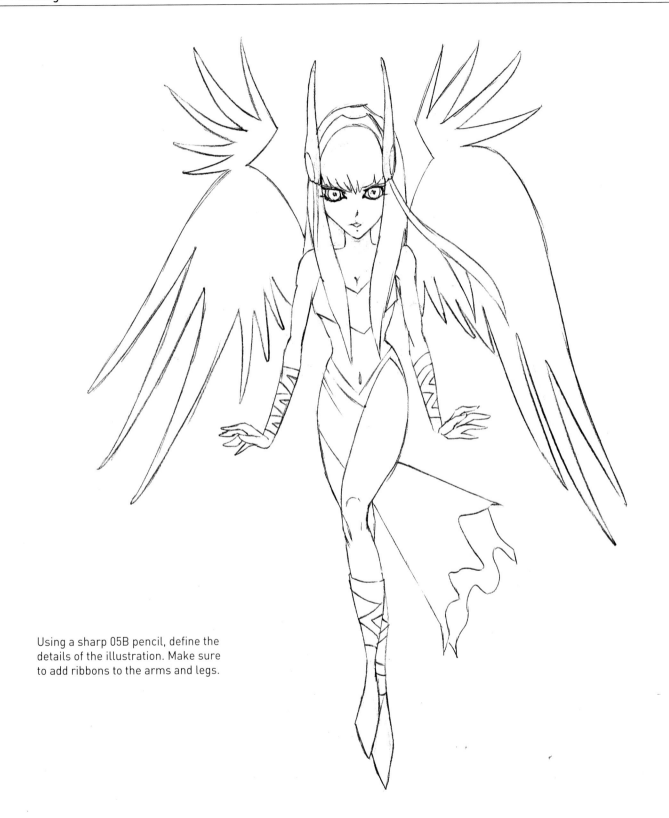

Using a sharp 05B pencil, define the
details of the illustration. Make sure
to add ribbons to the arms and legs.

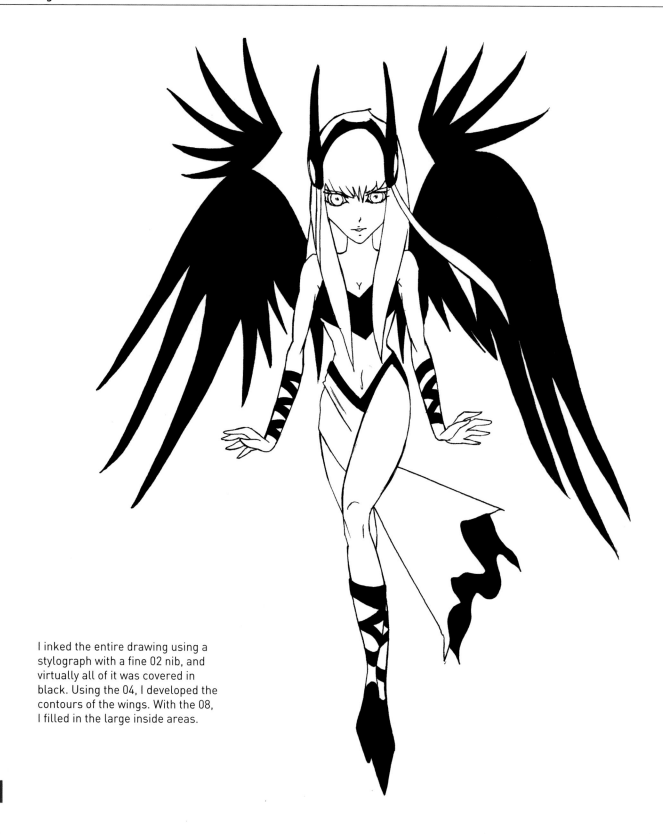

I inked the entire drawing using a
stylograph with a fine 02 nib, and
virtually all of it was covered in
black. Using the 04, I developed the
contours of the wings. With the 08,
I filled in the large inside areas.

The light comes from above. This adds volume to the chest and body, and to the leg that is raised.

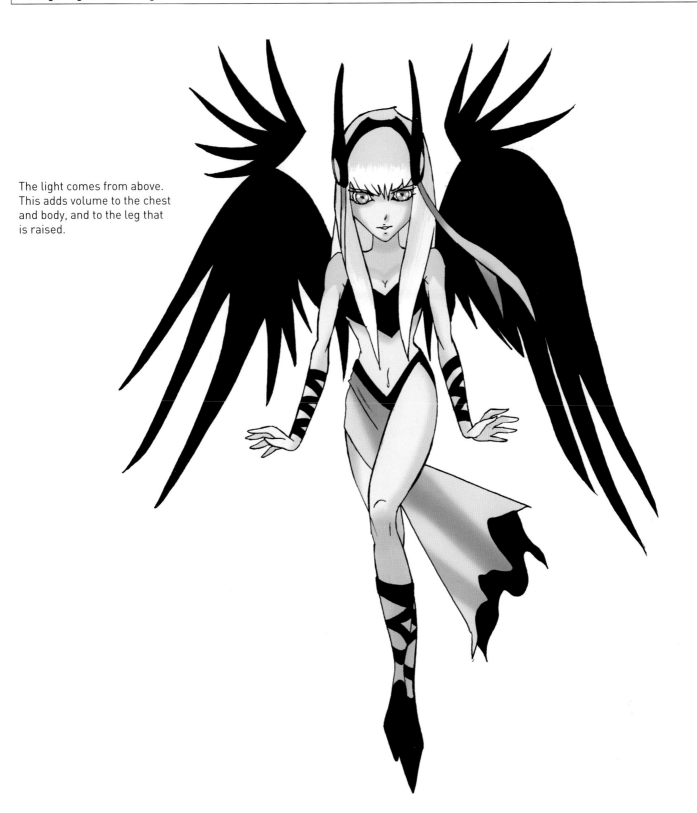

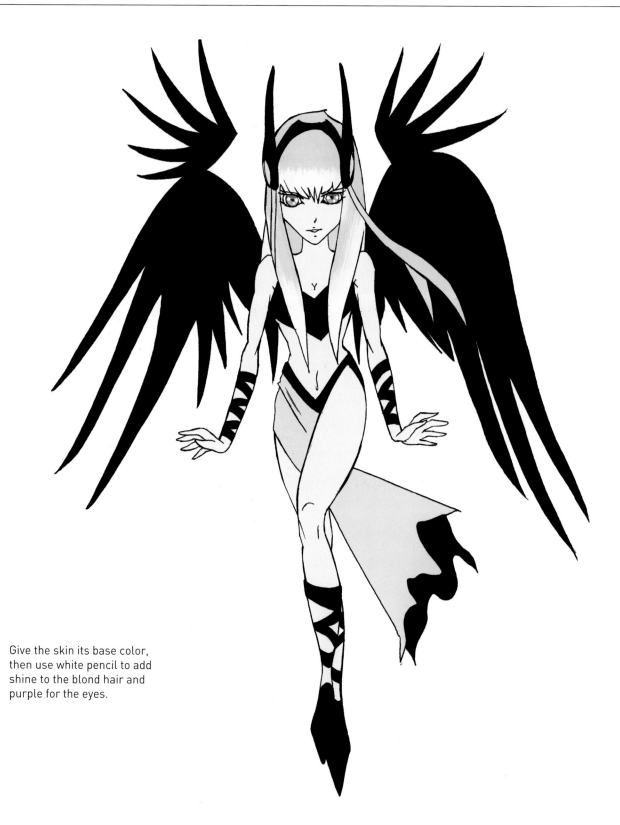

Give the skin its base color, then use white pencil to add shine to the blond hair and purple for the eyes.

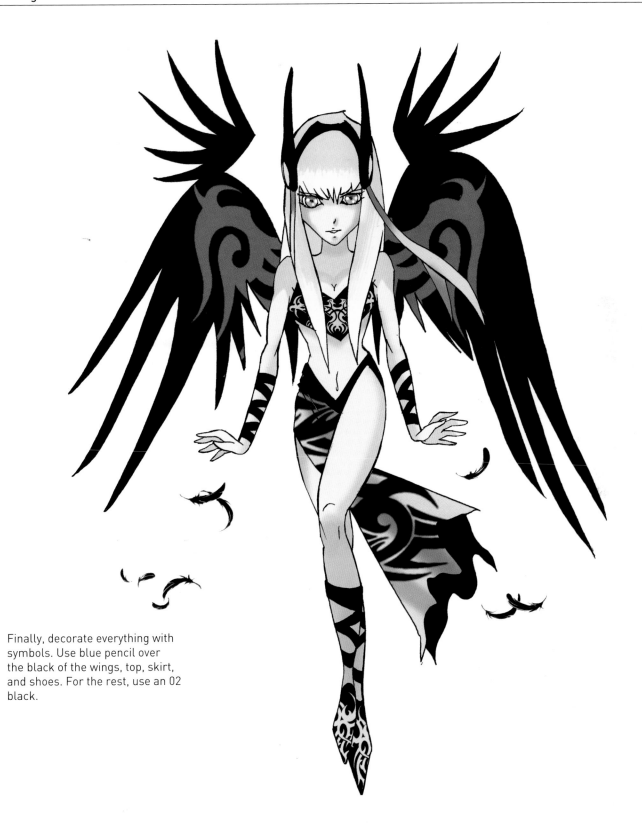

Finally, decorate everything with symbols. Use blue pencil over the black of the wings, top, skirt, and shoes. For the rest, use an 02 black.

GOTHIC KING

King Darkel Arkay is the most powerful king in the eastern lands. After the wars with the beings known as Wakrams, he restored peace and safety to his kingdom. He is a great warrior with un-paralleled courage and strength. He and his magic sword are un-rivalled in combat.

Draw the king using a blue pencil.
Give him a stately pose.

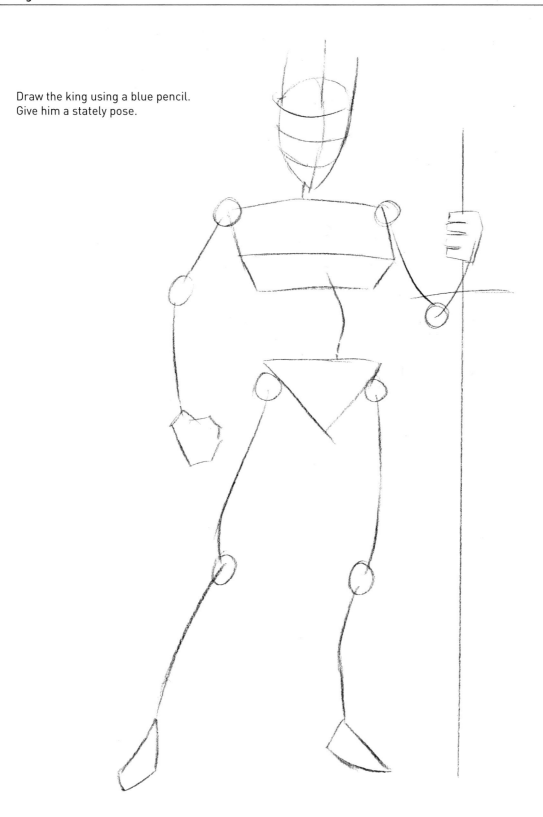

With a soft 2H pencil, draw the silhouette of the king, making sure that it fits well with the skeleton.

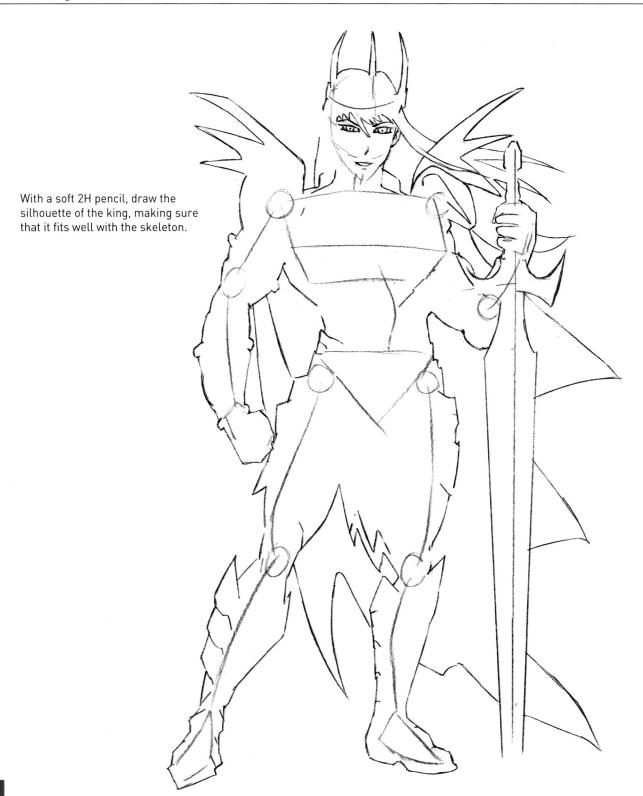

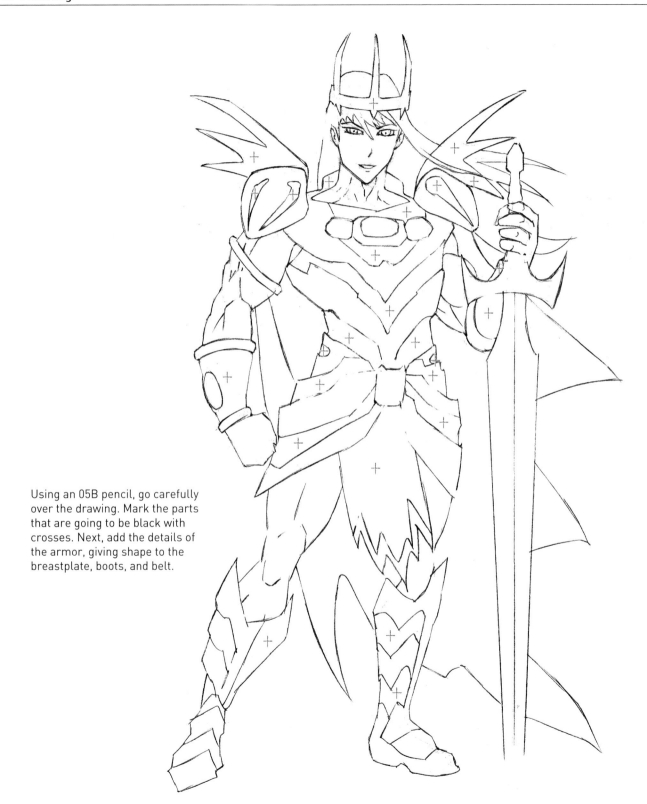

Using an 05B pencil, go carefully over the drawing. Mark the parts that are going to be black with crosses. Next, add the details of the armor, giving shape to the breastplate, boots, and belt.

Use a stylograph or 02 fine tip pen for the entire drawing. With an 04, highlight the contours of the sword. Use the 08 to fill in the black areas of the armor and crown.

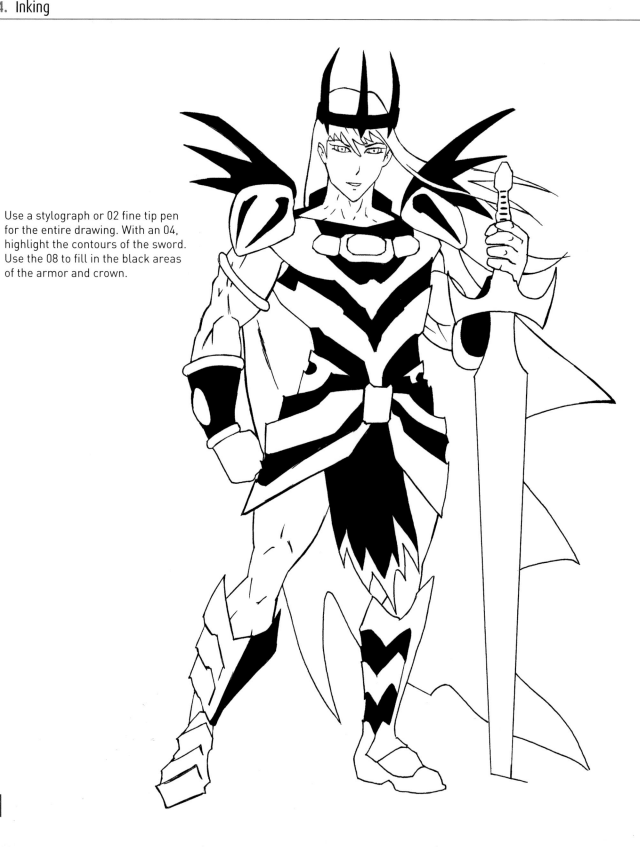

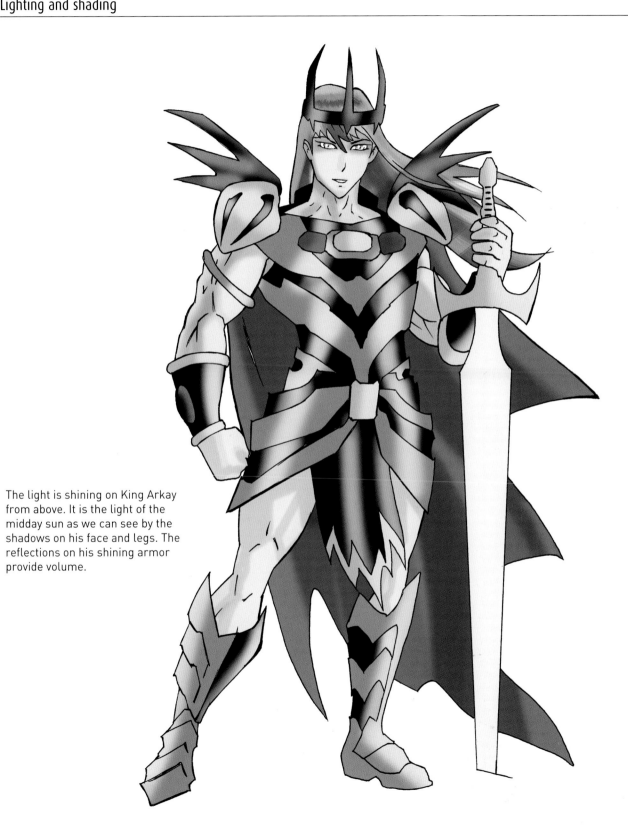

The light is shining on King Arkay from above. It is the light of the midday sun as we can see by the shadows on his face and legs. The reflections on his shining armor provide volume.

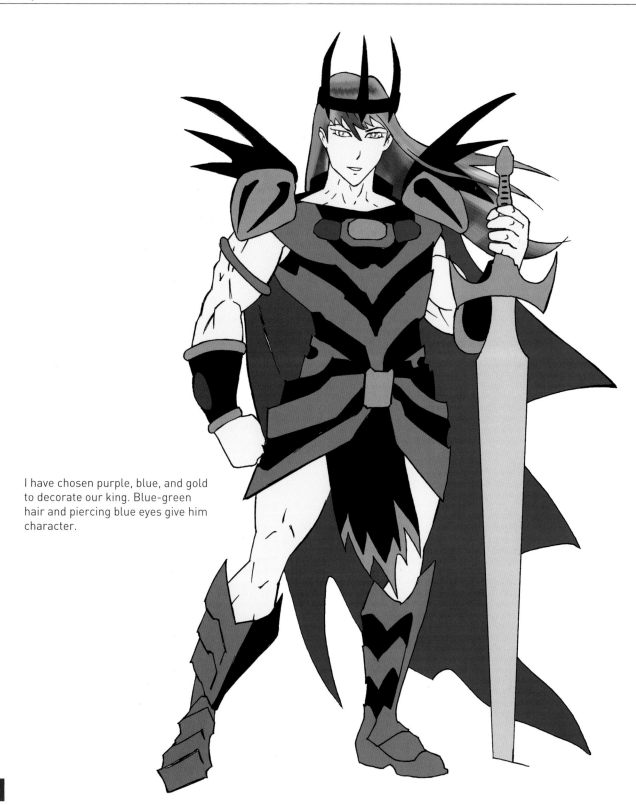

I have chosen purple, blue, and gold to decorate our king. Blue-green hair and piercing blue eyes give him character.

Add brilliance to the black with colored pencils, and volume with darker shades. Embellish the character with a tattoo on his arm and give him a magic sword. You could also add magical symbols.

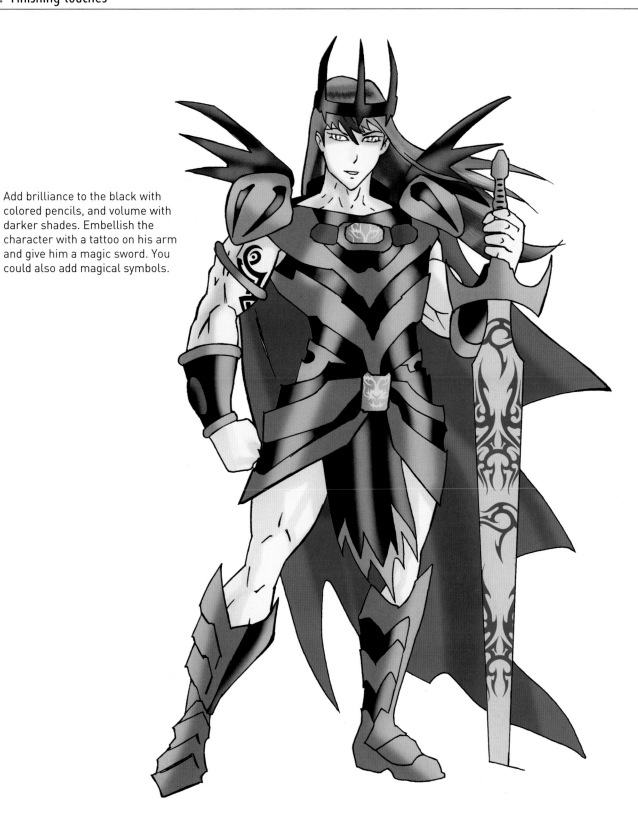

GOTHIC QUEEN

Naishai Lena Qur is the Queen of the West. No one has ever seen a queen as beautiful as her. A great warrior and dragon sorceress, she helps King Arkay in his fight against the Wakrams. Her glass throne, created by elves, was a gift from the King to thank her for her help.

In blue, draw the outline or skeleton
of the queen sitting on her throne.

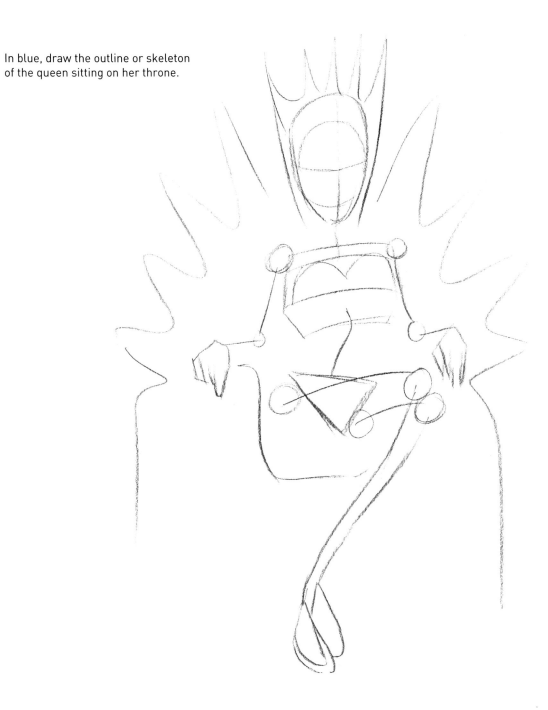

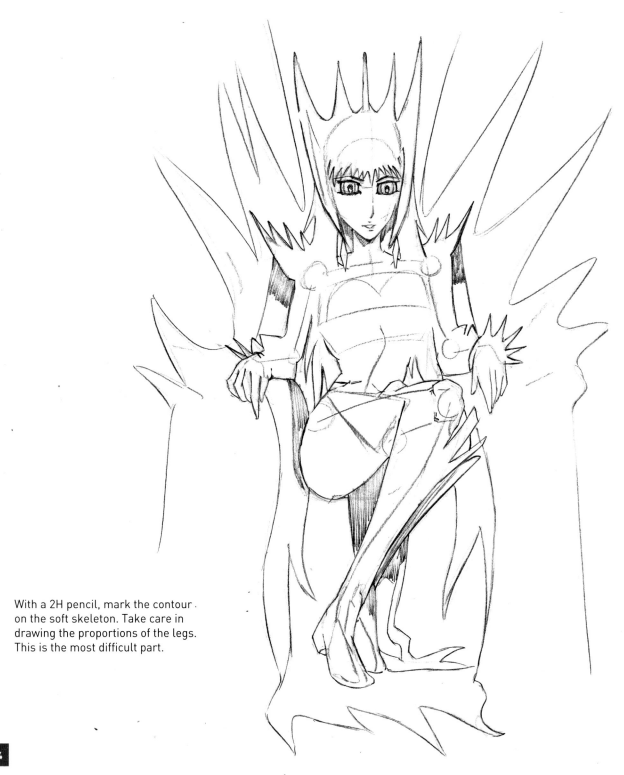

With a 2H pencil, mark the contour on the soft skeleton. Take care in drawing the proportions of the legs. This is the most difficult part.

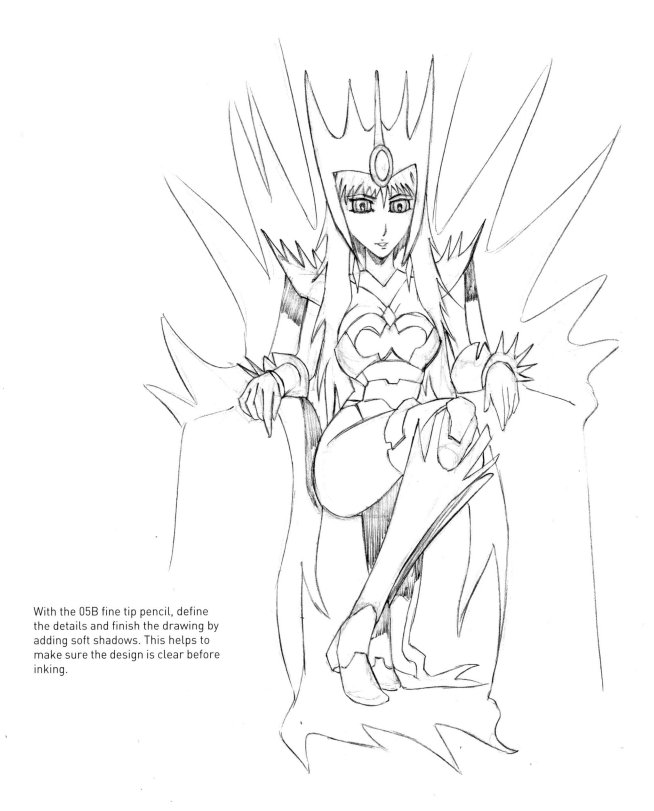

With the 05B fine tip pencil, define the details and finish the drawing by adding soft shadows. This helps to make sure the design is clear before inking.

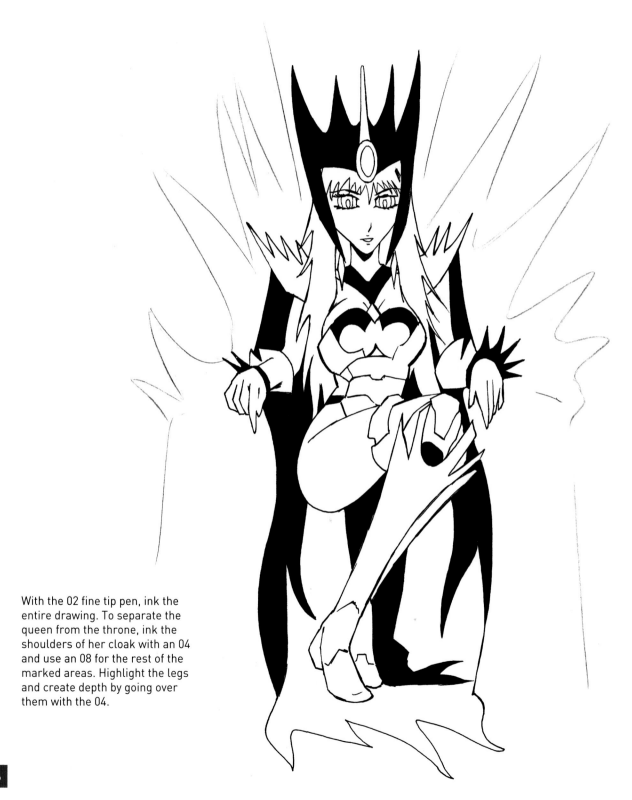

With the 02 fine tip pen, ink the entire drawing. To separate the queen from the throne, ink the shoulders of her cloak with an 04 and use an 08 for the rest of the marked areas. Highlight the legs and create depth by going over them with the 04.

The light comes from above and shines directly onto the character. Imagine that the queen has a large glass window in the roof of her palace and that the throne is beneath it.

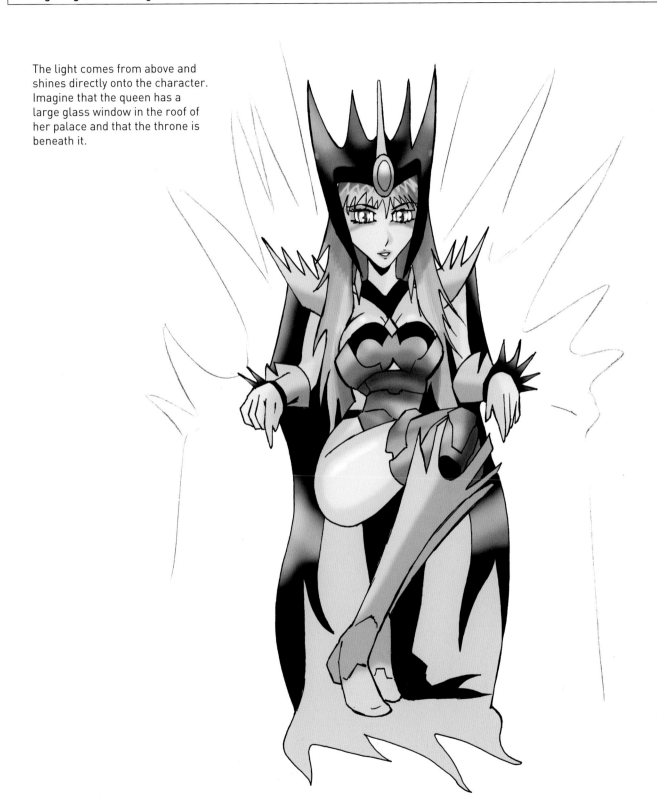

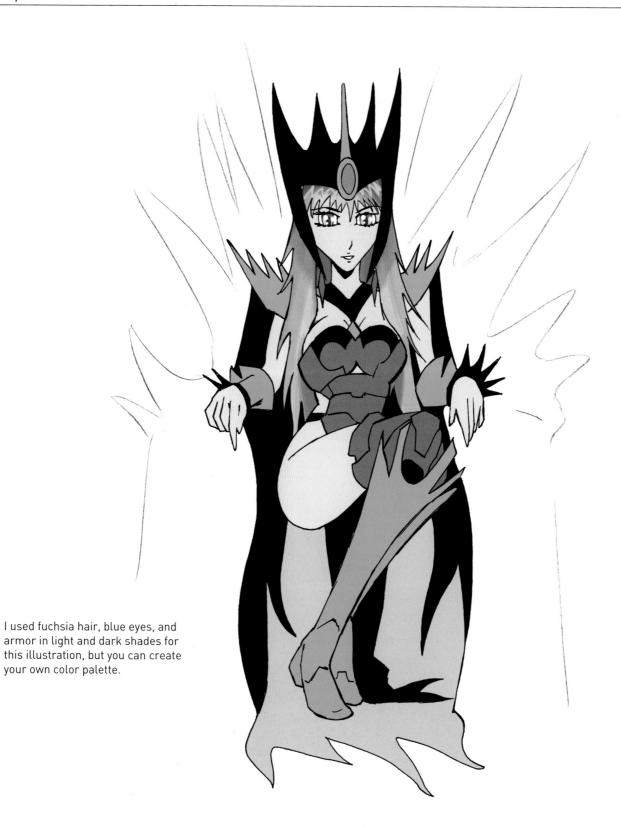

I used fuchsia hair, blue eyes, and armor in light and dark shades for this illustration, but you can create your own color palette.

With colored pencils, add shine to the black areas of the cloak, and to the scales of the queen's boots, bracelets, and shoulder pads. A few purple lines add a dark, gothic touch under her eyes. Finish with a few designs on her cloak and armor, and go over the silhouette of the throne in blue pencil.

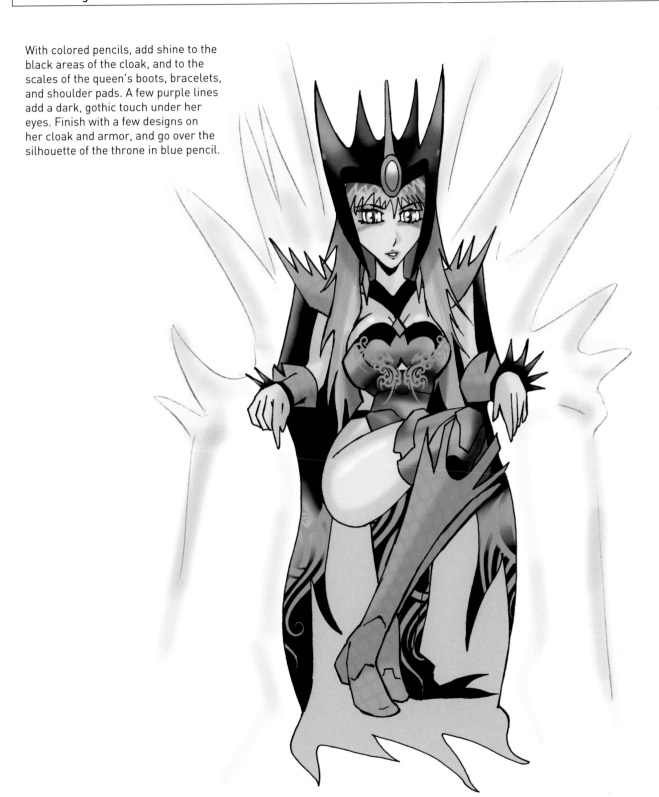

GOTHIC WARRIOR BOY

This is Azazel Calautir, the great dragon hunter. They say that in his adventures in the land of blue fire, he emerged victorious from every battle without a scratch on him. They also say that he is a sword master and that his armor of scales is impenetrable.

1. Outlining

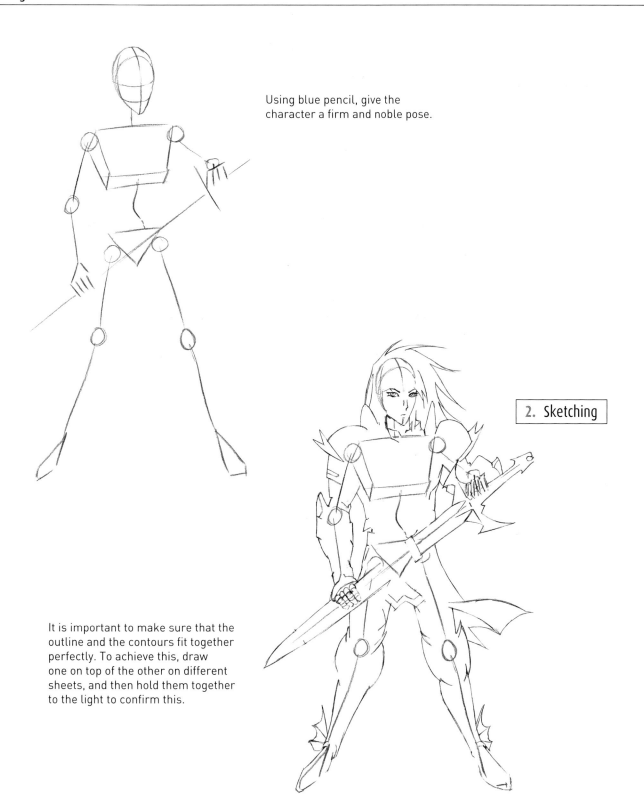

Using blue pencil, give the character a firm and noble pose.

2. Sketching

It is important to make sure that the outline and the contours fit together perfectly. To achieve this, draw one on top of the other on different sheets, and then hold them together to the light to confirm this.

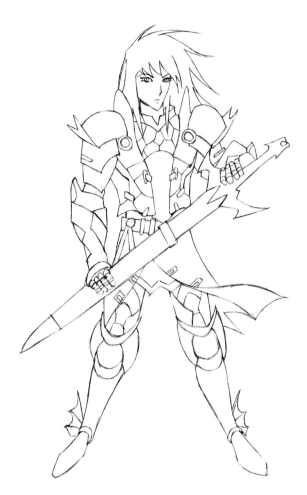

Draw the dragon hunter's figure with an 05B mechanical pencil or, if you find it easier, use a softer 2H pencil and then go over it with an 05B. Draw all the details of the armor, remembering that the better the pencil work, the better the inking will be.

4. Inking

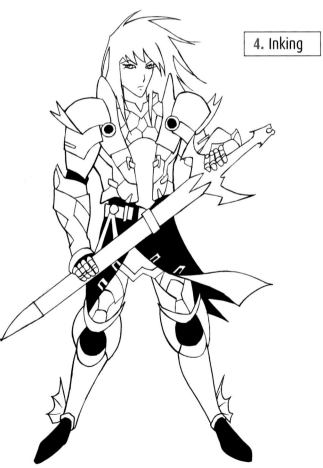

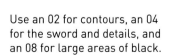
Use an 02 for contours, an 04 for the sword and details, and an 08 for large areas of black.

A direct light focuses on our character, making all the details of his armor visible and adding volume to the costume.

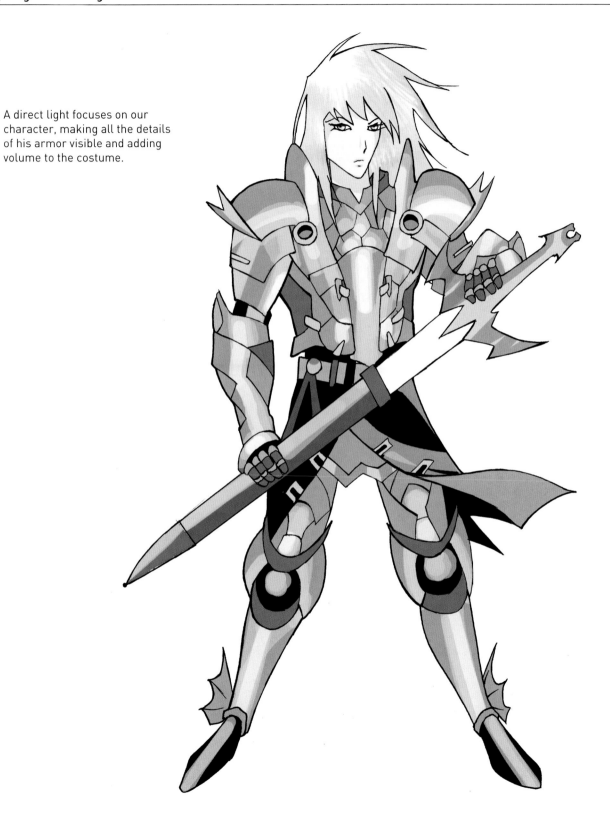

Introduce the base color shades: this time predominantly black, but with the addition of blue and metallic gray accents. The hair is blue with glimmers of white and his eyes are yellow.

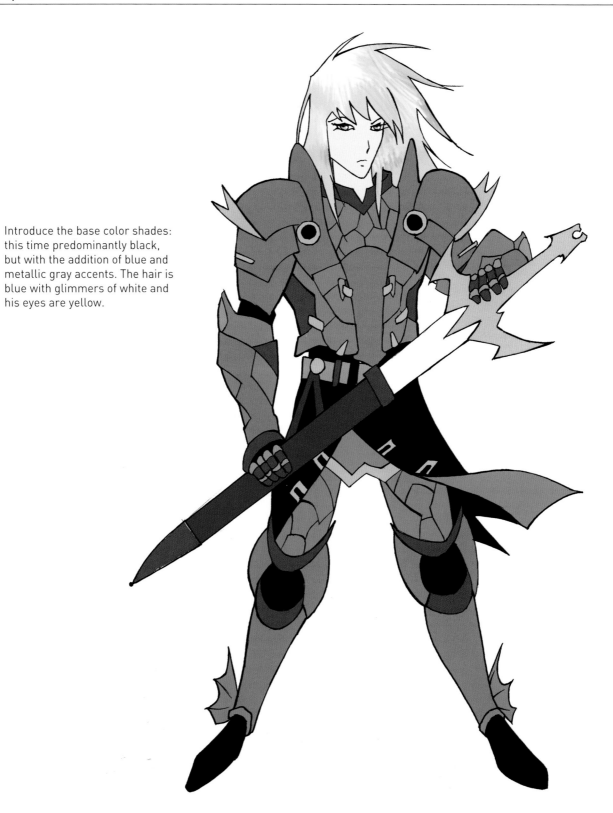

Azazel has his armor and sword covered with magical symbols to protect him. Add volume with a colored pencil and a shine to all the fastenings on the armor and his boots. To finish, illuminate the symbols with soft shades of yellow or gold.

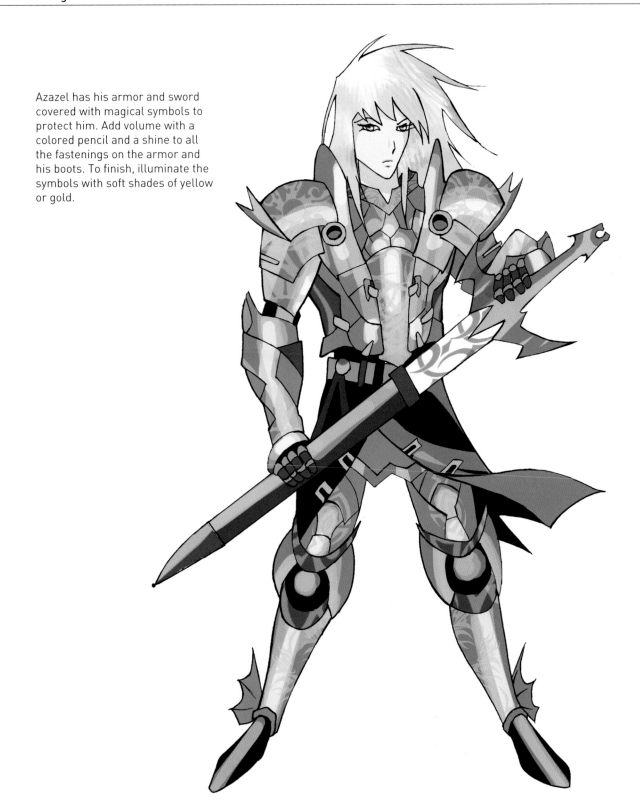

GOTHIC WARRIOR GIRL

Ava Lord is chief of the Iron Amazons and protector of the ruby doors of the kingdom of Targanor. Some time ago the dragons launched attacks at night to try and steal the rubies. The word has now spread that they are going to attempt this again, and she will need to prevent it.

1. Outlining

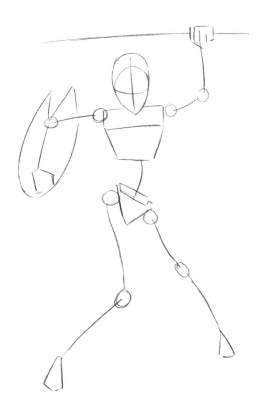

Draw a combat attack pose for the warrior in blue pencil, and mark out the sword and shield.

2. Sketching

With a soft 2H pencil, shape the contours of the figure and make sure they fit the skeleton.

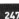

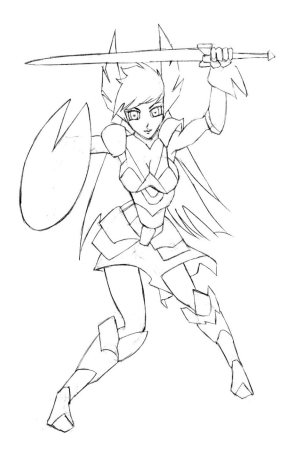

Use a sharp 05B pencil for the whole drawing. You can use a 2H for the details and then go over them with the B.

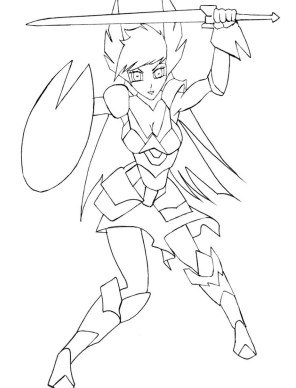

Use 02 markers for the entire drawing. Highlight the details with an 04 marker.

248

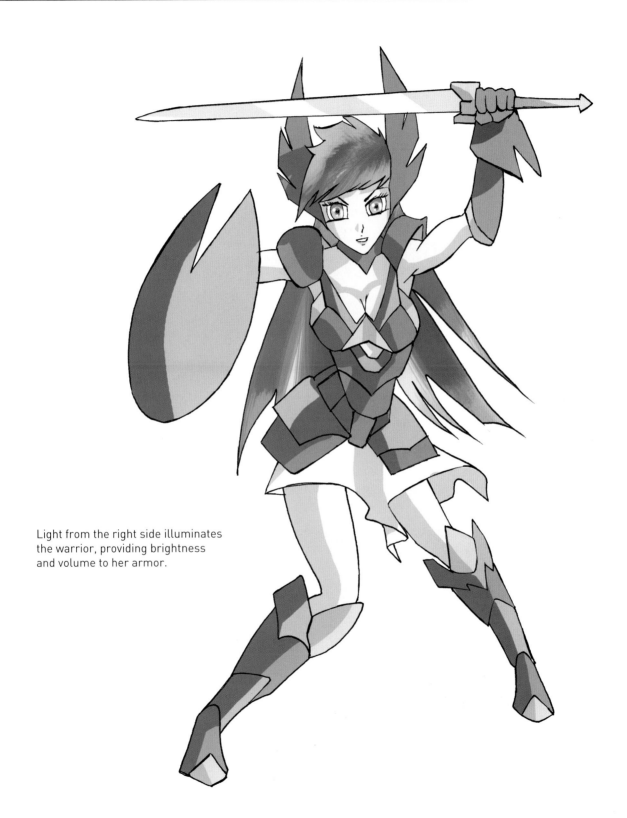

Light from the right side illuminates
the warrior, providing brightness
and volume to her armor.

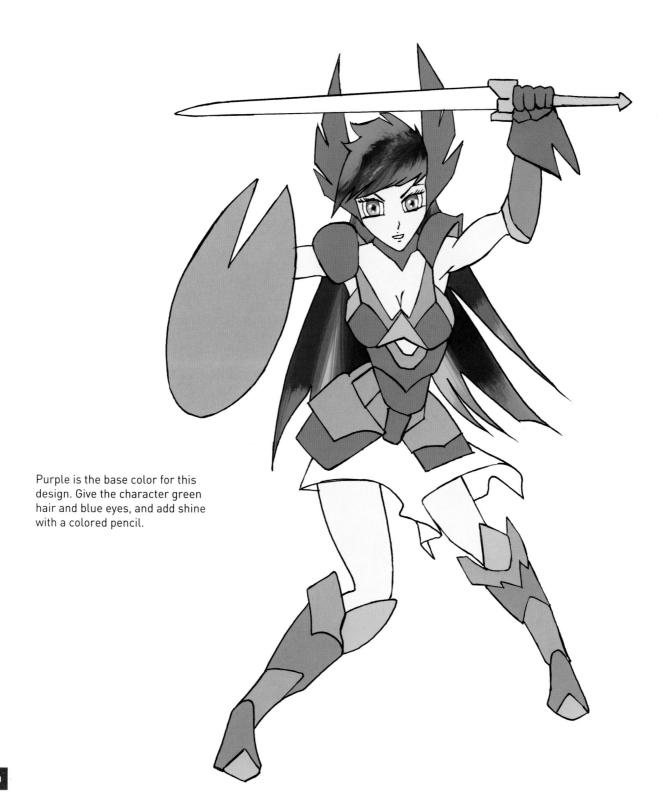

Purple is the base color for this design. Give the character green hair and blue eyes, and add shine with a colored pencil.

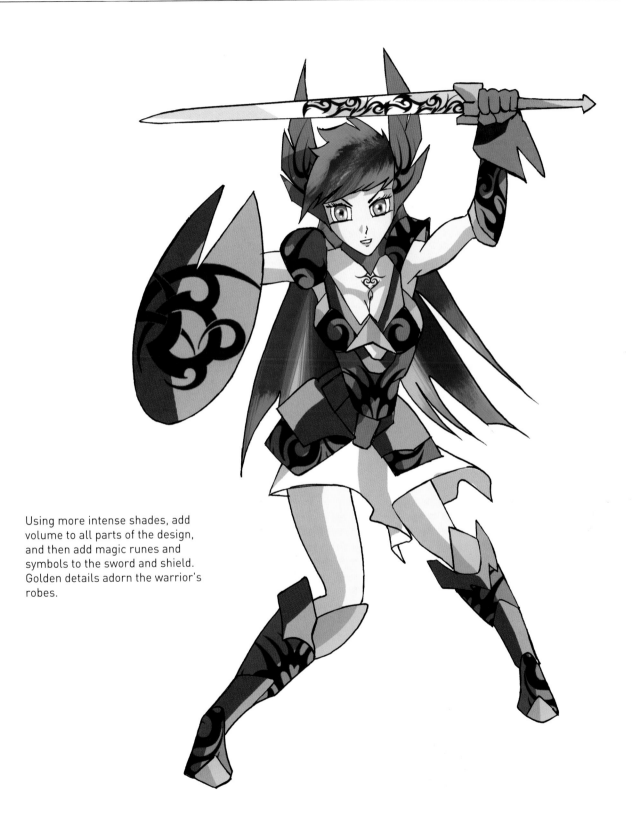

Using more intense shades, add volume to all parts of the design, and then add magic runes and symbols to the sword and shield. Golden details adorn the warrior's robes.

GOTHIC PRINCESS

Arya is a gothic princess of the Blue Mountain Kingdom. It is located in a very cold country, which has a huge expanse of ice, but there is warmth inside its mountains where her home is. Arya dreams of great adventures beyond the Sea of Ice, travelling with her friends on the back of her faithful polar bear, Grumt.

Draw the outline of the design
with a blue pencil.

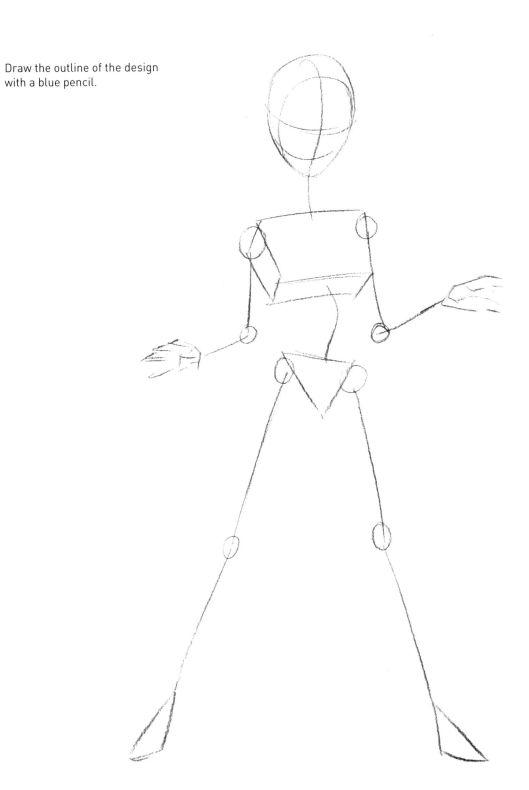

Use a soft 2H pencil to shape the contours of the figure, making sure they fit the skeleton. To practice, you can draw layers separately and hold them near a light to ensure they fit together.

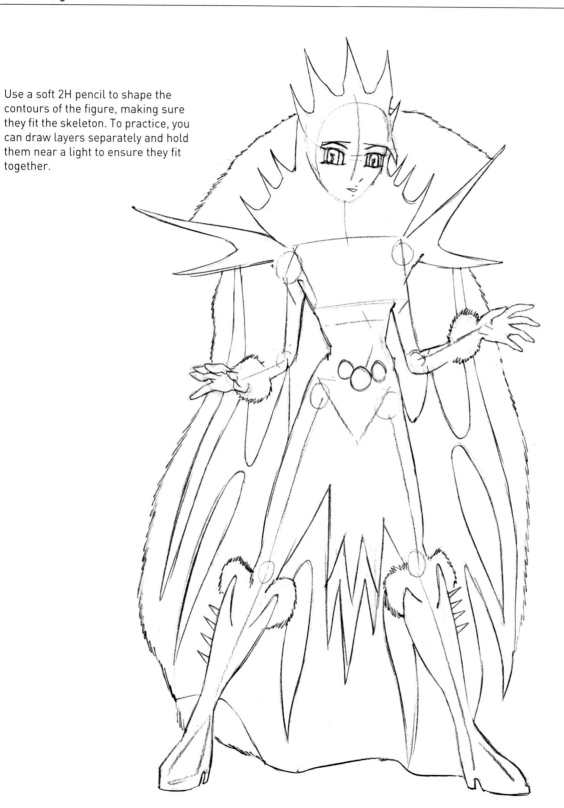

With a 05B fine tip pencil, draw the image as cleanly as possible. This design will have large areas in black and needs to be well-defined.

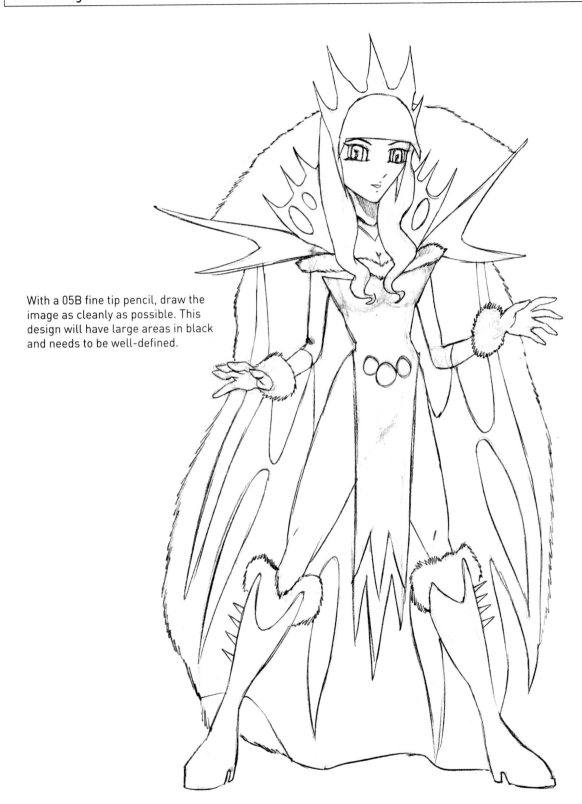

Use 02 and 04 markers for inking
the drawing, and an 08 for the large
areas of the costume that will be
filled in black.

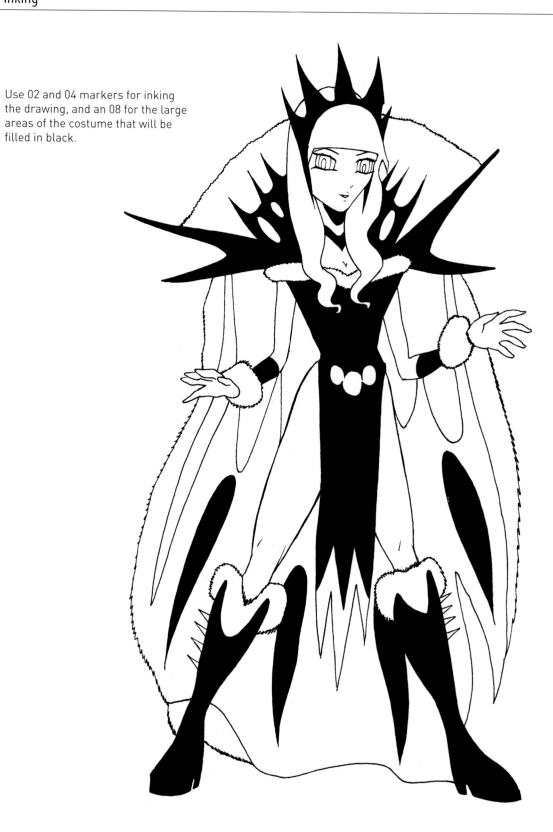

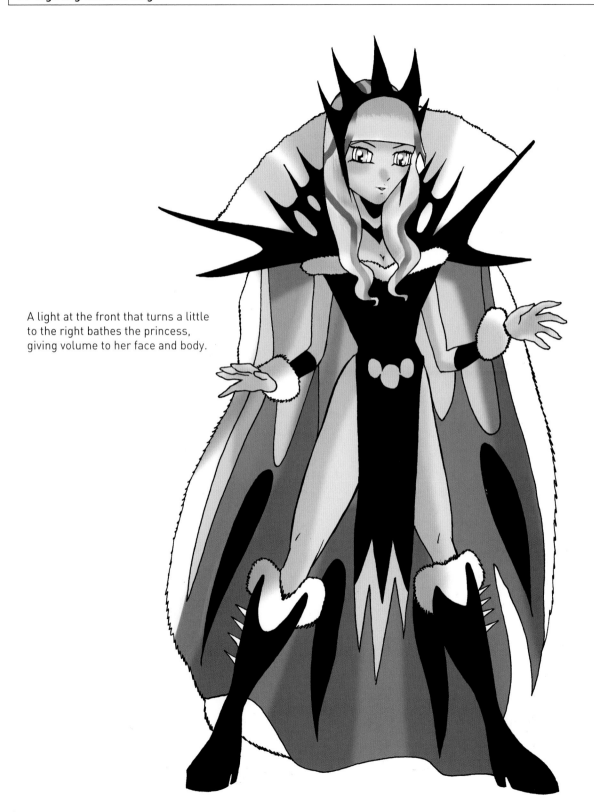

A light at the front that turns a little to the right bathes the princess, giving volume to her face and body.

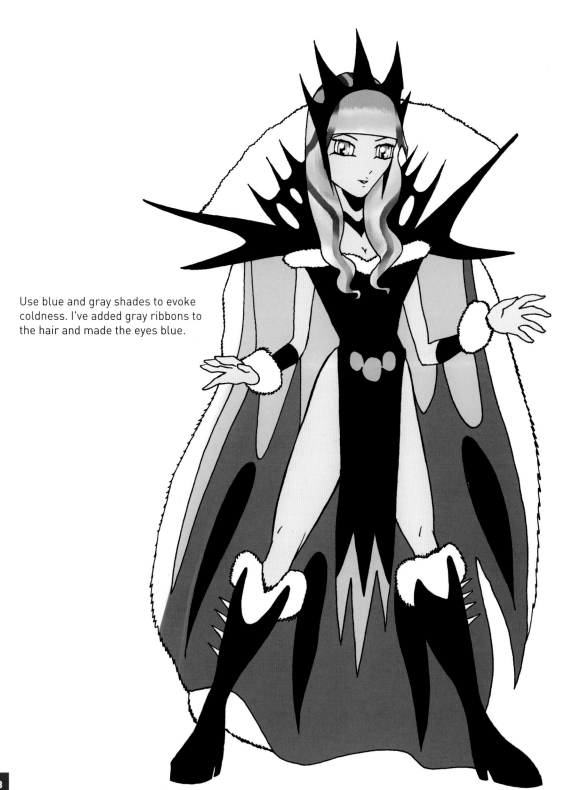

Use blue and gray shades to evoke coldness. I've added gray ribbons to the hair and made the eyes blue.

To finish the design, paint blotches on the princess' cloak, wristbands, and boots for a fur effect. Next, decorate her costume with tribal designs in white pencil.

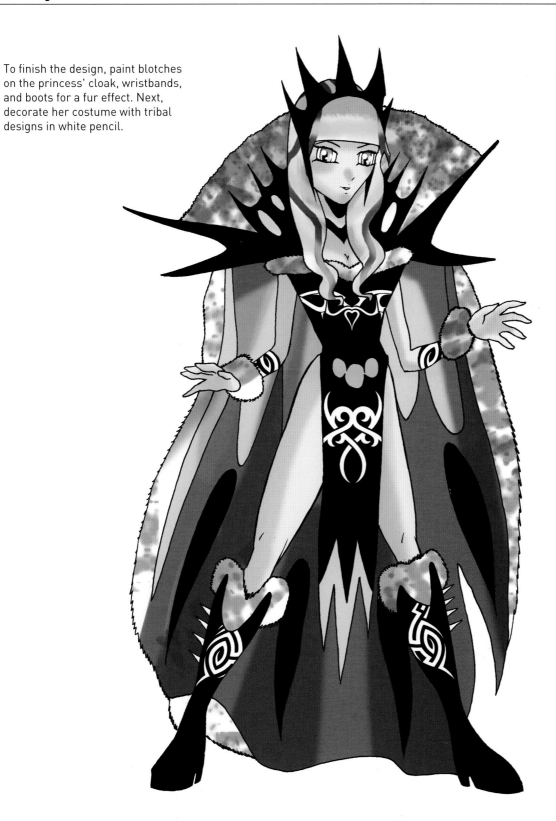

GOTHIC SPACE QUEEN

Xiara Sky-Hand is a warrior, buccaneer, and space pirate. She was snatched from her kingdom when she was a little girl. Her warriors serve her as their gothic queen and will fight alongside her to recover the kingdom that rightfully belongs to her.

Using blue pencil, prepare the outline with a cool pose. Think of the character as being in a ship's portal, sliding aboard a starship.

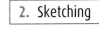

Use a 2H pencil for the contour lines to define the figure and its silhouette.

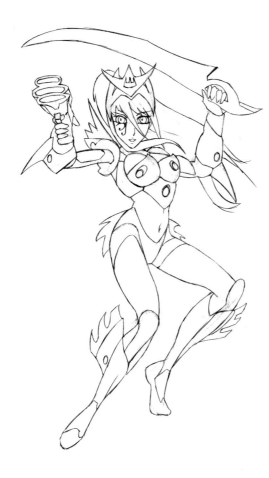

With an 05B pencil go over the entire drawing, taking care to make it as clean as possible.

4. Inking

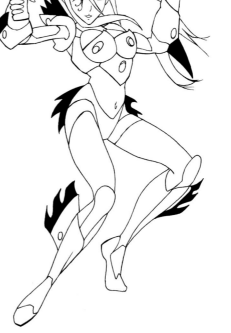

Ink the entire drawing with the 02 marker. Go over the outline of the gun with an 04 and fill areas of black with the 08. Be careful not to go outside the lines.

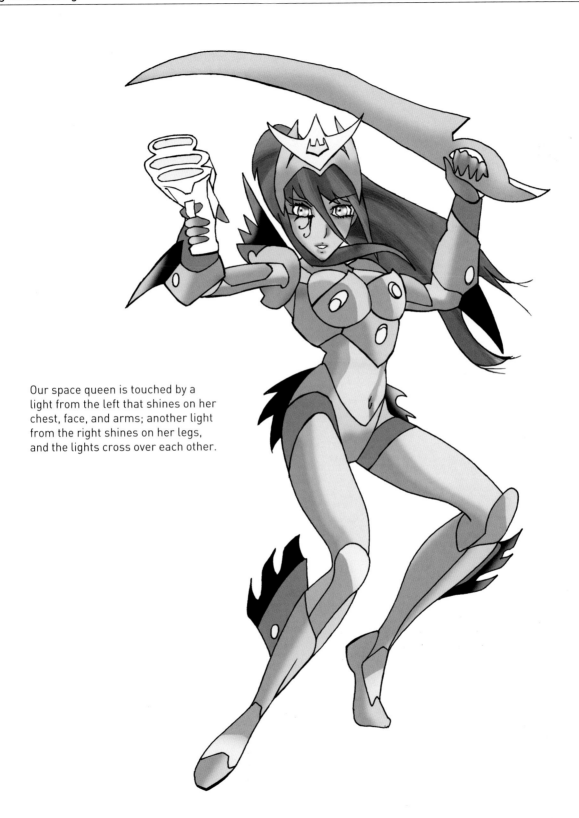

Our space queen is touched by a light from the left that shines on her chest, face, and arms; another light from the right shines on her legs, and the lights cross over each other.

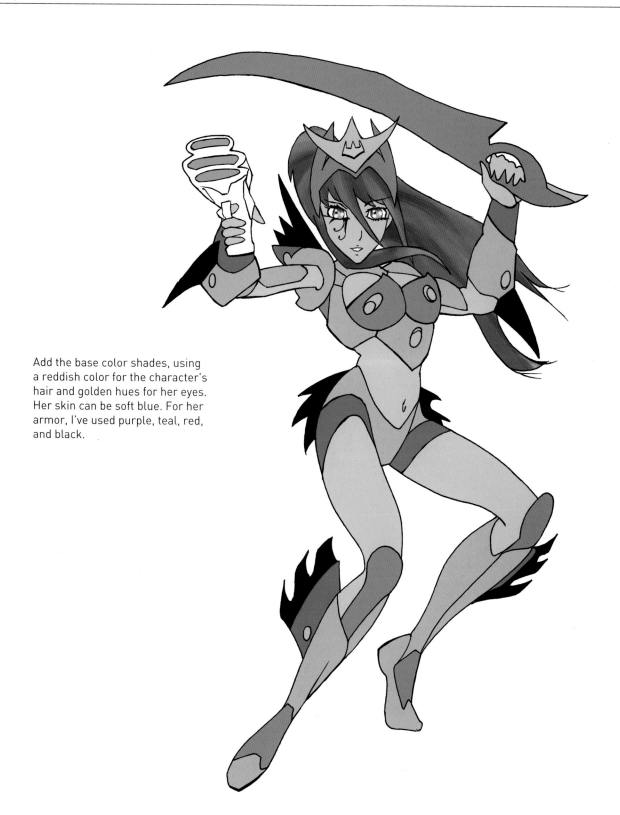

Add the base color shades, using a reddish color for the character's hair and golden hues for her eyes. Her skin can be soft blue. For her armor, I've used purple, teal, red, and black.

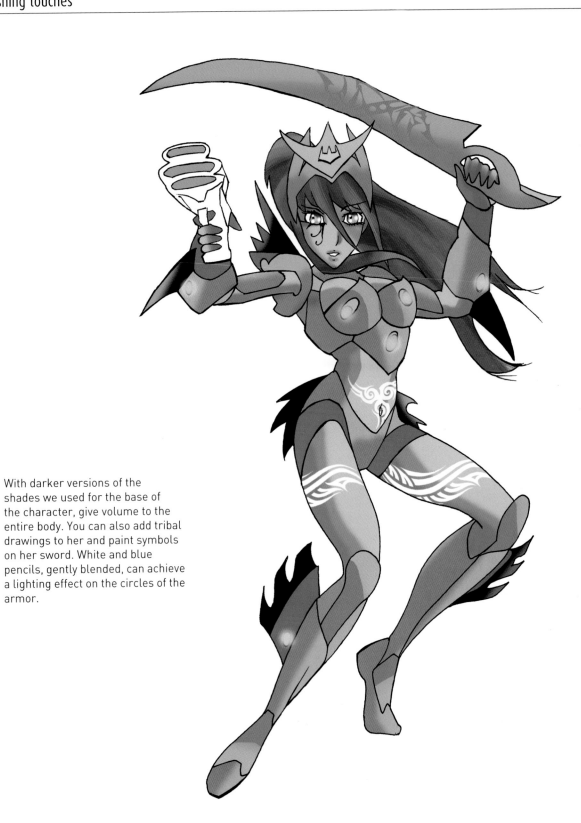

With darker versions of the shades we used for the base of the character, give volume to the entire body. You can also add tribal drawings to her and paint symbols on her sword. White and blue pencils, gently blended, can achieve a lighting effect on the circles of the armor.

GOTHIC ELF

Sashum Ravenlok is an elf from the gray forests of the East, and an expert in healing spells and eternal sleep potions. She is also good with short swords and the bow and arrow. It is well known that she seeks adventure and fortune at the side of Azazel, the dragon hunter.

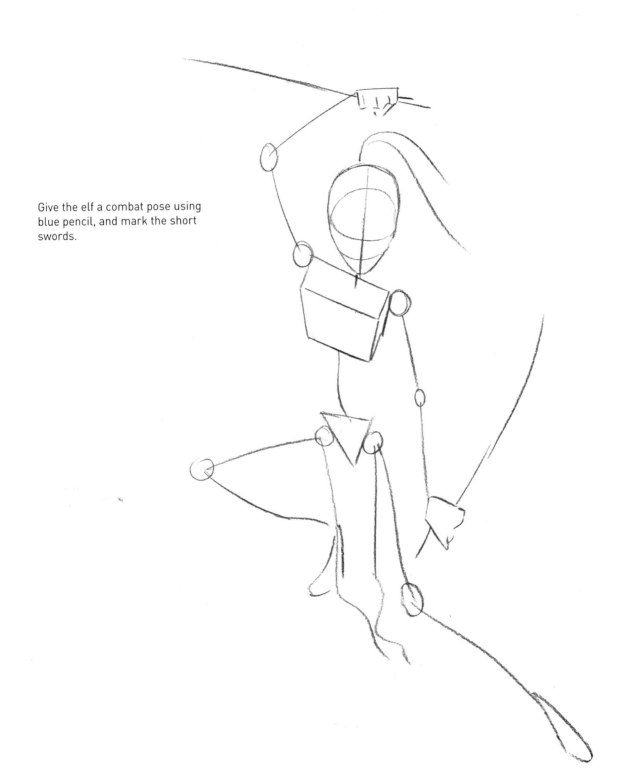

Give the elf a combat pose using blue pencil, and mark the short swords.

With a soft 2H pencil, shape the
contours of the figure and make
sure they fit the skeleton.

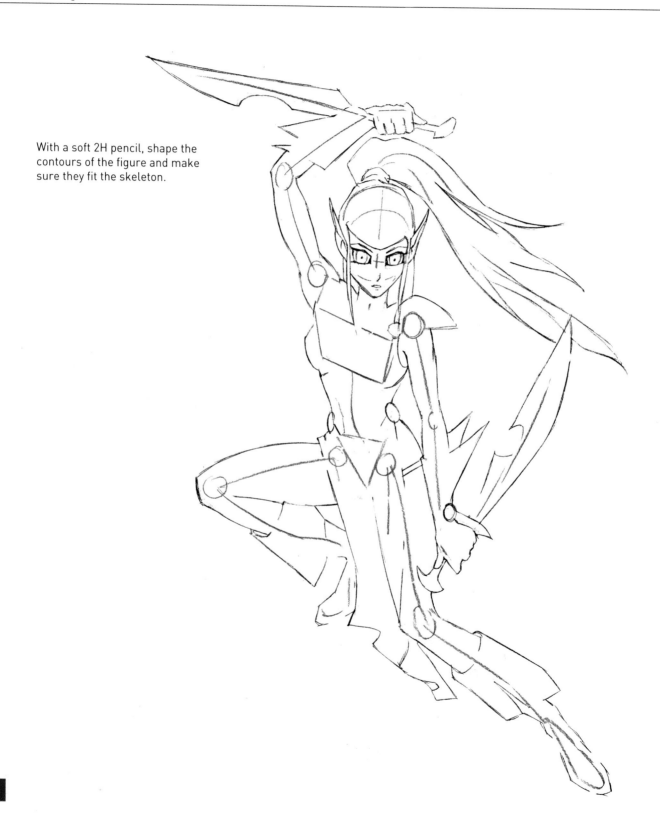

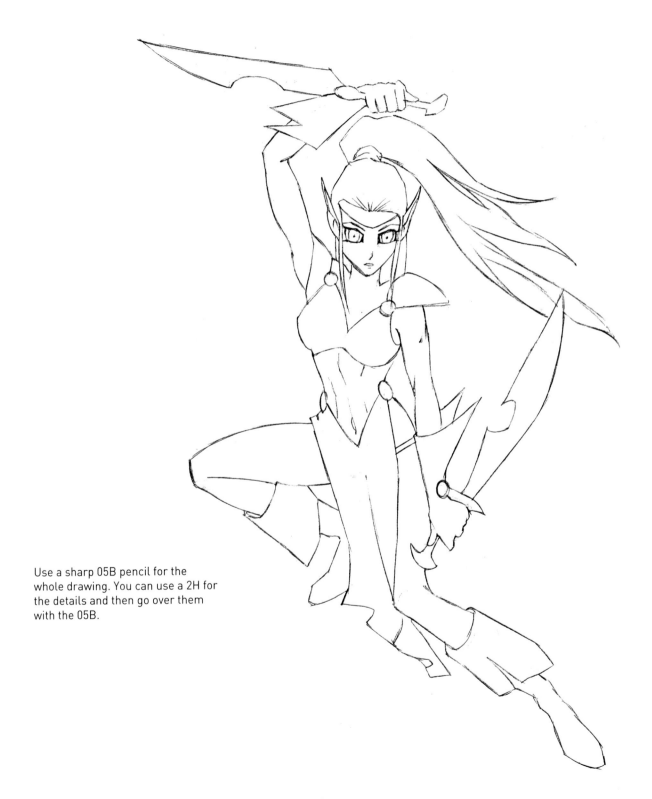

Use a sharp 05B pencil for the whole drawing. You can use a 2H for the details and then go over them with the 05B.

Use an 02 marker for the entire drawing. Highlight the details with an 04 and use an 08 for all areas of the costume that will be filled in with black.

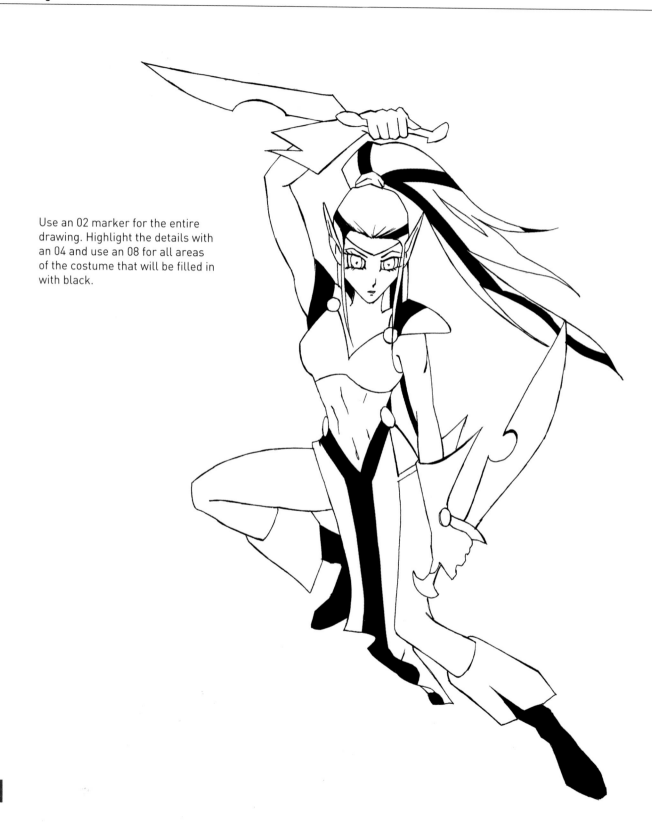

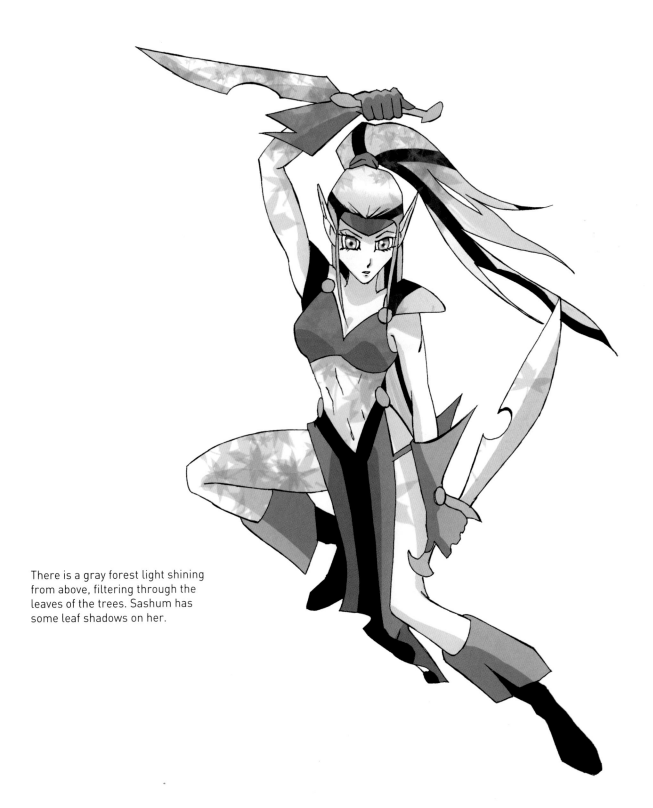

There is a gray forest light shining from above, filtering through the leaves of the trees. Sashum has some leaf shadows on her.

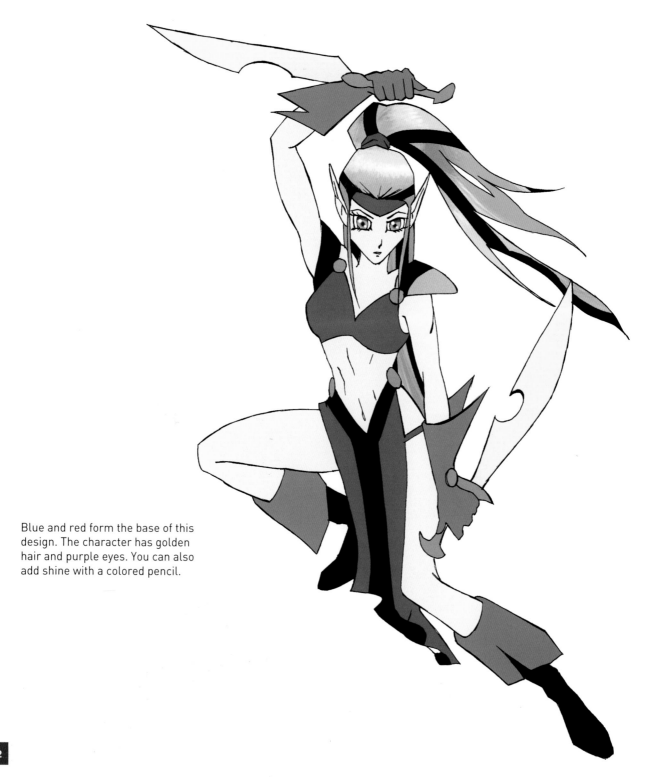

Blue and red form the base of this design. The character has golden hair and purple eyes. You can also add shine with a colored pencil.

Using more intense shades, add volume to all parts of the design. Finally, add magic runes to the swords and signs of protection to the elf's skin.

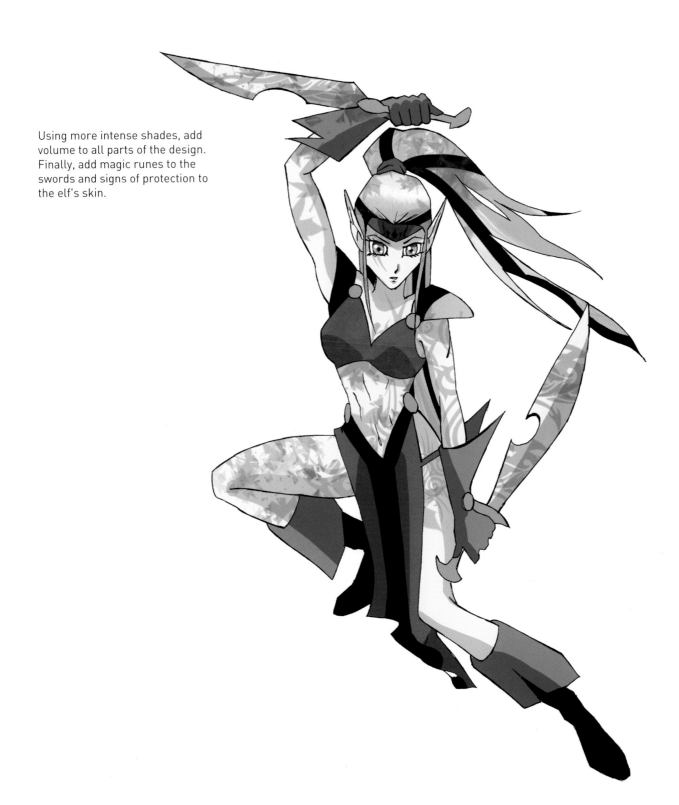

GOTHIC SATANIC BEING

Dayanna is a being of the underworld, a gothic, satanic sorceress serving the Lord of Darkness in hell. If you capture her, she will give you three wishes, but be careful what you wish for—your wish could backfire.

Draw the outline of a capture pose.
Be especially careful with the
character's legs, which are the most
difficult part.

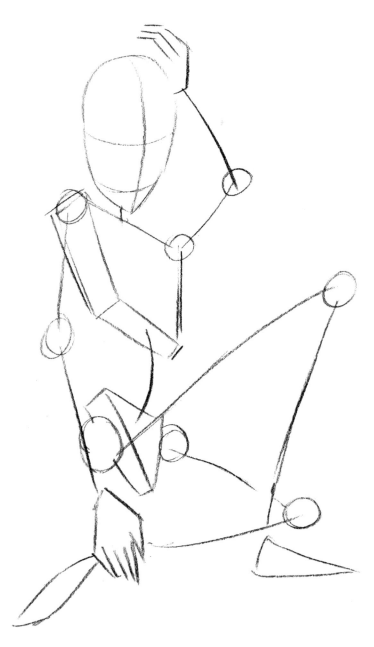

Add detail to the figure and legs
with a 2H pencil, giving the design
contours.

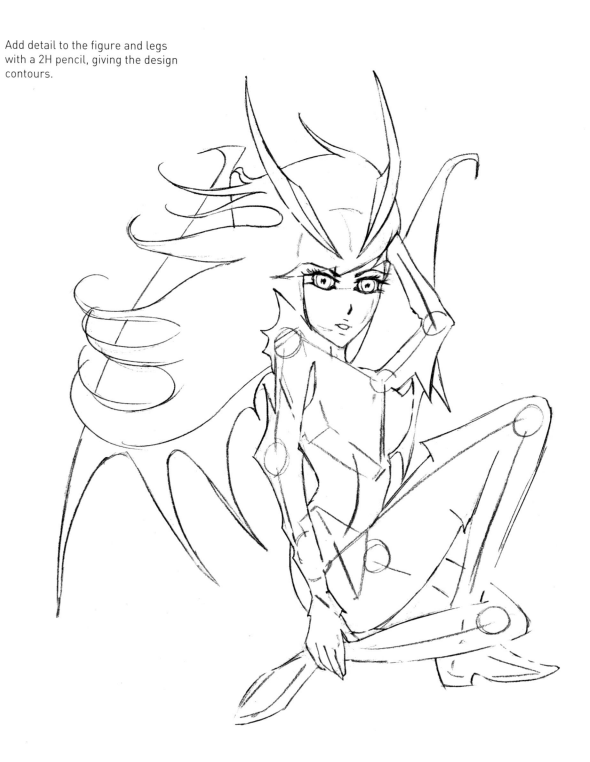

Using an 05B pencil, carefully go over the entire drawing.

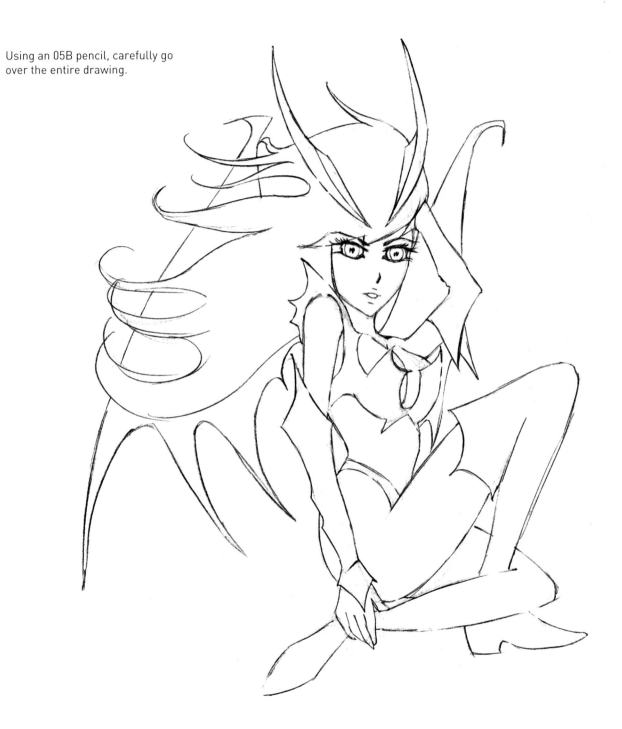

Use a stylograph or 02 fine tip pen for the entire drawing, and 04 and 08 ones to paint the gothic wings.

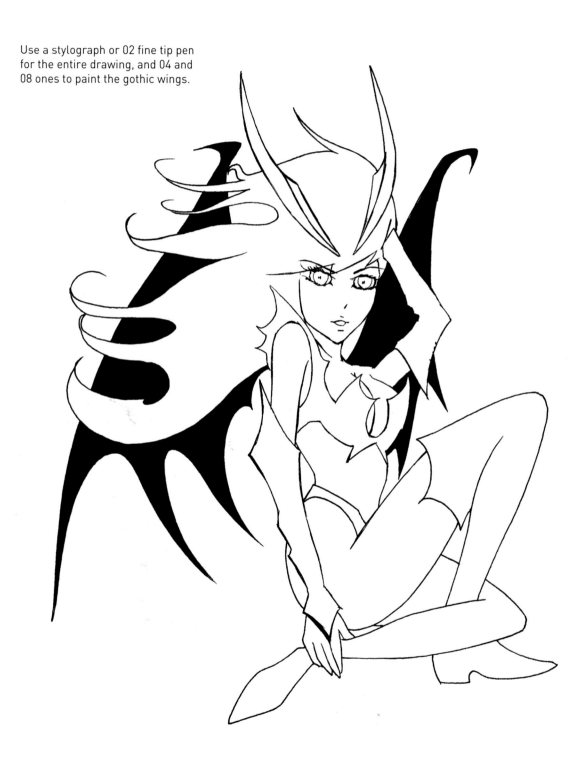

Light projected from the right adds volume to the character's figure and hair.

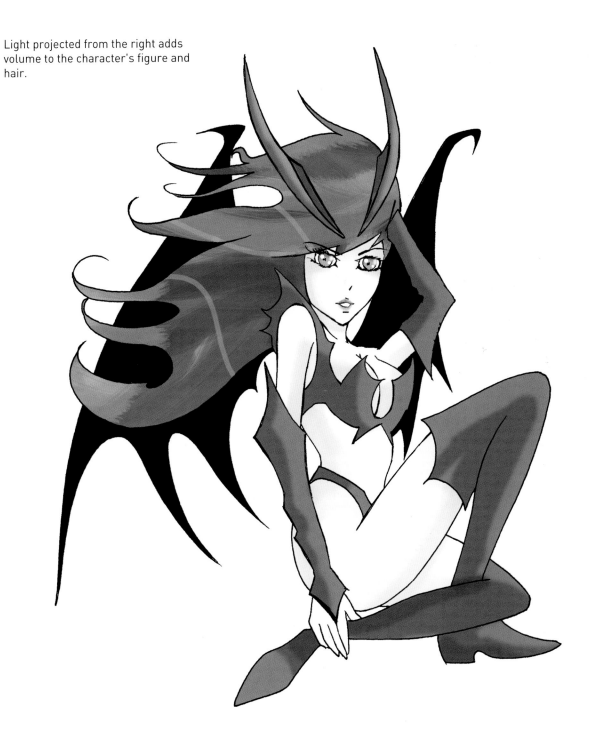

A sorceress of the underworld
only wears red, so you should use
several shades of red, from light to
dark, for the base color.

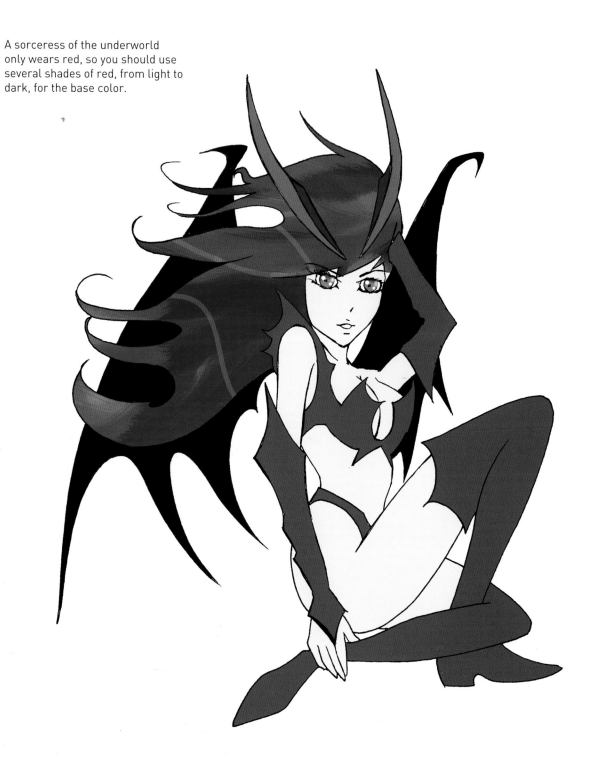

Use a darker tone of red to give volume to the skin and red leather costume, then add the magic ring and a few soft red gothic tattoos. Finally, add shine to the hair by using a pink, white, or soft red pencil.

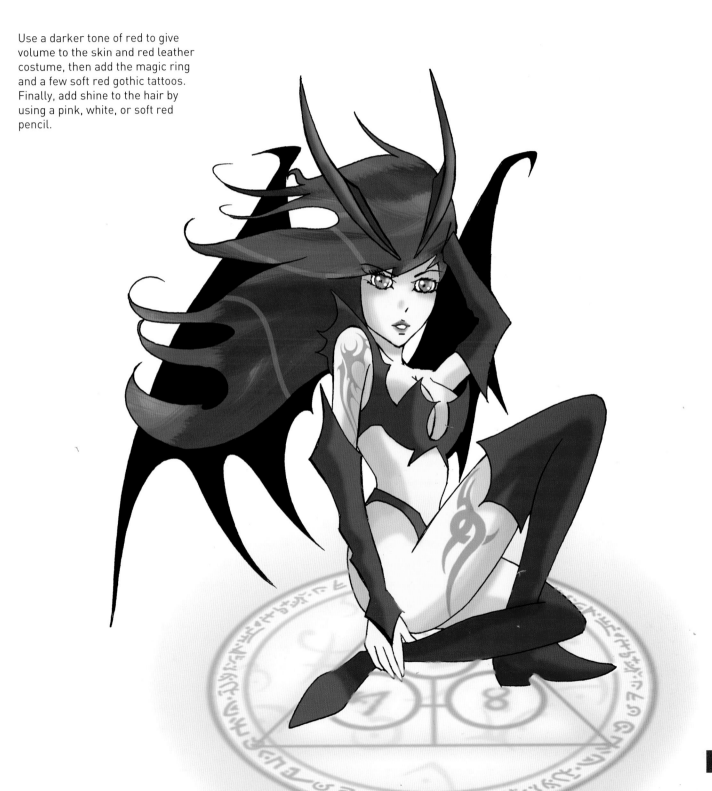

GOTHIC MONSTER

The Wakrams are gothic monsters living in the depths of the earth. They are fierce and able to swim in the large streams of underground water.

Draw the skeleton with a blue
pencil. A big skull and head give
it a strong, fierce look.

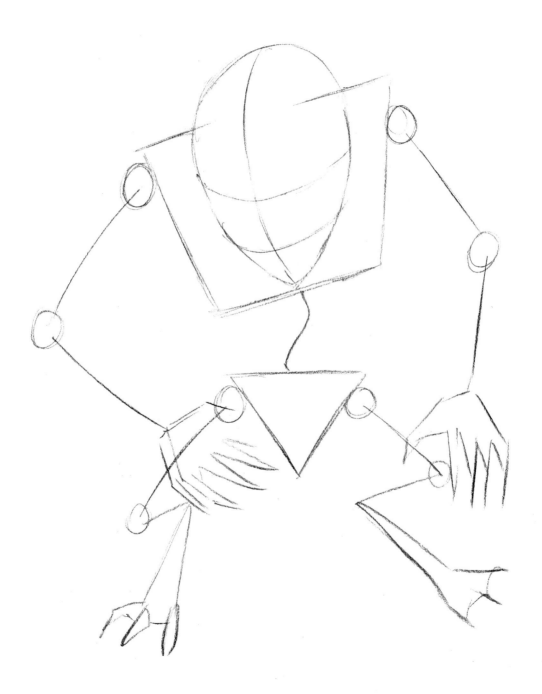

Mark out the silhouette and
contours of the drawing with
a soft 2H pencil.

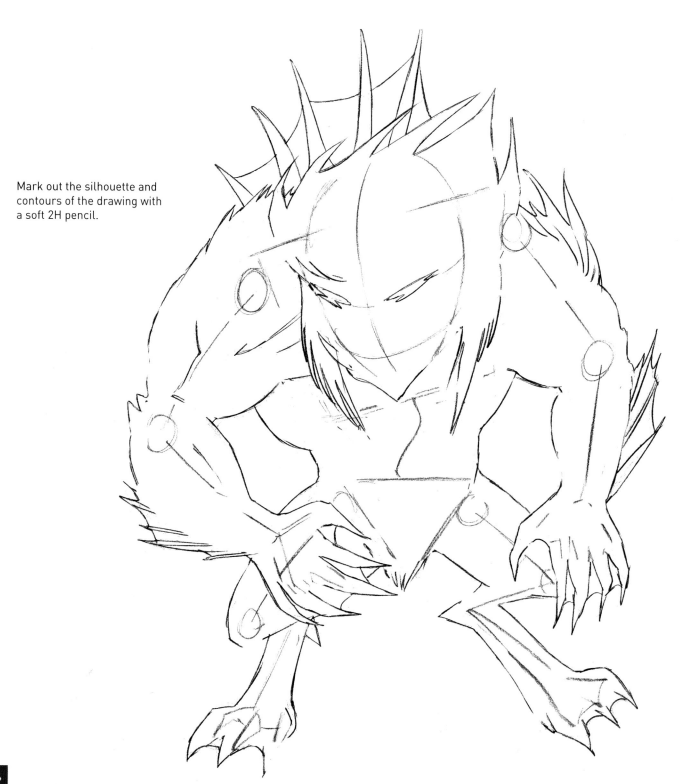

Draw the character's details with
a 2H pencil and then go over them
with the 05B.

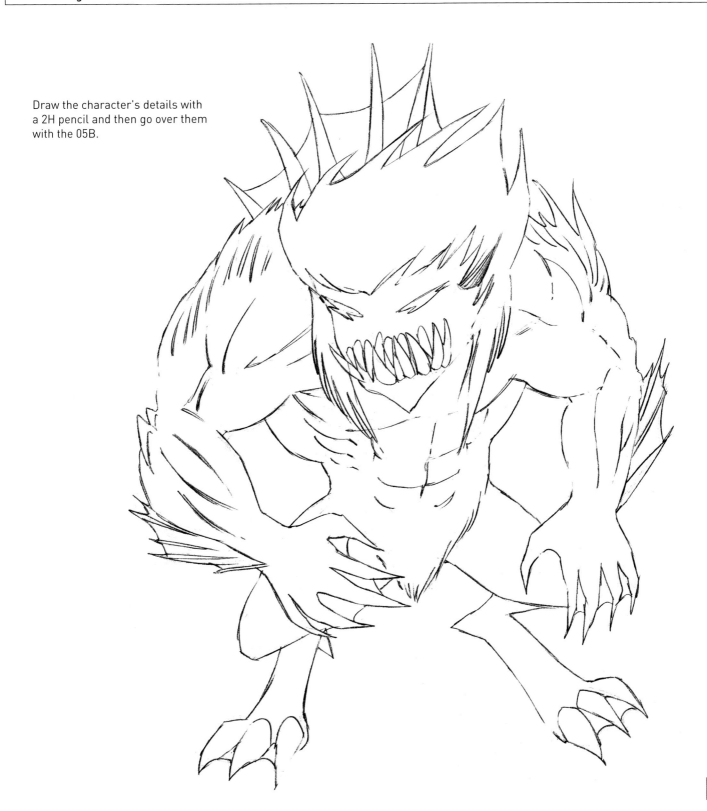

Ink the whole monster with an 02
fine tip marker and go over the
shape of its head with an 04 marker.

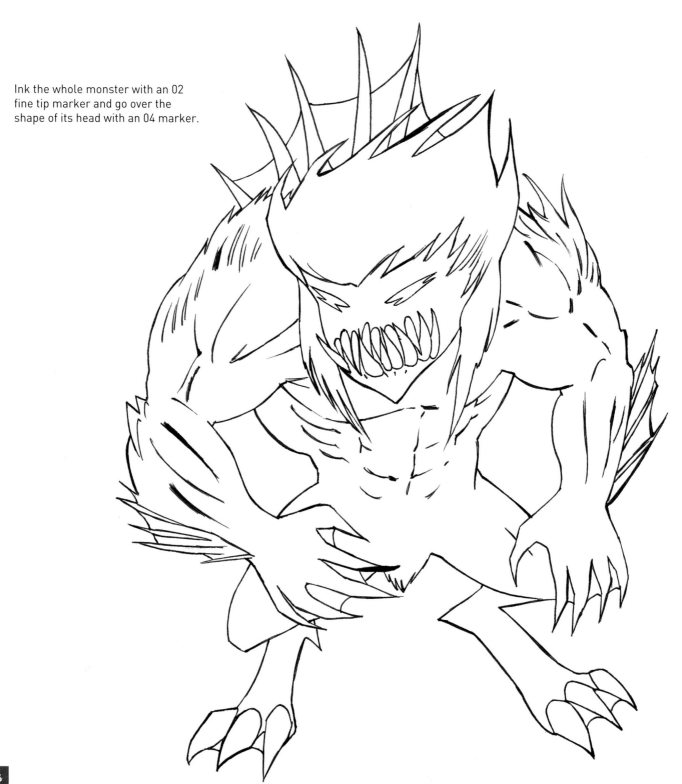

A light from above will emphasize the monster's muscles, giving the volume we want.

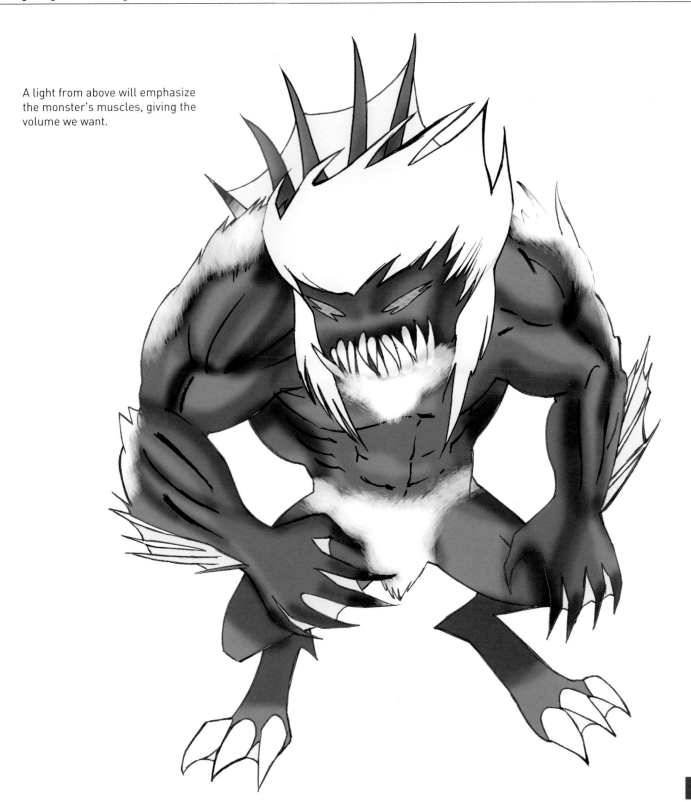

The purple and light green colors give shape to this gothic monster. The eyes are pink and red. White pencil adds shine to the hair.

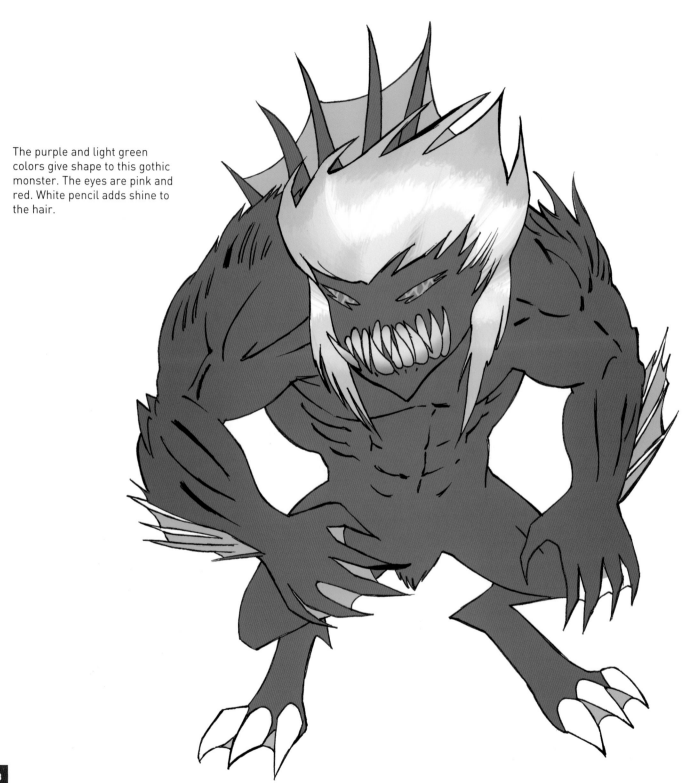

Use a dark shade of purple to give volume to the body and to highlight muscles and shadows. Add a dark green mesh of membranes to the hands, feet and back, and a few tribal tattoos on the shoulders in white pencil.

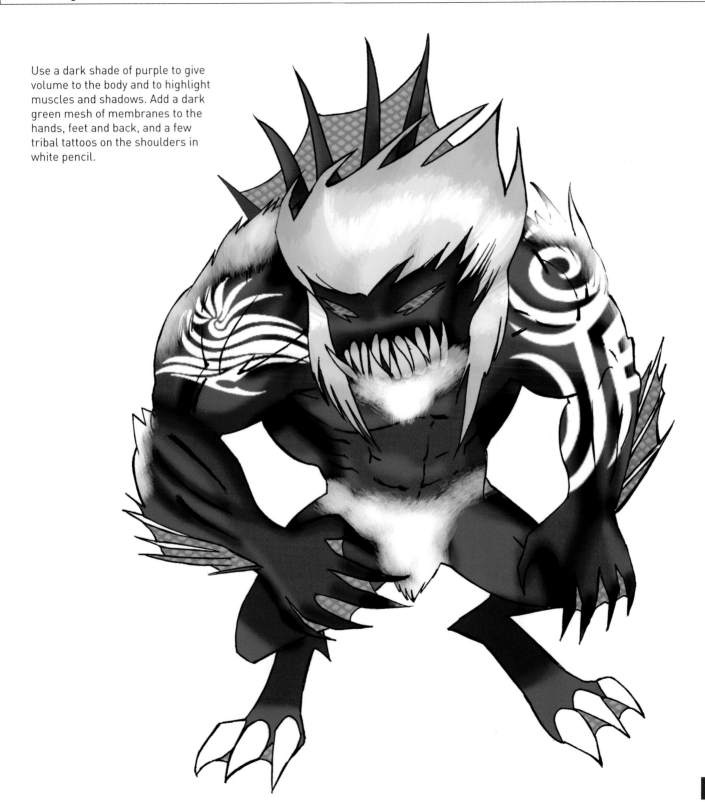

GOTHIC ZOMBIE

This gothic zombie is not very bright, but compensates for this with its tenacity in battle. It usually engages in hand-to-hand combat, although sometimes may inaccurately use a weapon.

1. Outlining

Using a blue pencil, draw the zombie's skeleton. Aim to create a pose that makes the zombie look like he is walking along, dragging his feet, just like a typical zombie.

2. Sketching

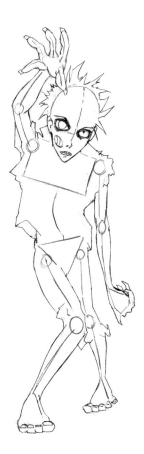

Use a 2H pencil to mark the contours. Be especially careful when positioning the legs.

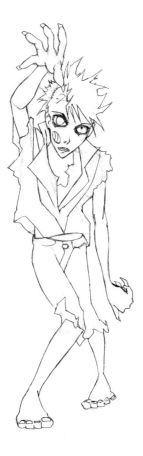

With a sharp 05B pencil, define
the details and finish the drawing.
Resting your hand on a piece of
paper will help avoid smudging.
Remember to always work in the
same direction with the eraser.

4. Inking

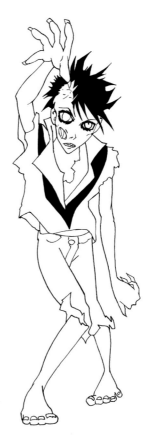

I inked the entire drawing with a
fine tip 02 marker. I then filled in the
finer areas of black with an 04 and
the larger ones with an 08.

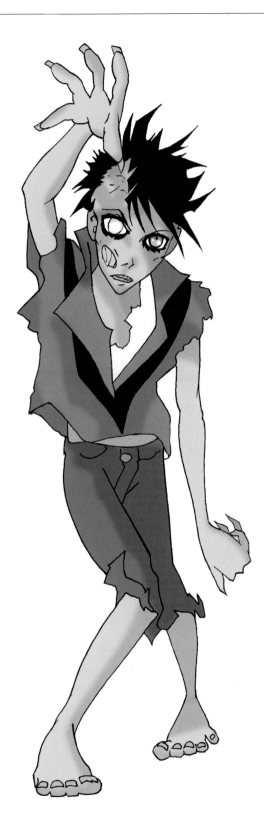

The light comes from above and shines directly on the character, like a searchlight.

Use shades of green and gray for the zombie's skin, a touch of yellow on his face, red for the jacket, and gray for the torn trousers. His one working eye is green, and he has a small amount of black hair. Remember to add shine with the colored pencils.

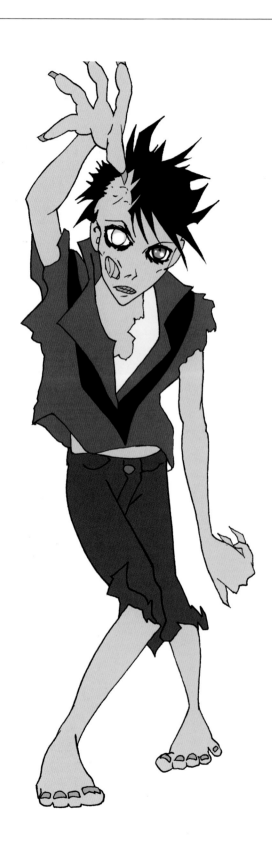

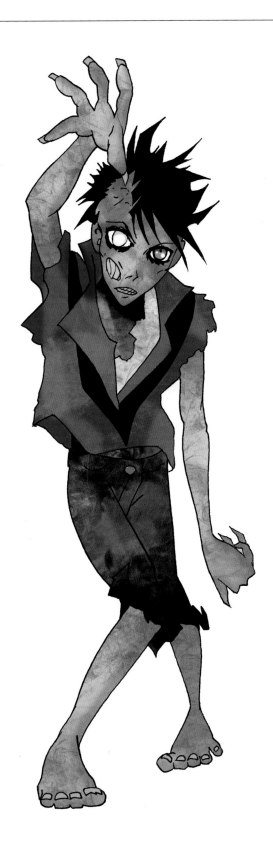

Zombies are always dirty, so use shades of green, red, and dark brown on the character and its clothes. Add spots of red blood with a red marker.

GOTHIC PHANTOM

Kandi is a gothic ghost who roams the large mansion that once belonged to her family. She hopes that someone will solve the mystery of what turned her into a ghost and release her forever.

Use a blue pencil to draw an outline of Kandi. Give her skeleton a droopy position.

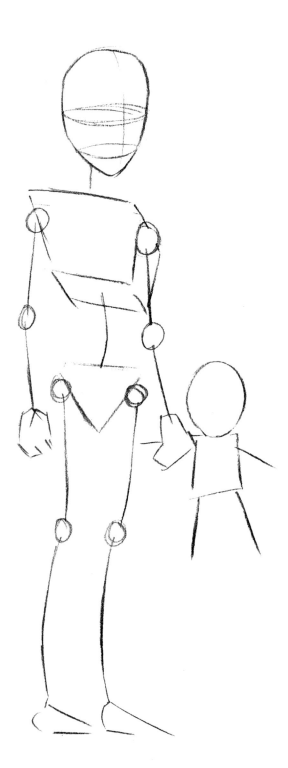

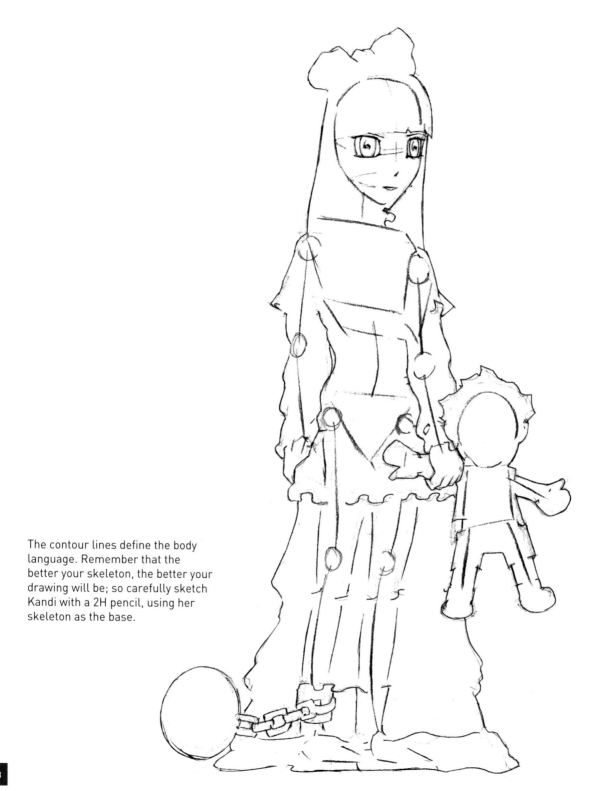

The contour lines define the body language. Remember that the better your skeleton, the better your drawing will be; so carefully sketch Kandi with a 2H pencil, using her skeleton as the base.

With an 05 pencil, define the details in preparation for inking. Try to draw cleanly and then erase using the softest rubber available.

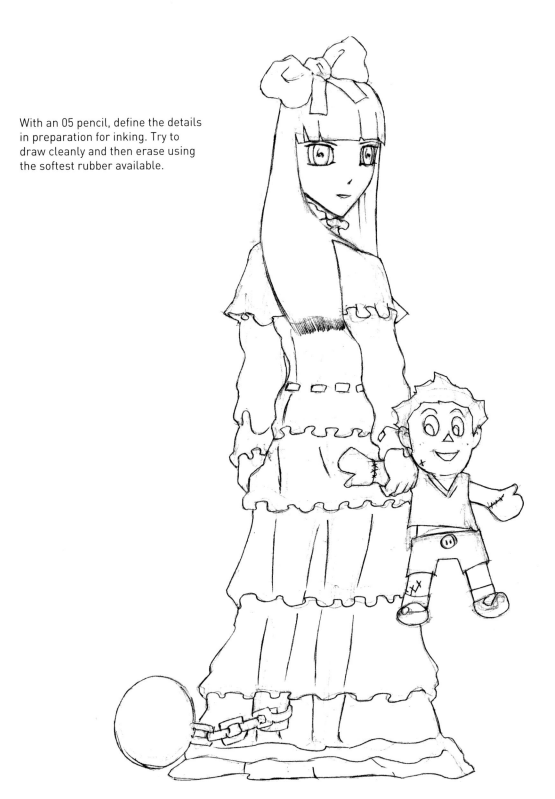

Using an 02 stylograph, ink the
entire drawing. Add details to the
hair ribbons with an 04 marker and
fill in the black areas with an 08.

Kandi is a ghost, so the light emanates from within her. Try to create the effect of a lamp inside her to create ghostly transparency.

Use very light and soft shades for the character's clothing and save the intense colors for her doll. The gold specs in her eyes will be the only note of color on the character.

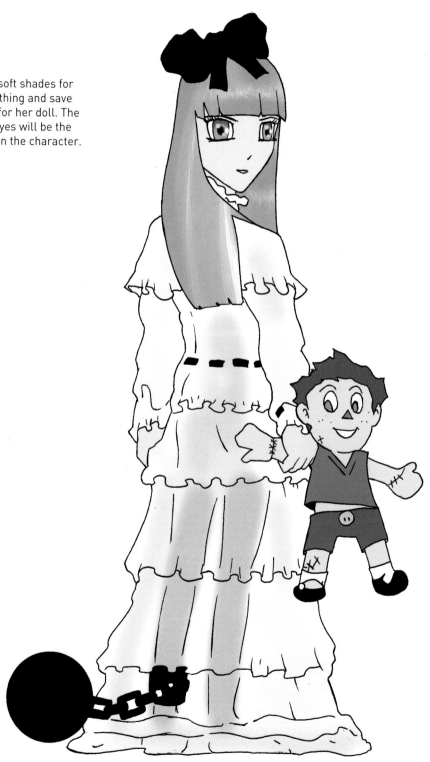

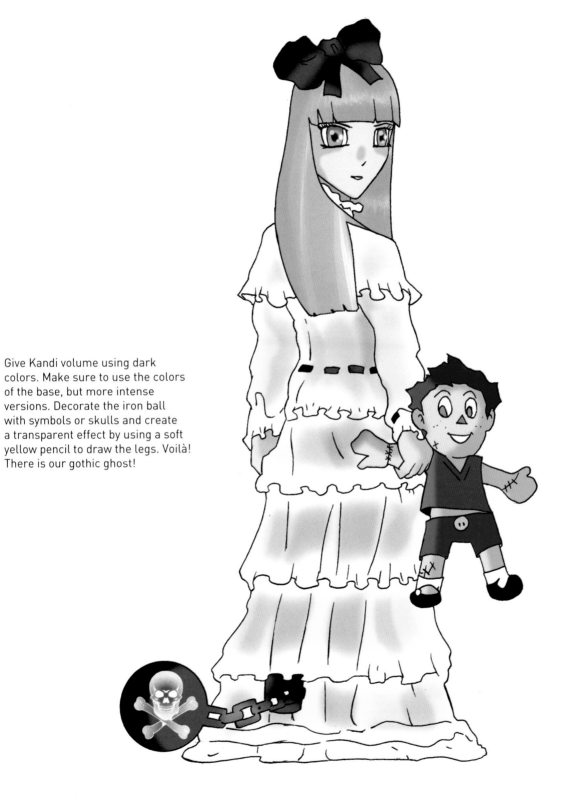

Give Kandi volume using dark colors. Make sure to use the colors of the base, but more intense versions. Decorate the iron ball with symbols or skulls and create a transparent effect by using a soft yellow pencil to draw the legs. Voilà! There is our gothic ghost!

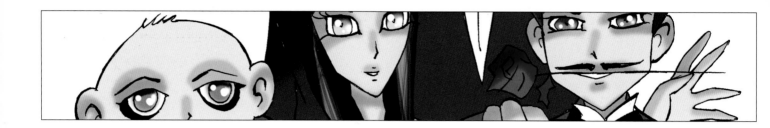

FREAKISH FAMILY

This is quirky family who keep carnivorous plants as pets. The father is a sinister character who tortures himself. The mother is a femme fatale who likes to walk around the cemetery. The other members of the family are their gloomy children, weird uncle, butler, and a hand with a life of its own.

This composition of several characters will be organized as follows: the two children first, then the three adults, then the huge butler behind them all with their friend, the hand. Draw the outline of the characters in blue pencil, taking care to keep all of them proportionate.

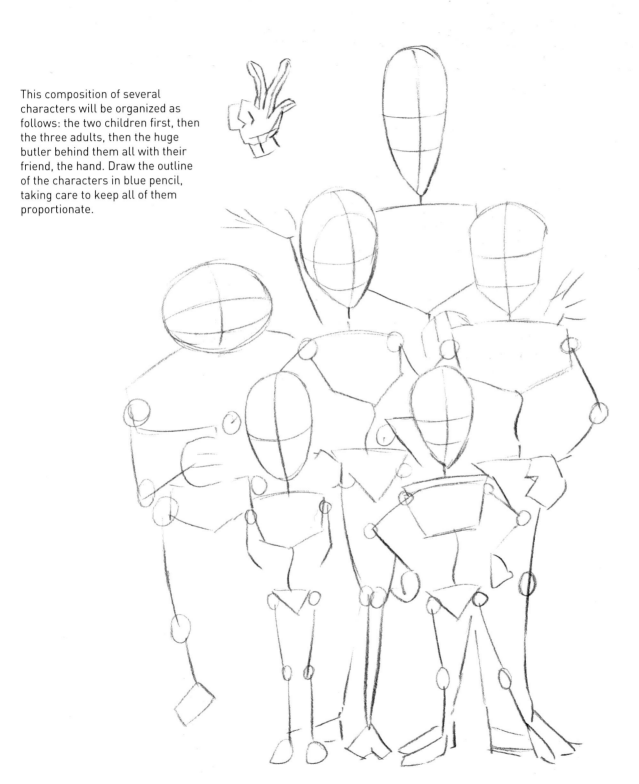

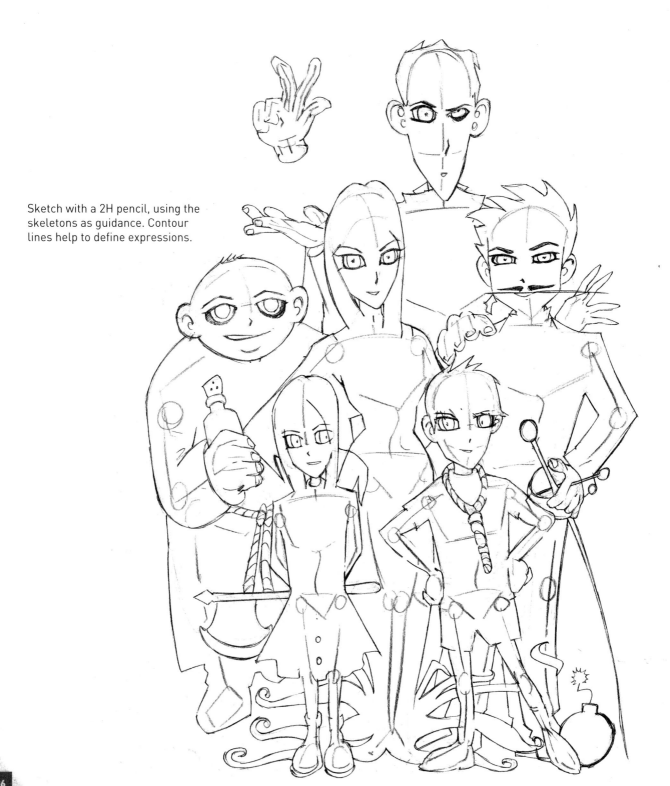

Sketch with a 2H pencil, using the skeletons as guidance. Contour lines help to define expressions.

Use an 05 pencil to define details before inking. Try to draw cleanly, and then do any necessary erasing with the softest available rubber. Always work in the same direction.

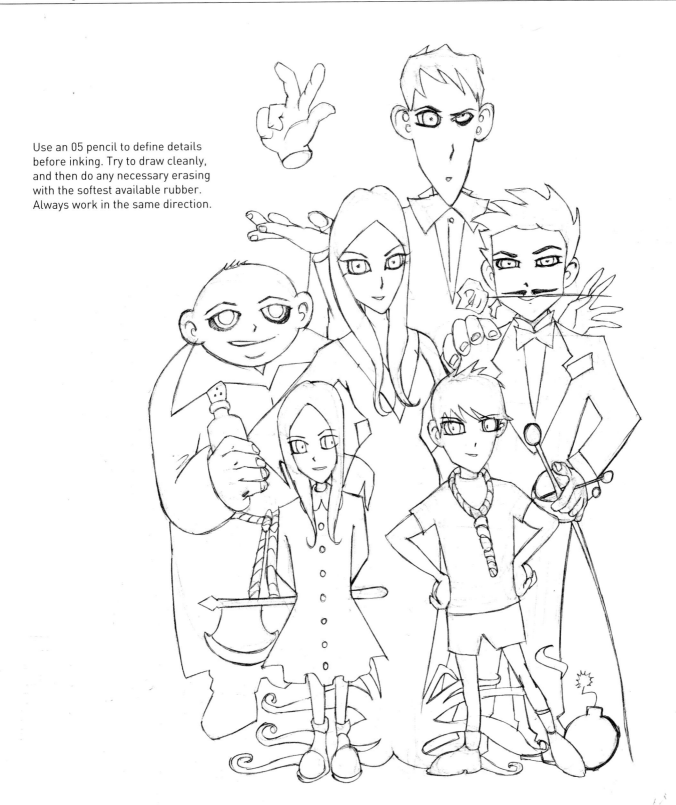

Ink the entire drawing with a fine tip 02 stylograph, then add contours to the three characters in the middle with an 04. Use an 08 for the main characters (the children), and for filling the marked areas with black.

A light at the bottom shining upward will give the family a gloomy appearance that looks scary without the need for further decoration.

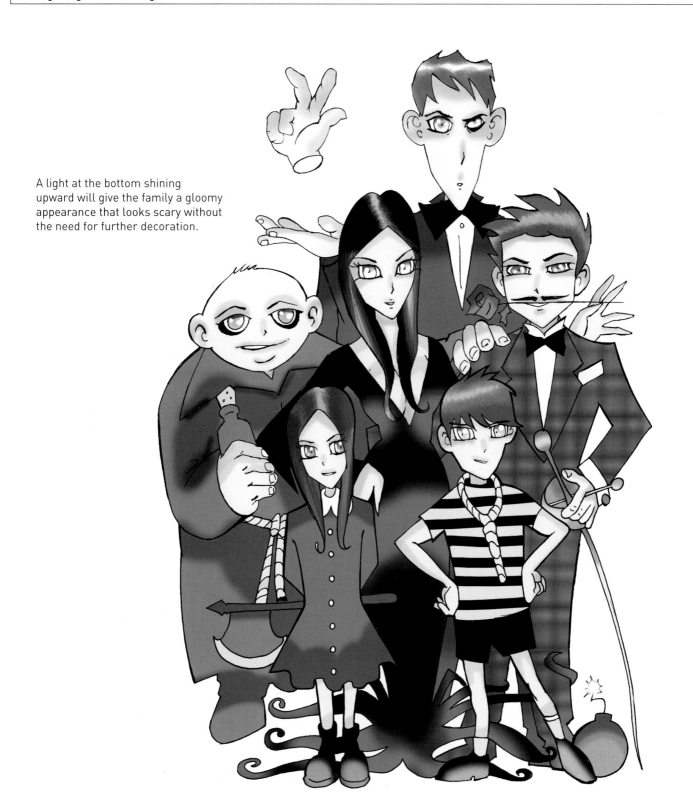

Add the base colors to the characters' clothes.

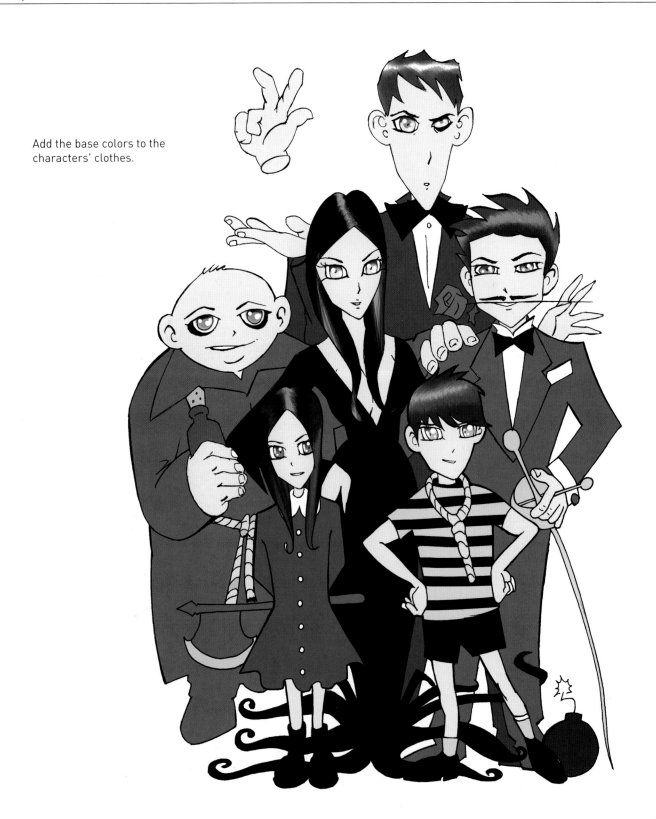

Give the characters volume using dark colors, making sure that they are the same colors as the base, but more intense shades. Add final gothic touches and this family is ready to terrorize.

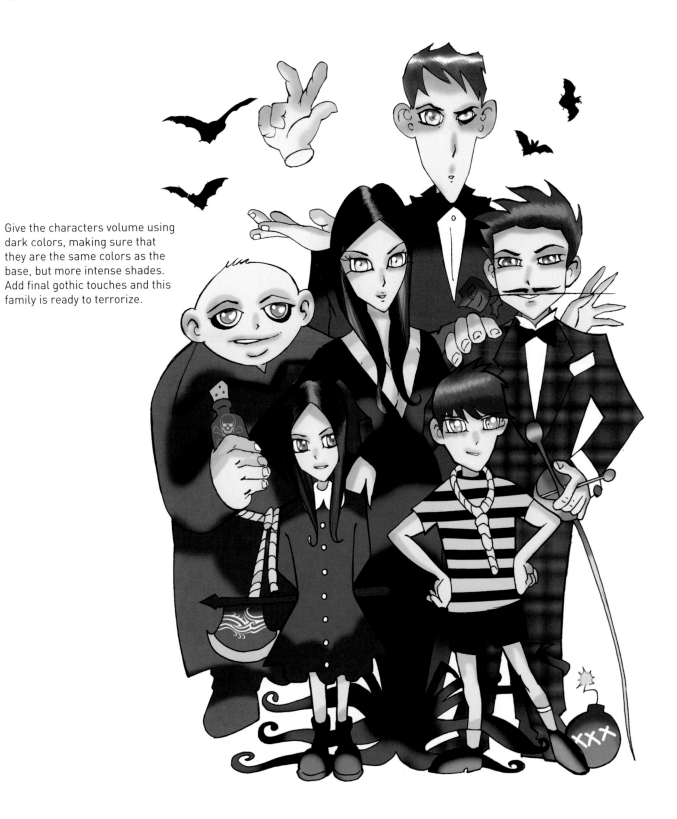

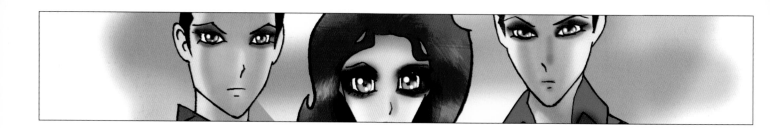

VAMPIRE AND WEREWOLF

Three teenagers embark on a love story, a shared love between a mortal girl, a werewolf, and a vampire. The two male characters, with their fantastic powers, compete for the love of the girl who appeared in their lives and together live adventures with love and action as a backdrop.

This design is going to have a
trio formation. In the foreground,
pencil in the blue outline of the girl.
Behind her, draw the outlines of the
other two characters.

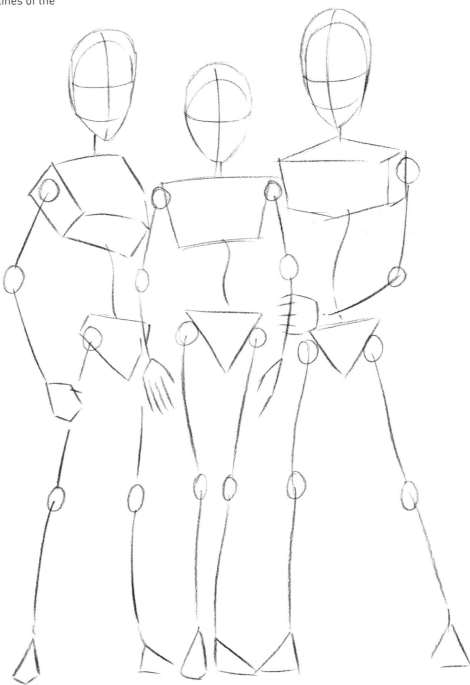

With a 2H pencil, add contour lines to give the figures shape and volume. Make the characters fit their skeletons.

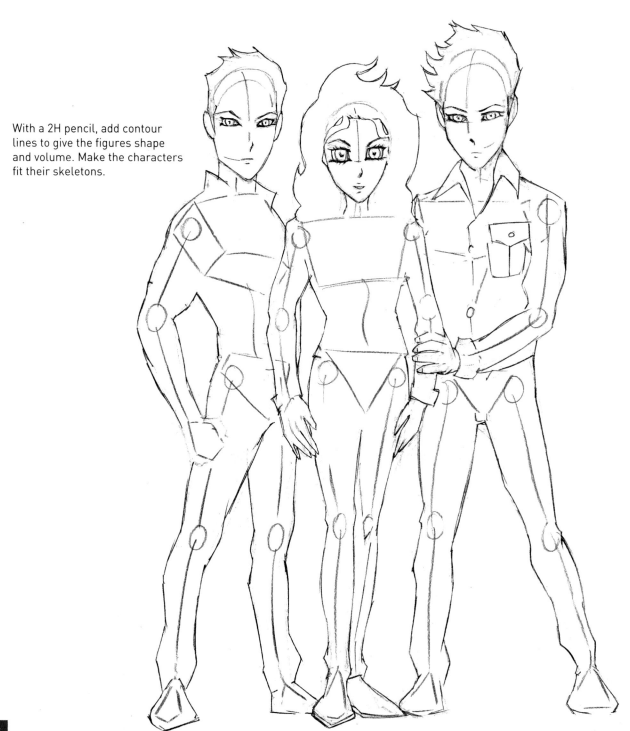

Go over the entire drawing with an
05B pencil, keeping the lines as
clean as possible. Always use a soft
rubber for erasing.

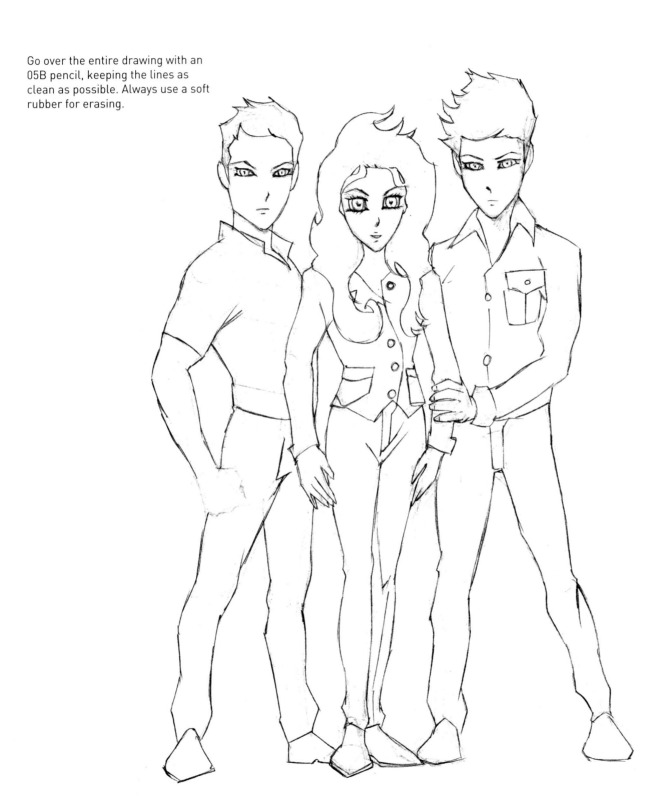

With the pencil lines defined, ink the entire drawing with an 02 marker. Go over the girl's outline in an 04 and fill in selected areas in black using an 08.

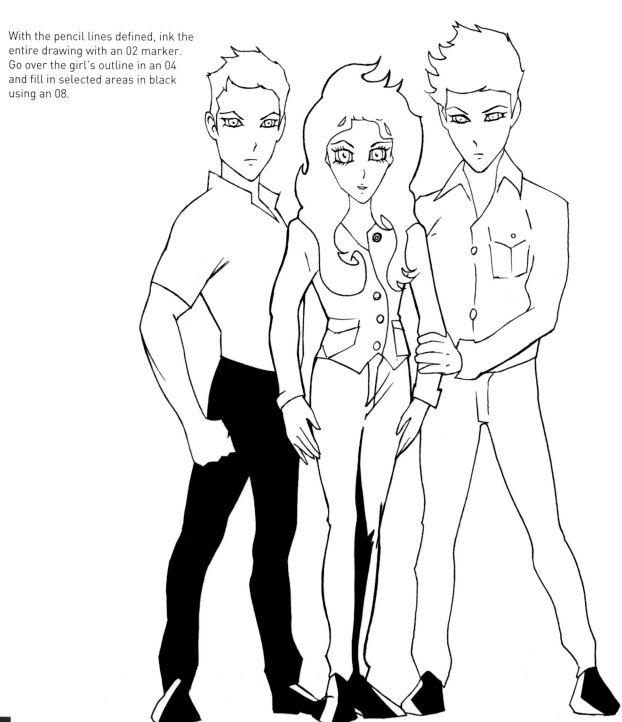

There is nothing better than cross-lights to highlight the contours and volumes of the three characters. These should go from right to left and left to right.

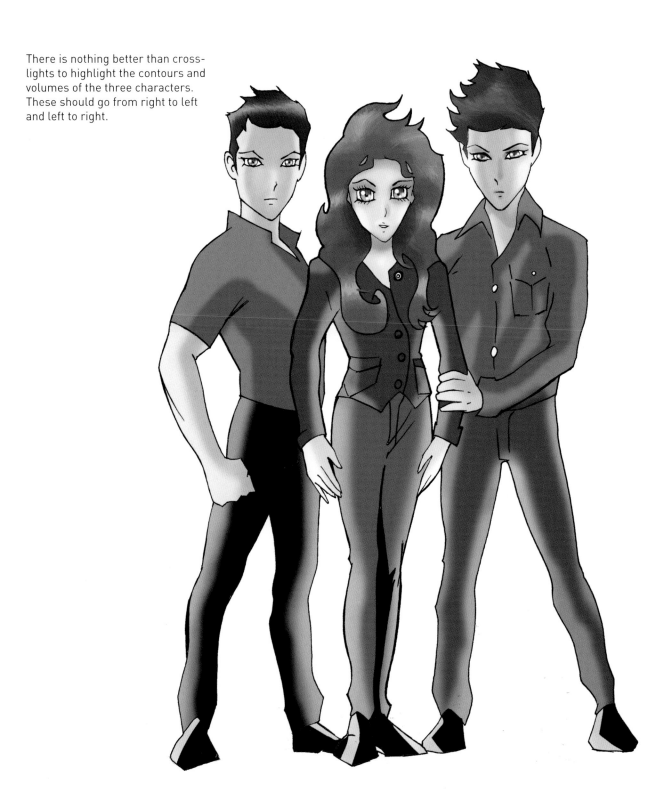

I have chosen a different base
shade for each character: green,
purple, and blue.

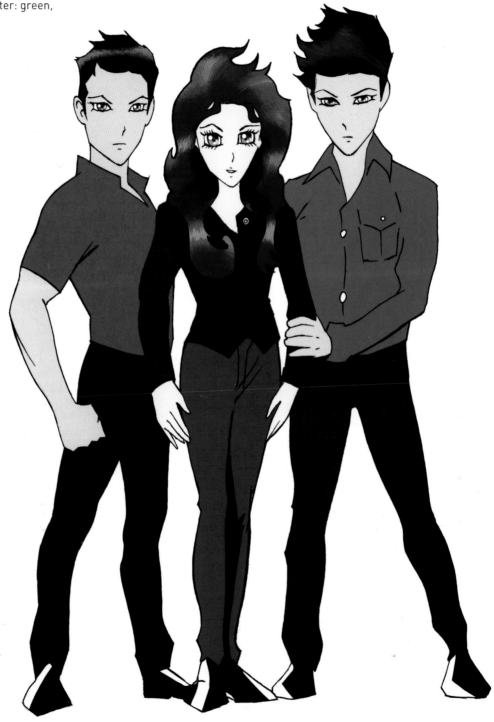

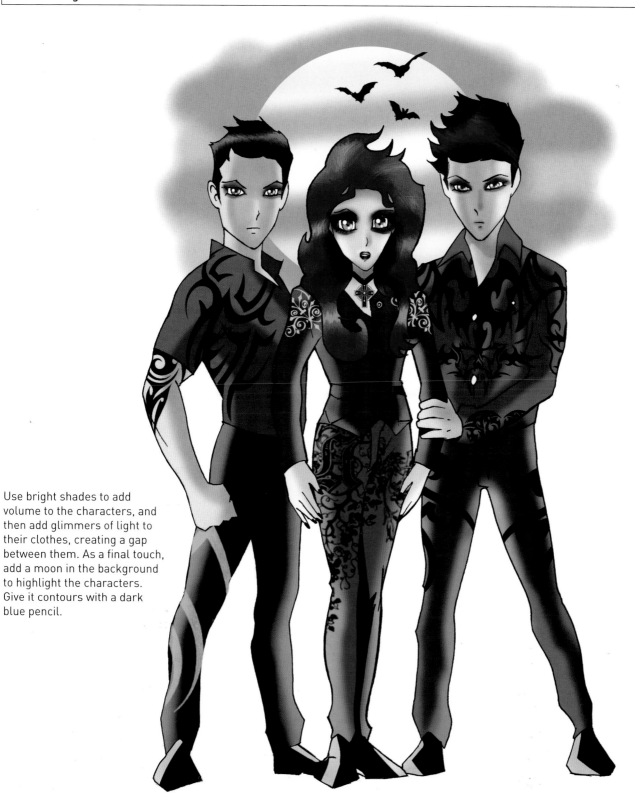

Use bright shades to add volume to the characters, and then add glimmers of light to their clothes, creating a gap between them. As a final touch, add a moon in the background to highlight the characters. Give it contours with a dark blue pencil.